Gender Politics

Gender Politics

From Consciousness to Mass Politics

Ethel Klein

Harvard University Press
Cambridge, Massachusetts,
and London, England

Copyright © 1984 by the President and Fellows of
Harvard College
All rights reserved
Printed in the United States of America
10 9 8 7 6 5 4 3

Library of Congress Cataloging in Publication Data

Klein, Ethel, 1952–
 Gender politics.

Includes index.
 1. Women in politics—United States—History—20th
century. 2. Feminism—United States—History—20th
century. 3. Women's rights—United States—History—
20th century. 4. Sex role—United States—History—20th
century. I. Title.
HQ1236.5U6K54 1984 305.4′2′0973 84-8992
ISBN 0-674-34196-1 (cloth)
ISBN 0-674-34197-X (paper)

To My Family

Ludwig, Anna, Joel, and Rosemarie
Kent, Holly, Barbara, Sandy, Elaine, and Terry

Acknowledgments

This book began almost a decade ago when I first wondered how political groups form and what leads to the emergence of social movements. Now that the book is completed and I look back on the journey, I feel a sense of gratitude and fondness for the people who helped me along the way. At the University of Michigan I worked with M. Kent Jennings, an adviser who is committed to women, creates research opportunities for his students, and teaches them to become social scientists. In addition to being a mentor, Kent has been a loyal friend. The care and concern that he and his wife, Holly, have shown me over the years has made them part of my family.

At the Institute for Social Research, where I began writing the book, I worked with Philip E. Converse, the social scientist's social scientist, and A. F. K. Organski, the institute's European intellectual, both of whom encouraged me to tackle broad questions and debated with me over the answers. I owe them, as well as Gregory B. Markus and Lutz Erbring of the institute, a great intellectual debt. I also thank Raburn Howland and Henry Heitowit for helping to make an institute a home.

At Harvard University I was fortunate to find colleagues like Sidney Verba, Robert D. Putnam, H. Douglas Price, Harry N. Hirsch, Terry Karl, Lisa Anderson, Stephen Cornell, and M. J. Peterson, who either read the manuscript or patiently listened as I worked through the ideas. I owe Sid Verba special thanks for his care and time in going over several chapters.

I am grateful to Charles Tilly, William Gamson, Patricia Gurin, Gerald Gurin, Michael Lipsky, and Karl Deutsch, on whose work this book builds.

The book could not have been written without the help and moral support of my colleague and friend Barbara G. Farah, who read and commented on early drafts. Additional support came from Jack Thomas, Samuel Evans, Sandra Gubin, Celinda Lake, Hazel Markus, Jamie Catlin, Nick Vasilatos, Kevin Kennedy, Patricia Nolan, Diana Stone, Nancy Krieger, Marjorie Lefcowitz, Fran Featherston, Gerald and Linda Kline, Aurie Hall, Judy Jarvis, Elaine Ader, Christine Aquilino, Geraldine Bolter, and Beverly Peterson.

Aida Donald and Virginia LaPlante of Harvard University Press encouraged me throughout the writing process. I thank them both for their important role in the completion of this book.

Finally, I would like to thank Anna and Rosey Klein for always being there.

Contents

GENDER POLITICS

Introduction

Consciousness and Politics

On August 26, 1970, the fiftieth anniversary of passage of the Nineteenth Amendment granting women the suffrage, women from all over the country joined in support of the Women's Strike for Equality. The participants in this nationwide demonstration expressed their solidarity by marching, holding teach-ins, and picketing in support of equal employment and educational opportunities, abortion, and child care. Housewives, secretaries, lawyers, mothers, grandmothers, and students were drawn together out of a sense of injustice, personal frustration, and the need to change inequities in the treatment of women. Many of these women had no prior organizational commitment to women's rights. They came with a specific agenda of activities and policies aimed at gaining for women economic and social independence. The golden anniversary of the woman suffrage amendment was thus celebrated with the largest demonstration for women's rights in United States history.

This event marked the beginning of women's liberation as a mass movement. Earlier feminist efforts in the 1960s had been ridiculed, but the magnitude of support for the strike forced recognition of women's rights as a legitimate issue. The turnout in support of feminism surprised not only the mass media and the general public but also the organizers of the strike, some of whom had questioned the judiciousness of such activity, fearing that it would attract little support among women. It is difficult to declare a war if no army can be recruited. But thousands of women did come to this demonstration, as they would to subsequent marches to demand their rights.

Feminism is a political ideology which argues that men and women should have equal roles in society and that women have been denied support within the home and access to the marketplace because of discrimination and inadequate social institutions. The women's movement that emerged in 1970, also known as the women's liberation movement or the feminist movement, was the first social movement to press for demands to ensure women's equality. This protest movement evolved into an organized, sophisticated, political lobby, which initiated legislation and litigation and supported electoral campaigns on behalf of women's rights. These efforts to help women define their interests, have the confidence to articulate them, and then seek attention for them in the public realm contributed to the emergence of a women's vote in 1980 when, for the first time, women were significantly less supportive of the winning candidate than were men. This vote difference, popularly called the gender gap, followed ten years of organized feminist effort to encourage women to ask: What is best for women, and what do women feel is best for the country?

A political movement, such as the women's movement, is an expression of widely shared grievances. People turn to political action when they feel that the government has some responsibility to help remedy their problems. Yet most hopes and fears never gain a political voice, because people view their problems as personal and look to themselves, their families, or their friends for solutions, rather than to political authorities. The question addressed in this book is how women's personal problems became politicized and why women— and even men—now demand equal social and economic opportunities when they did not do so in the past.[1]

Having a hard life and being a member of an exploited group does not in itself lead to political unrest. People often blame themselves for their difficulties. Only when they see that their problems are shared by other people like them, the group, can they attribute the source of their concerns to social conditions, such as discrimination, and look to political solutions. The belief that personal problems result from unfair treatment because of one's group membership rather than from a lack of personal effort or ability is known as group consciousness.

Group consciousness is a critical precondition to political action. The workers who endured the pain, poverty, and alienation of the mills, mines, and factories with acquiescence instead of rebelliousness is a classic example of the need for consciousness. The revolt of the proletariat, according to Karl Marx, could not take place until the workers understood that, no matter how hard they worked, they would continue to suffer because they were exploited by the existing class divisions of workers and owners. Only with this consciousness would a class whose members lacked solidarity and pursued their

goals as individuals be transformed into a class whose members engaged in collective efforts to gain control over the means of production.[2]

Consciousness need not be limited to an understanding of economic conflicts.[3] Other attributes of society, such as race, ethnicity, sex, and religion, can serve as bases for group action. People who believe that their lives are shaped by the fact that they are working class, Catholic, or black have formed unions, built political machines, and marched in the streets to claim their rights.

The rise of political consciousness is a three-stage process.[4] It begins with affiliation, a recognition of group membership and shared interests. Over the centuries most men and women have failed to view women as a group. Women's primary affiliations have been familial, ethnic, or religious, but not gender-based. Women first needed to recognize that they faced certain problems precisely because they were women in order for a feminist movement to emerge.

But for the psychological attachment to a group to induce political action, it must be coupled with a rejection of the traditional definition for the group's status in society, to make way for a new group definition. As long as women believed that they belonged in the home, they did not question why they were not represented in business, government, or the arts. Only when they reached the next stage of rejecting the traditional group image could an alternative image based on gender equality be internalized and a new framework be made available for political change. Yet the new group definition based on social equality also did not automatically translate into political demands. More was needed to acquire a feminist consciousness.

People tend to think that personal problems can be solved simply by working harder. Personal problems become political demands only when the inability to survive, or to attain a decent life, is seen as a consequence of social institutions or social inequality rather than of personal failure, and the system is blamed. Women began to look to political solutions when they felt that they faced discrimination or recognized that the problems they encountered, such as inadequate day care or sexual violence, could not be solved by the efforts of individuals. Women who reached this third stage, where they believed that they deserved equal treatment but were denied opportunities because of sex discrimination, had a feminist consciousness.

For most of human history men's and women's different roles were accepted as biologically based and unalterable. This view is currently being challenged by the feminist movement, which asserts that women's roles are learned and socially determined. Whereas egalitarian roles were historically seen as radical, if not crazy and a threat to society, women today are willing to advocate sex equality, or the sharing of equal responsibilities within the home and the marketplace.

But feminism is not new. In fact, the ideology, the problems, and even some of the solutions espoused by contemporary feminists have been around for a long time. Abigail Adams and Mary Wollstonecraft raised these issues in the eighteenth century. Margaret Fuller, John Stuart Mill, Elizabeth Stanton, and Friedrich Engels championed feminism in the nineteenth century. Emma Goldman, Charlotte Perkins Gilman, Virginia Woolf, and Simone de Beauvoir were twentieth-century feminists who raised the issues embodied in contemporary critiques of femininity long before Betty Friedan or Gloria Steinem discussed these problems. Yet people were ready to listen to Steinem and Friedan, not to the feminists who preceded them.

Women's daily experiences, options, and responsibilities differ dramatically from those of their great grandmothers. The meaning of womanhood has fundamentally changed over the last three generations, a transformation that has allowed women to hope for a future based on sex equality, a wish seldom voiced by women of past generations. The integration of women into the work force, improvements in educational opportunity, the availability of contraception, and increased life expectancy revolutionized women's place in American society. Unfortunately, these changes also created new problems. Because women's work roles were merely added on to their family responsibilities, the sexual division of labor was not truly altered. As a consequence, women suffered from the burden of dual careers, at home and in the work force. This difficult arrangement was perpetuated by a host of legal, economic, and social policies aimed at reinforcing traditional assumptions about women's roles.

Despite the radical transformation of women's lives, the historian Carl Degler lamented in 1964 that a political movement which addressed the problems brought about by these changes would not emerge because, "To enact legislation or to change roles requires persuasion of those who do not appreciate the necessity for change. Those who would do so must organize the like-minded and mobilize power, which is to say they need a rationale, an ideology. And here is the rub: in pragmatic America . . . any ideology must leap hurdles. And one in support of working wives is additionally handicapped because women, themselves, despite the profound changes in their status, do not acknowledge such an ideology."[5] Degler doubted that social change would be directly converted to political action, arguing that women would not mobilize on their own behalf because they did not subscribe to a feminist ideology. Without the critical intervening factor of an aroused consciousness, the feminist movement was a lost cause.

Examining these same social trends from a closer perspective in 1970, the demographer Abbott Ferriss asserted: "Events of the past decade provide evidence of no compelling cause of the rise of the

new feminist movement. A number of inciting forces may be mentioned but none of them appear primary. Historians of the future will have the task of sifting and sorting events to evaluate why women today have begun to be militant about changing their status."[6]

Neither the historian nor the demographer found the key to the emergence of feminism, because they failed to note that group solidarity is not just a by-product of social and economic changes that promote conflict over valued resources. Women had to learn to reject traditional group definitions based on biological explanations and to accept new images of womanhood based on sex equality. This learning process was critical to the emergence of contemporary feminism. People conform to traditional behaviors and expectations because they are exposed to a limited array of information and few opportunities for alternative action. Available role models consistently repeat behavior that has been defined as appropriate. Conformity is positively reinforced, while attempts to try new roles are negatively sanctioned. When social behavior is so rigidly defined that alternative options are rarely expressed, it becomes internalized as a nonconscious ideology, an inability to imagine that life could be any other way.[7]

For women, this traditional, nonconscious pattern centered around marriage and child care. An adult woman was expected to marry and take care of her family. In cooking, sewing, teaching, and administering tender care, she worked to help her family cope with the harsh realities of life. Being a good person meant being a good wife and mother. For most of history, women who deviated from this pattern were viewed with contempt or pity. The spinster, the career woman, and the mistress were failures. Their fate was to be avoided at all costs. Because of the mesh between behavior and traditional values, women accepted their roles as natural and valuable. So long as the congruence lasted between women's traditional behavior, expectations, and values, there could be no political consciousness.

Yet the context in which learning takes place is not static. Periods of rapid change caused by altered social conditions, economic disaster, war, or technological innovation often promote new behavior that is more adaptive to the changed circumstances. As the new behavior is rewarded, people begin to challenge the validity of traditional expectations. At this point a new group definition or consciousness begins to develop.

The critical dimensions of women's lives, which traditionally were characterized by a stable family relationship centered around children and domestic production, changed around the turn of the century when the country became more urbanized and industrialized and the government became more involved in providing social services. The demands of the new economy transformed women's lives and pro-

moted a new definition of womanhood, placing increased emphasis on women's role as workers and less emphasis on mothering. As a result, women's private hopes for equality suddenly in the 1970s found a political voice. The new norm had allowed for the emergence of a feminist consciousness and hence of a mass feminist movement. Historically, the transformation of women's traditional roles, changes in the perception of sex roles and sex discrimination, and the evolution of women's political efforts to ensure their rights occurred between 1890, when the National American Women's Suffrage Association (NAWSA) was founded to win women the vote, and 1980, when the women's vote finally emerged with women as a group voting differently from men for the first time.

Women were politically active in pursuit of their rights to varying degrees throughout this period. Their efforts developed from the traditional lobbying of narrow interest groups to a mass social movement involving large numbers of previously uncommitted people. The pattern, intensity, and success of these efforts to gain women's rights were shaped by changes in women's roles. In particular, increased labor force participation, declining fertility patterns, and rising marital instability resulted in a new understanding of women's lives. As a result, changes in women's labor force participation are a sign of changes in their degree of commitment outside the home. Fertility and childrearing patterns reveal the degree to which women's lives remain child-centered. And the incidence of marital disruption measures the stability of the family unit. These three indicators, drawn from census data, together show how and when women's roles were transformed over the course of the twentieth century.

A feminist consciousness emerged from women's reactions to these experiences. The rejection of women's traditional group definition caused women to evaluate their circumstances in a new light. Old justifications for differential treatment came to be challenged once sex discrimination and role rigidity had been accepted as the root of women's problems. The degree of public support for sex equality and the pervasiveness of perceptions of sex discrimination are the critical components of feminist consciousness, revealing when the constituency for a feminist movement has emerged. Changes in attitudes toward work, family, and marriage are illustrated by the images of women presented in novels, women's magazines, and public opinion polls.

Women who experience nontraditional roles are expected to develop a feminist consciousness and support feminist politics, but support for the women's movement derives from a variety of impulses other than a specific worry for women's plight. It can develop from a belief in social justice and equality, a liberal political perspective, or a sense of the need for change. Men too are affected by changes

in women's roles and sex discrimination. Their support for political efforts to address these problems helps to shape public policy.

Men's feminist sympathy, however, is not the same as feminist consciousness. It is rather an abstract, ideological commitment to equality. In contrast, consciousness refers to an internalized political perspective derived from personal experience. Thus, feminism can be important to both men and women, but the sexes support feminism for different reasons, and consequently, their beliefs can have different political implications. The distinction between feminist sympathy and consciousness is illustrated in the different reasons of men and women for becoming feminists and the different ways in which their feminist concerns shape their political assessments. The experiences that lead people to feminism and the relation of their views on this issue to their other political attitudes, policy preferences, candidate evaluations, and voting histories are revealed by national election surveys of people eighteen years and older that were conducted during the first three Presidential election years of the women's movement, in 1972, 1976, and 1980.

Feminism has an impact on politics in both the unconventional domain of protest activity and the conventional arena of electoral politics. Protest movements depend for their success in part on their ability to generate large-scale public support for their cause.[8] The expansion of the scope of conflict to include a broad audience of sympathetic people places increased pressure on politicans to respond to the demands of the protesters. But feminist support based on abstract commitments to social justice and equality is diffuse and has a relatively weak and short-term impact on people's political choices. In contrast, support based on personal experience and solidarity with the experiences of other women, on feminist consciousness, fosters a vigilant commitment to the pursuit of sex equality. The three national surveys of the electorate serve as tools to assess the level of public support for the goals, strategy, and tactics of the women's movement and the degree to which this support is based on feminist consciousness as compared to liberal ideology.

In contrast to the indirect pressure brought by protest activity, the feminist vote has a direct impact on shaping the political agenda. A feminist vote exists when the voters' evaluations of the candidates' positions on women's rights influences their choice of candidate. The strength of the feminist movement and of women's consciousness is tested in part by the degree to which feminist concerns shape electoral outcomes. Analysis of the vote decision in the Presidential elections of 1972, 1976, and 1980 illustrates the circumstances promoting a feminist vote. This analysis reveals how women's policy preferences have evolved differently from men's and why in 1980 Reagan was less popular among women voters.

The meaning of being female has been transformed during this century. Changes in women's family and work experiences have led to the emergence of a gender politics, which promotes nontraditional roles for women and endorses policies to address women's interests as they seek equality in the home and marketplace. The incorporation of women into the public domain of business, government, and industry has raised pressing questions about women's rights in the workplace and their responsibilities in the home. These questions include: Should mothers of young children work? Should the government provide day care? Should girls have the same access to sports facilities as boys? Do women have a right to reproductive choice? And are men better suited to positions of power? Discussion of these questions is best served by understanding why these issues are currently before the public and learning from the past to prepare for the future.

Political Mobilization of Women

The contemporary feminist movement is not the first time in American history that women have demanded their rights. Women have been politically active to promote their own interests since they first won the vote in 1920. Many of the ideas, policies, and strategies identified with the current women's movement have been around since the turn of the century. But efforts expended by women to secure economic and social equality during the twentieth century have followed a sketchy pattern. In fits and starts, women have lobbied legislators, initiated litigation, hoisted picket signs, gone to jail, infiltrated political parties, and boycotted major corporations to secure their rights.

These actions were not spontaneous expressions of political discontent. They were organized efforts to effect change. Consciousness is a central element in the emergence of such efforts, but resources, organization, and leadership are also needed.[1] Collective action is an expensive proposition, requiring time, money, knowledge, and human energy, not to mention duplicating machines, telephones, and postage stamps. A social movement requires an organizational network to draw together like-minded people willing to commit themselves to action. A sustained collective effort, moreover, needs an active leadership to take responsibility for promoting group goals and designing strategies to achieve those ends.

But chief among all the elements necessary for movement formation and success is consciousness. The resources, organization, and leadership for a women's movement had existed in some form since

the turn of the century; what was missing was a mass constituency willing to support demands for women's rights. People needed to acknowledge a sense of shared grievances, or group consciousness, before they would support organizations, fall in behind group leaders, and relinquish their precious resources to promote group goals rather than using them to improve individual well-being.

The variable intensity of women's political efforts from 1890 to 1980 illustrates the importance of a feminist constituency for the success of the women's movement. Women have lobbied for their rights throughout the period with different degrees of energy and success. The precise relationship between action and success can be quantified by comparing the number of activities to the number of positive outcomes.

Women's activism is here measured by the number of events aimed at changing women's traditional status per year from 1890 to 1980. A variety of events which have been reported in women's histories or in articles on women's rights indexed in the *New York Times* for this period are used to catalogue women's activism. Since the women's movement is a broad-based effort at political change, the main events are national in scope. Local events, such as the establishment of feminist services, the passage of state-level legislation, the formation of local groups, or local demonstrations, are included only if they represented an exemplary case that was followed by a proliferation of similar activities. Local events that received national coverage or had implications for national policies are also recorded. This measure accurately illustrates the trend, if not the number, of events for each period, for events recorded generally concerned lobbying for the passage of legislation and the formation of national organizations, all activities involving a substantial number of people and equally likely to be noted throughout the century.

Certain kinds of events are omitted from this catalogue. Women have been visibly active in such movements as progressivism, the peace movement, the student movement, and the socialist movement, but their central concern in participating in these movements was not to change women's status or to assert their rights. Such activities are therefore not included. There have also been movements and efforts aimed at preserving women's traditional status, such as by opposing women suffrage and the Equal Rights Amendment (ERA), which are catalogued only to the extent that they hindered the development of the women's movement. Recent efforts, however, to countermand the advances of the women's movement, are omitted, mainly because they are not germane to the rise of the feminist movement.

The outcomes of women's political efforts are hard to assess because of the magnitude and diversity of their agenda over time. Their

goals ranged from keeping a maiden name, serving on juries, and playing sports to suffrage, affirmative action, and the ERA. At heart, their efforts aimed toward empowerment, the use of political power to ensure women greater control over their lives. The outcomes of feminist activism are therefore evaluated in terms of two dimensions of power: access and influence. Access constitutes a minimal condition of success, requiring that political decisionmakers recognize women's rights organizations as representatives of legitimate interests. Influence is a more difficult form of success, requiring the attainment of concrete new advantages.[2]

Women's access to political decisionmakers is measured by the number of bills and joint resolutions concerned with women's issues introduced in either house of Congress from 1899 to 1980, or from the Fifty-sixth through the Ninety-sixth Congresses, as indicated by the listings in the *Congressional Record Index* under the headings "woman/women/women's," "sex discrimination," and "civil rights" (where gender is explicitly mentioned).[3] Introducing a bill in Congress serves as an expression of sympathy and interest. At a minimum, it constitutes a symbolic act designed to win favor with constituents and women's organizations and to gain the attention of the news media. The ability of women's organizations to gain support for their legislation serves as an indicator of their access to congressmen and their ability to compete with other pressure groups for political support.

Women's influence is measured by their ability to get their legislation passed by Congress, as indicated by the public laws referring explicitly to women in *U.S. Statutes at Large.*[4] The passage of legislation means new advantages have been gained and is therefore more difficult to achieve than getting bills introduced. It requires months and years of lobbying and of sidestepping the numerous pitfalls that can derail a bill from passage through both houses. Few bills successfully complete this trip. In the Ninety-sixth Congress of 1979–1980 only 613 of the 12,581 bills and joint resolutions introduced became public laws, for a success rate of less than five percent.

These measures illustrate women's political efforts, their access to political authorities, and their influence on legislative decisions over the course of the twentieth century. The interplay among these indicators of activism, access, and influence reveals when an action was successful (Fig. 1.1). This quantitative approach complements an historical discussion of the types of activities that women have pursued, the goals around which they have found a common voice, and the specific gains that they have made through their efforts, both of which approaches illumine the circumstances that prompted the empowerment of women.

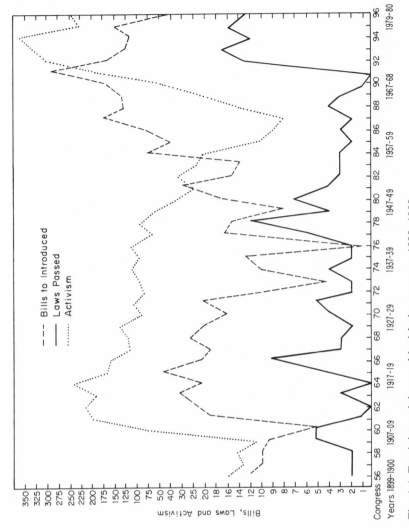

Fig. 1.1 Feminist activism and legislative success, 1899–1980

Feminism Through 1925

The goals of the contemporary feminist movement date back to 1848 when a number of feminists met in Seneca Falls to draw up a Declaration of Sentiments and Resolutions which held "all men and women are created equal."[5] These women were committed to eliminating the rigid division of labor that had separated the activities and opportunities of men and women. Their message, however, was received by a hostile audience, who accepted the differences between men and women as God-given, and the movement failed to gain mass support.

Organized efforts to secure woman suffrage began in 1867 with a state referendum in Kansas, which failed. In 1869 two organizations, the National Woman Suffrage Association and the American Woman Suffrage Association, formed in order to win women the right to vote. These organizations were small, elite groups that had little public support and even less political success. They merged in 1890 to form NAWSA, and in that year Wyoming entered the Union as the first state with full suffrage for women. Colorado followed with the vote for women in 1893, and Utah and Idaho enfranchised women in 1896.

Thereafter the suffrage movement ground to a halt, as women's activism centered instead around social reforms, such as health and housing inspections, consumer protection, child labor restrictions, and minimum wage and hours for women workers. Efforts to gain woman suffrage were not revitalized until 1908 when the vote became accepted as a means of implementing this reform agenda. Women's activism thus rose from a low level of 3 events in 1890 and 11 events in 1900 to 64 events in 1908 when the suffrage movement reemerged, and it peaked at 173 events in 1915 when women's groups narrowed their efforts to concentrate on passage of a federal suffrage amendment. After winning the franchise in 1920, women's activism diminished but did not disappear. The suffrage movement was succeeded by an active women's lobby, which averaged 65 efforts per year between 1920 and 1925 in hopes of using women's votes to implement their reform agenda.

As women became more politically active, their access to Congress and their influence in passing legislation also increased. Women's groups had already gained some access to politicians between 1899 and 1908, when congressmen introduced 46 bills and passed 16 laws on issues of concern to women. Once the mass movement surfaced in 1908, women's access to Congress mushroomed, with 208 bills for women's rights introduced between 1908 and 1925. But not until women's high level of activism had been sustained for nearly a decade did Congress respond to this pressure, passing 19 pieces of major legislation between 1917 and 1925. These bills were passed in antic-

ipation of a women's vote. When the vote did not materialize, the women's lobby lost a critical resource, and as a consequence, women's access and influence in the political arena after 1925 were greatly reduced.

The women in Seneca Falls had wanted the vote as a means to ensure equality. But as the movement aged and personnel changed, suffrage rather than equality became the basic issue. Twentieth century suffragists abandoned feminism, the belief that men and women are equal, by accepting differences between the sexes as inherent and stressing the vote as a means of protecting the sanctity of the home and preserving their families.[6]

The growth of cities and industries at the turn of the century and the influx of millions of immigrants changed the texture of American life. New factories welcomed low-wage workers, whose large numbers swelled the cities. Progress was marked by skyscrapers, wealth, opportunity, and inventions, but was marred by poor sanitation, overcrowding, and poverty.

This was a period of social reform. While men worked to build industry, women worked to create a better future through settlement houses, women's clubs, and welfare agencies. These women fought for women's concerns, including the vote, but they were not feminists, because they did not believe that men and women are or should be equal. Each sex, according to these social reformers, has its own sphere. Women rationalized their efforts at public reform in the name of women's responsibilities as mothers and housekeepers: "Women by natural instincts as well as long training have become the housekeepers of the world, so it is only natural that they should . . . become effective municipal housekeepers as well."[7] Arguing that they were simply operating within their spheres as the nation's homemakers and mothers, women turned to reforming society by building housing in slum areas, protecting the rights of juveniles, endorsing factory inspections, and promoting minimum wage and child labor legislation.

This notion of woman suffrage as a form of "enlarged housekeeping" drew many supporters to the cause. In 1893, NAWSA had only 13,000 members, but by 1907 over 45.5 thousand women belonged to it. In 1917, NAWSA membership reached two million. Yet it was not until women abandoned their appeals to women's equality and to the natural right to the vote, stressing instead the need for the vote in order to help "clean up" society, that the idea of suffrage became widely accepted.[8]

A two-year drive by NAWSA, started in 1908, produced the names of 400,000 women demanding their political rights. Around this time, the Women's Political Union was formed to organize business and professional women in support of suffrage. They initiated mass meetings focused on this issue and coordinated parades in which large

numbers of middle-class women demonstrated their determination to win the electoral privilege. These were the first significant efforts to bring women closer to the vote. Suddenly, Washington granted women suffrage through a referendum in 1910, followed by California in 1911 and Oregon, Kansas, and Arizona in 1912.

In 1913 the Congressional Union, a militant branch of NAWSA, was founded to work for the federal suffrage amendment. One of its first efforts was to organize 5,000 women to parade at President Woodrow Wilson's Inaugural ceremony in order to protest his opposition to the suffrage amendment. In the same year the union organized a nationwide automobile pilgrimage to Washington, D.C., where the suffragists presented senators with petitions bearing 200,000 signatures from all over the country in favor of suffrage. In 1915 the union organized another elaborate automobile pilgrimage, which started in San Francisco and culminated in a huge rally and a march on the Capitol to give the members of Congress petitions containing a half-million signatures.

Because of its increasingly militant tactics, the Congressional Union split from NAWSA in 1916 to form the National Women's Party. The following year the party organized round-the-clock picketing in front of the White House to protest Wilson's inattention to woman suffrage. The result was the arrest of 218 women from 26 states, 97 of whom went to prison. Public support for the National Women's Party began to wane in 1917, however, when it failed to support the war effort. The party's new slogan, "Democracy Should Begin at Home," was viewed as painting women in an unpatriotic light.[9]

In contrast to the national focus of the Women's Party, NAWSA first promoted suffrage by establishing state-level organizations. Early statewide efforts brought victory for woman suffrage in Illinois in 1913 and Montana and Nevada in 1914, but these triumphs were soon followed by dramatic defeats in other states. Although NAWSA pressed hard for suffrage referenda in New York, New Jersey, Pennsylvania, and Massachusetts, the effort to win women the right to vote failed in all four states.

In 1916 NAWSA turned its attention to national politics when 5,000 members lobbied for a strong stand on suffrage at the Republican Convention. In the next major public demonstration, organized by NAWSA in New York on October 27, 1917, a parade of 25,000 women carried placards bearing the signatures of more than a million women supporting the suffrage petition. These women were followed by contingents of women farmers, industrial workers, doctors, and nurses, who were showing their intention to vote in the next election.

The suffrage movement recouped some of its earlier losses at the state level when in 1917 North Dakota by legislative action granted

woman suffrage in presidential elections. Ohio, Indiana, Rhode Island, Nebraska, and Michigan followed in rapid succession. These victories were crowned that year with the first historic breach in the solid South, when the Arkansas legislature granted women the right to vote in primaries.

In 1918 the suffrage amendment passed the House of Representatives but fell two votes short of the necessary votes in the Senate. Despite this national defeat, six more states—Iowa, Minnesota, Missouri, Ohio, Wisconsin, and Maine—granted women the presidential vote in 1919. Five hundred civic, church, labor, industrial, and farm organizations petitioned Congress to grant woman suffrage. In May 1919, the Suffrage Amendment was finally passed by the United States Congress. And on August 26, 1920, the Nineteenth Amendment became the law of the land. This victory came after 56 referendum campaigns, 480 efforts to get state legislatures to allow suffrage referenda, 47 campaigns at state constitutional conventions for suffrage, 277 attempts to include woman suffrage in state party programs, and 19 campaigns to get the Nineteenth Amendment through Congress.

The suffrage machine was now highly organized and running full steam. With the threat of a "woman's vote" to back them, the League of Women Voters, as NAWSA was renamed in 1919, and the National Women's Party pushed for further legislation at the state and national levels.[10] The basic agenda proposed by the League of Women Voters included jury duty for women, funds to teach mothers how to care for babies, federal aid for vocational training, a merit system in the civil service, a federal department of education, and minimum wage and hours legislation to protect women workers.

Over the next year twenty-one state legislatures gave women the right to jury duty. Two states passed equal pay laws, and Wisconsin passed a general equal rights bill that served as a model for the ERA. At the national level, the Women's Bureau was formed as part of the Department of Labor to address the needs of working women. At the 1920 party conventions, the Democratic party incorporated into its platform twelve of the fifteen proposals outlined by the League, while the Republican party endorsed five.

The women's organizations that had formed during the suffrage era also pressed for reform legislation in areas connected with women's traditional spheres of child care and the home. In 1921 the Sheppard-Towner bill allocated over a million dollars for educational instruction in the health care of mothers and babies, and the Packers and Stockyard bill instituted meat inspection designed to increase consumer protection. Congress passed the Cable Act in 1922 to equalize citizenship requirements for men and women, the Lehlbach Act in 1923 to extend the merit system in the civil service, and the Child

Labor Amendment to the Constitution in 1924 to prevent children from being forced to work.

These successful legislative efforts were not matched at the polls. The first few elections showed that women were not voting as a group and that most women were not even voting. Thus the Nineteenth Amendment, which had handed the suffragists a major victory, dealt feminism a suppressing blow. Suffrage, once conceived as a major revolutionary tool, turned out to be a minor reform. The victory was barely over before women returned to their traditional pursuits, and public indifference to the question of women's place in American society resumed. The dissipation of interest in the women's movement was taken as a sign not of failure but of completion. Now that women were true citizens, there seemed to be nothing they could want.

The only group to question this conclusion was the National Women's Party. They drafted the ERA demanding equality for women and submitted it to Congress in 1923 in order to finish the revolution that the suffrage movement had started. But many former suffragists responded antagonistically and actively thwarted efforts to get the amendment passed by Congress. Essentially, their opposition centered around the belief that women are fundamentally different from men and therefore have to serve different social and economic roles. The Women's Bureau and the League of Women Voters, for example, which had campaigned for protective legislation premised on basic differences between the sexes rather than on equality, vigorously lobbied against the amendment and even testified against its passage in congressional hearings.

Commenting on the issue of equal rights for women in 1924, Harvard law professor Felix Frankfurter emphasized that "Nature made men and women different," and thus "the law must accommodate itself to the immutable differences in Nature." Women's reform organizations who opposed the ERA made a similar argument that "no law . . . can change physical structures that make women the child-bearers of mankind."[11] The proponents of this biologically defined view of women's social role triumphed.

The Barren Years, 1925–1960

The years from 1925 to 1960 are often viewed as the feminist wasteland in which virtually no activity for women's rights took place.[12] But once the vote had been won, the only part of the women's movement that dissipated was the mass base. Women's rights organizations continued to lobby on behalf of women. Having achieved a significant political victory in gaining passage of the Nineteenth Amendment, these women's groups had earned a place within the more traditional interest-group community.

Women continued to be very active in promoting women's rights after the women's vote failed to materialize. There were 321 events recorded between 1925 and 1929 and 493 events in the 1930s. These efforts dropped off to 275 events in the 1940s and slumped still further to 98 events in the 1950s. Although women's activism plummeted during this period, their access to political decisionmakers grew. During the 1930s the women's lobby had been inexperienced. It pursued a broad agenda, but since many women's groups were divided on the ERA and protective legislation and fought among themselves, only 58 bills were introduced in Congress. By the 1950s these organizations had evolved into an established lobby with greater political sophistication which succeeded in having 236 bills introduced in Congress that were focused on a considerably narrower set of goals than those pursued in the 1930s.

This greater access did not translate into an ability to influence the passage of legislation. Congress passed almost the same number of statutes concerning women in the late 1920s and 1930s (11 and 12, respectively), when women's organizations had relatively little access to Congress, as it did in the 1950s (14), when women's groups were considerably more experienced and had important political contacts. Congress was most receptive to women's rights during the 1940s, when it passed 33 statutes, largely in response to women's contribution to the war effort. While women did not gain a great deal of influence during this period, the evolution of an experienced women's lobby was an important phase in women's political history because it provided an organizational context for maintaining and increasing pressure for women's rights in the future.

During the Depression the rights of working women came under increasing attack. In 1932 Congress passed the Federal Economy Act that discriminated against wives of government employees for federal jobs and stipulated that women with employed husbands be dismissed first when cutbacks were needed. Over 1,500 people, mostly women, were fired under the provisions of this act. In 1935, the National Recovery Administration established federal wage codes that gave women less pay for the same jobs as men in 25 percent of the jobs coded. In addition, 30 states passed laws inhibiting the employment of women, while the majority of public schools and over 40 percent of all public utilities discriminated against married women in hiring.

Women's groups organized to defend their economic rights and to protect women from financial disaster. They pressed for better wages, increased safety, and old age and unemployment security for working women, as well as for job security for married women workers. The General Federation of Business and Professional Women's Clubs (BPW) advocated the right of working wives to keep their jobs. The

National Women's Party fought plans to lessen the unemployment crisis by giving women's jobs to men. The American Association of University Women protested increasing sex discrimination in the workplace and lobbied for jobs for older women. The Women's Trade Union League championed the rights of unemployed women and domestic workers. The National Church Club for Women spent over $6,700 to aid unemployed women. The Union of Unemployed Single Women educated legislators to the problems of women who were not working for pin money but were supporting families. The League of Women Voters lobbied to repeal laws dismissing married women from government service jobs. The National League of Women Shoppers protested the exclusion of domestic workers from the Social Security Act, and the Women's Bureau issued reports documenting discrimination against women workers.[13]

Whereas most women's groups fought for equal pay for equal work and improved employment opportunities for women, they were not united on other economic issues. A debate raged over which actions served to promote women's economic interests. Many of the women's rights groups, such as the League of Women Voters and the Women's Trade Union League, favored protective legislation that limited the number of hours women could work, the time of day they could work, and the kinds of jobs they could fill, so as to protect women workers from exploitation. Other organizations, such as the National Women's Party and BPW, opposed protective legislation, favoring equal treatment instead. These organizations argued that labor legislation and workplace stipulations that applied only to women deprived women of economic opportunities and served to legitimate sex discrimination. Rather than helping women, these laws were said to disadvantage them economically.[14]

Workplace issues and the debate over special protection continued to be of concern through the 1940s. Women's organizations held symposiums on the problems of women workers; the American Association of University Women sponsored workshops for unemployed women over age forty; the Young Women's Christian Association (YWCA) held seminars on how to find and keep a job; and BPW discussed placement problems and the postwar readjustments facing women workers. In 1945 the League of Women Voters and other women's organizations sponsored the Equal Pay Act, which mandated that men and women receive equal pay for equal work, while other women's groups lobbied for adequate housing for working women with dependent children and pensions for housework. During the 1950s the Women's Bureau championed the rights of women workers for equal pay, better employment opportunities, and improved social security benefits, as well as the rights of women veterans to jobs and benefits, while remaining committed to protective legislation. Both

the lobbying effort of the Women's Bureau and the influence of women party workers kept the Equal Pay Act before Congress and led President Dwight Eisenhower to endorse it.[15] Despite this support, the act was not passed.

The debate over whether special protection helped or hurt women workers lay at the heart of arguments over the ERA during this period. In 1935 women's organizations began to lobby both the Democrats and Republicans to include the ERA on their party platform. In 1937 the National Women's Party, the National Council of Women, and the BPW lobbied for the amendment in Congress, while the League of Women Voters, the Women's Trade Union League, the Women's Bureau, and the National Council of Catholic Women actively opposed the amendment. The opposition groups proposed as an alternative to the amendment a women's charter for equality and protection. Eleanor Roosevelt and Secretary of Labor Frances Perkins lambasted the ERA in public speeches and party caucuses. The lobbying effort was so intense that one senator noted that he had received over 3,600 telegrams in one month instructing him how to vote on the amendment.[16]

Women's organizations convinced the Republican Party to endorse the amendment in 1940. In the same year the National Women's Lawyers Association joined ERA proponents in a close but unsuccessful lobbying effort to include the amendment on the Democratic platform. By 1943 the ERA effort, now joined by the General Federation of Women's Clubs, had secured 40 co-sponsors of the amendment in the House and 23 co-sponsors in the Senate. The Democrats finally endorsed the ERA in 1944, despite continued opposition from prominent women leaders. President Harry Truman publicly endorsed the ERA in 1945, a year when the amendment won 76 co-sponsors in the House and 26 co-sponsors in the Senate.[17]

By 1947 over thirty-three national women's organizations backed passage of the ERA. As the popularity of the amendment increased, anti-amendment groups campaigned for a congressional commission on the status of women in lieu of ERA, designed to investigate women's needs and to document the prevalence of discrimination against women. Their insistence that protective labor legislation was "justified by differences in physical structure, biological, or social function" made a compromise with pro-ERA groups impossible.[18] This fierce debate within the organized women's lobby guaranteed that neither the ERA nor the congressional commission had a chance of approval, though it also kept the issue of women's rights alive.

When special protection was incorporated into the ERA to ensure the gains secured by women's past efforts, Eleanor Roosevelt and the AAUW withdrew their opposition, and the American Bar As-

sociation came out in support of the amendment. This watered-down version of the amendment, with over one hundred sponsors, was pushed through the Senate in both 1950 and 1953. But the YWCA and the American Association of Nurses joined the traditional opponents of the amendment to ensure its defeat in the House. After three decades of fighting for the amendment, the National Women's Party accepted defeat. The momentum for the ERA was exhausted, with public opinion increasingly championing domesticity and motherhood, and many women's organizations turned their energies to other concerns, such as public affairs, access to professions, and equal pay.

Political representation was another issue that united many women's groups during the period 1925–1960. As more women entered political party work or gained lobbying experience in women's organizations, they became increasingly dissatisfied with their positions and opportunities within the political realm. They protested the paucity of female representation in public affairs and demanded that local, state, and federal leaders appoint more women and support more women candidates. In 1933 six national women's organizations petitioned President-elect Franklin Roosevelt to appoint women to the Cabinet. In 1937 the League for Women for President and Other Public Offices listed ninety-five prominent women who were qualified for high public office and pressed for the nomination of a woman vice president. The League of Women Voters, the BPW, and the AAUW lobbied for more women in public office and urged their members to take a greater role in public affairs. In 1949, Senator Margaret Chase Smith of Maine tried to get the Republicans to nominate a woman for Vice President.[19] During the 1950s the effort of the Women's Bureau and the influence of women party workers prompted both Truman and Eisenhower to appoint more women to political posts.

Women's groups built a viable women's lobby in the years between 1925 and 1960. The tensions that divided women's organizations during the 1930s and 1940s were defused in the 1950s as women's groups abandoned the ERA and focused on a more limited agenda centered around equal pay, greater access to job opportunities, and political representation. In the course of this period the intensity of women's activism diminished markedly, but women's organizations, working both with a Women's Bureau that promoted women's issues within the government and with women activists who pressured for women's rights within the political parties, greatly increased their ability to force Congress to address women's issues. These three bases for women's rights activities established a solid political foundation upon which future efforts to promote women's interests could build.

The Women's Movement, 1960–1980

By the 1960s women were doing the bulk of the work required for the day-to-day maintenance of the party system—campaigning, stuffing envelopes, canvassing, typing, and organizing. Having paid their dues, these women began to press for change. Owing to their efforts, feminism reemerged.[20]

The groundwork for the women's movement was laid in the years between 1960 and 1966. During this time Congress considered 432 pieces of legislation on women's rights, a commission was established to explore and document problems of sex discrimination, and two landmark pieces of legislation ensuring equal pay and employment opportunities were passed by Congress. Political recognition of women's issues increased markedly, thanks to the efforts of traditional women's organizations and women activists in government and political parties, but Congress still failed to resolve any of these problems.

The lack of congressional response to this heightened awareness of women's needs led to a mounting frustration on the part of many women activists. In the mid-1960s their dissatisfactions took on a feminist voice, and new women's organizations formed to demand sex equality. Unlike the long-established women's lobby, these groups turned to more militant tactics in hopes of implementing a broad agenda aimed at assuring women's equality and economic independence. This new feminist lobby augmented the efforts of the existing women's lobby in hopes of pressuring politicians to act on behalf of women's rights.

During the 1960s Congress considered 884 bills concerned with women's issues, but only 10 were passed. Only after the Strike for Equality in 1970, which established the presence of a social movement committed to sex equality, did Congress act on women's behalf. Women's activism, which had involved 26 events in 1968, increased to 165 events in 1970 and reached a high of 256 events in 1975; it then sustained an average of 116 events per year for the rest of the decade. Women's influence over public policy increased markedly with their increased activism. During the 1970s Congress passed 71 pieces of legislation concerned with a broad spectrum of women's rights and needs, or almost 40 percent of all legislation aimed at women during this century.

The initial gains of the early 1960s for women's rights were modest and seemingly innocent. In 1961 President John Kennedy, acting in part to repay the hundreds of women who had worked in his campaign and perhaps also to postpone the need to consider the ERA, established a Presidential Commission on the Status of Women. This commission was the first presidential advisory body ever created to review the status of women.[21]

The establishment of state-level organizations on the status of women followed. Michigan was the first state to establish its own commission in 1962. In 1963, the BPW committed its members and resources to the establishment of state commissions across the nation. At the first national conference of state commissions in 1964, twenty-six states were represented. By the end of the year, nine more states had established state organizations. The unobtrusive but extensive women's network building around these commissions was completed in 1967 with all fifty states accounted for.

Changes emerged on other fronts as well. Kennedy issued a directive reversing an 1870 federal law that barred women from high-level civil service jobs. After almost twenty years of persistent lobbying, the Equal Pay Act was passed in 1963. A year later Title VII prohibiting sex discrimination in employment was included in the Civil Rights Act, and passage of the bill handed the feminist cause a serendipitous victory.

By 1966 the National Commission on the Status of Women had completed its report, recommending 24 areas for combatting sex discrimination. In addition, 351 women had filed complaints under the Equal Pay Act. Because of the failure of state commissions on the status of women to address these issues, 28 members of those bodies met to found the National Organization for Women (NOW), whose goal, according to Betty Friedan, a founder, was "to take action to bring women into full participation in the mainstream of American society, *now*."[22]

In 1967 NOW began a war on sex discrimination. It organized a national day of picketing against the Equal Employment Opportunity Commission (EEOC) for its refusal to outlaw sex-segregated want ads, which forced EEOC to hold hearings on establishing guidelines. NOW members also picketed the *New York Times* to protest its sex-segregated want ad policy.[23] In 1968 NOW filed a formal complaint against the *New York Times* and a mandamus suit against EEOC to force compliance with Title VII of the 1964 Civil Rights Act. EEOC finally ruled that sex-segregated want ads were in violation of that act. One year later EEOC established that state protective labor legislation which applied only to women was also in direct violation of Title VII.

Women formed other more radical feminist groups in 1968, including New York Radical Women, Seattle Radical Women, Chicago Cadre of Women, and Women's International Conspiracy from Hell (WITCH). New York WITCH covens hexed the New York Stock Exchange, whereupon the market dropped five points. The Washington coven hexed United Fruit on Halloween. Radical women protested the Miss America Pageant both by throwing into a "freedom trash can" bras, girdles, false eyelashes, and other paraphernalia

designed to objectify women and by crowning a live sheep Miss America. This was the first feminist activity to receive front-page coverage across the land. The first modern feminist publication, *Voices of the Women's Liberation Movement,* also began publication.

The Women's Equity Action League (WEAL), founded in 1968 by former members of NOW, barraged the courts with charges of sex discrimination. Federally Employed Women (FEW) was also formed in 1968 to protect the interests of women employed by the federal government and to monitor the actions of the Civil Service Commission. The National Coalition of American Nuns and Church Women United were founded in 1969 to support civil rights and to pressure for women's equality within the Catholic Church.

In 1970 NOW filed blanket complaints of sex discrimination against 1300 companies receiving federal funds. WEAL filed a class action suit against all medical schools. Three hundred other educational institutions were charged with sex discrimination in violation of Executive Order 11375, which prohibits government contractors from discriminating on the basis of sex. The Department of Justice filed its first sex discrimination suits under Title VII against Libby-Owen, United Glass, and Ceramic Workers of North America. Virtually every woman on the editorial staff of *Newsweek* magazine filed formal complaints with EEOC. *Time, Life, Fortune,* and *Sports Illustrated* were charged with sex discrimination by 147 women, most of whom were not previously linked to feminist groups. Airline stewardesses sued Trans World Airlines, charging discrimination in pay scales and in company rules that demanded immediate dismissal of married women and mandatory retirement at age thirty-two or thirty-five.

Feminist activists did not limit their efforts to economic and professional issues. In 1970 Hawaii, Alaska, and New York passed liberal abortion laws with the explicit statement that women have a right to control their bodies. New York Radical Feminists held a Rape Speak Out, where women discussed rape as an expression of male violence against women, and organized women to establish rape crisis centers and work toward reforming existing rape laws. This was the first attempt to focus political attention on the issue of rape. The National Committee for Household Employment was formed to improve the wages and working conditions of domestic workers. Five separate bills authorizing funds for day-care centers were introduced into Congress. Women artists picketed exhibits at the Whitney Museum, protesting their lack of equal representation. The women's professional tennis tour was planned as a protest against unequal prize allocations. The Episcopal Church voted to allow women to be ordained deacons.

Feminist fever even converted some former foes. The United Auto Workers reversed its opposition to the ERA and gave the amendment strong endorsement. The Women's Bureau also withdrew its past

reservations about the amendment and came out in strong support of it. The YWCA, which since its founding in 1867 had never explicitly participated in a political movement for social change, changed its platform in 1970 by urging women to "move beyond being sexual playthings of the men to an affirmation of their roles as human beings, with capacity for leadership and contribution in varied ways. They need an identity of their own." The YWCA formed a National Women's Resource Center "to revolutionize society's expectation of women and their own self-perception."[24]

By 1970 the women's movement had emerged from obscurity. It had been dealt with by nearly every major magazine in a cover story. NOW also influenced the media to give the Women's Strike for Equality extensive network coverage. As a result, after that strike 80 percent of American adults were aware of the women's movement.[25]

In 1971 the Professional Women's Caucus instituted a class action suit against all law schools receiving federal funds, charging discriminatory admissions policies. Texas WEAL documented charges of discrimination by Dallas banks. The National Women's Political Caucus (NWPC) was formed to promote women into elected and appointed political positions. Girls were admitted to play in the Little League and to serve as pages in the Senate.

Responding to these efforts by an activist women's lobby, which was comprised of both established women's organizations and new feminist groups and was supported by a visible social movement, Congress in 1972 passed more legislation to further women's rights than had the previous ten legislatures combined. Title IX of the Higher Education Act prohibited sex segregation. Equal employment opportunities were extended to teachers and school administrators as well as to local and state employees. The Equal Opportunity Act empowered the EEOC to go to court with discrimination cases and expanded its jurisdiction to cover more working women. Parents with incomes up to $18,000 per year were allocated up to $400 dollars a month in child-care costs. Federal employee benefits, cost-of-living allowances in foreign countries, and regulations concerning marital status were equalized for women. And on March 22, 1972, after forty-nine years of effort, the ERA was overwhelmingly approved by Congress and submitted to the states for ratification. By the end of the year twenty-two states had approved the amendment.

Feminist efforts to secure congressional passage of the ERA illustrate the importance of the coalition between traditional women's groups and new feminist organizations in working to change women's political status. The ERA provided a rallying point for feminist activism because it served as a symbol of women's rights, but getting the amendment passed by Congress was no small feat. It took an enormous, two-year effort involving over fifty organizations. The

BPW sent at least 100,000 letters to state officers and local club presidents asking them to lobby support for the ERA. It spearheaded the ERA drive in localities where there were no feminist organizations. The AAUW mobilized its members in support of an ERA drive. A National Ad Hoc Committee for the ERA, established to oversee the lobbying effort, sent over 40,000 letters to presidents of national organizations asking them to write their legislators in support of the ERA and to publish items in their newsletters urging members to write as well. Common Cause alone sent 215 letters encouraging its members to lobby for the amendment, and it donated its WATTS line to ERA advocates, who made over 51,000 phone calls as part of the lobbying effort. Legislators received as many as 1,500 letters a month. The ERA was said to have generated more mail than the Vietnam War. Congressional passage of the ERA cost a tremendous amount of money, voluntary labor, and political expertise.[26] The bulk of this material support came from the traditional women's groups, but it took the newly formed feminist groups, bolstered by the public support for women's rights, to raise the question of sex equality and to press for placing the ERA back on the political agenda.

The feminists did not rely on legislation only but formulated their own solutions to women's problems as well. In 1972, the first rape crisis center was formed in Washington, D.C., and antirape squads were established in Los Angeles and Seattle. Women Advocates of Saint Paul, Minnesota, started the first shelter for battered wives. The first feminist gynecological clinic, the Women's Health Center, opened in Los Angeles. Prostitutes formed a union, Call Off Your Old Tired Ethics (COYOTE). *Ms.* Magazine began regular publication. And the first women's bank, women's law firm, and women's credit union were established.

These grass-roots feminist efforts were also initially dependent on the resources of traditional women's organizations. Local YWCAs, for example, acted as catalysts for community-based feminist activities. The YWCA helped sponsor the Welfare Mother's Movement in Milwaukee and assisted in the founding of Women Employed, a group that addresses the concerns of working women in Chicago. The Boston Women's Health Book Collective grew out of a self-help workshop on women's bodies and health issues held by the YWCA. Similarly, 9 to 5, a Boston-based working women's association, emanated from a YWCA-sponsored workshop on the concerns of clerical workers. Almost 200 YWCAs have shelters for battered women; 177 YWCAs offer day care.[27]

As the public support for feminist efforts increased, the government took stronger action to fight sex discrimination. The Justice Department forced AT&T to establish affirmative action programs and to give women $15 million dollars in back wages. The EEOC

brought suit against several major companies, including General Motors, Sears, and Ford, for sex discrimination in hiring. The first Title IX textbook complaint was filed with HEW. The Equal Credit Opportunity Act was passed.

When the United Nations declared 1975 International Women's Year, President Gerald Ford established a national commission on the observance of the year, which brought together over 150,000 people, mostly women, from throughout the country to discuss the needs of women citizens. Delegates were selected to the National Women's Conference of 1977, which adopted a national plan of political action. The plan called for an end to violence in the home and an end to discrimination in education, credit, and insurance. It sought better health care, improved job opportunities, child-care programs, protection for displaced homemakers, and reproductive freedom. It urged greater attention to the needs of minority, elderly, and poor women, as well as increased representation for women in elective and appointive office. Finally, the plan demanded ratification of the ERA.[28]

By now the ERA was in trouble. Many of the amendment's historical opponents, including the League, Women's Bureau, YWCA, and AAUW, had withdrawn their opposition and joined the BPW and the newer feminist organizations, such as NOW and the NWPC, to campaign for passage of the ERA. But after the old proponents of special protection and biological determinism had joined their former opponents in demanding sex equality, new women's organizations were formed to take up the mantle of women's special status as wife and mother. Phyllis Schlafly formed STOP-ERA in 1972 in order to launch a nationwide antiratification campaign. Antifeminist groups mushroomed, including American Women Against the Ratification of the ERA (AWARE), Females Opposed to Equality (FOE), Happiness of Motherhood Eternal (HOME), Women Who Want To Be Women (WWWW), and the Eagle Forum. These groups spearheaded efforts to rescind the ERA in ratified states and to halt further ratification. They perceived their struggle as one to save the traditional family.[29]

Although the feminist groups were just as committed as the antifeminist ones, they were not so well organized and financed. In 1976, when the possibility emerged that the amendment might fail, ERAmerica, a coalition of women's groups, was formed to organize a grass-roots campaign to save the amendment. In 1978, when it became clear that the ERA would not be ratified by the deadline, over 100,000 women marched on Washington to demand an extension of the ratification period, while hundreds of women's groups and prominent civic leaders lobbied Congress for the same purpose. Congress complied by extending the ERA deadline three years.

In 1980, ERA advocates worked to elect supporters to state legislatures, applied economic pressure through boycotts of non-ERA ratified states, and commissioned public opinion polls to demonstrate widespread support for the amendment. Women poured into Illinois, North Carolina, and Florida to canvass, leaflet, and lobby for the ERA. All this effort, however, was not enough, and by the deadline of June 30, 1982, the ERA was still three states short of the thirty-eight states needed for ratification.

The year 1980 saw other feminist defeats. Ronald Reagan became President on a platform opposed not only to ERA but also to reproductive freedom. Conservative groups successfully cut back women's access to abortions. Liberal candidates and incumbents favorable to women's rights were defeated at the polls. To many, these events marked the end of the feminist movement.

Yet like a phoenix rising from the ashes, the movement turned these defeats into temporary setbacks. During 1980 women developed increased political clout. Sixty years after they had won the right to vote, the women's long-awaited vote finally arrived. The emergence of the "gender gap," or sex differences in vote choices and policy preferences, placed women's concerns back on the public agenda.

Mass activism for women's rights surged with the suffrage movement, but once the vote was won, the intensity of women's activism subsided. Many formerly prosuffrage organizations turned to lobbying for equal pay, improved employment opportunities, and increased representation of women in political positions. Yet within this women's lobby there were also disagreements, as some groups promoted equal treatment, while others demanded protective legislation. After the Second World War during the era of the feminine mystique, women's groups turned gradually to other issues and appeared to abandon their previous agenda for increased economic opportunity and political representation. Yet an active women's lobby functioning within the government and the political parties continued to press for women's rights, establishing the groundwork for the reemergence of feminist activism in the 1960s and the mushrooming of women's liberation in the 1970s. This new feminist movement, which drew many more women than ever before into political activity for women's rights, persisted into the 1980s.

The history of women's activism illustrates the centrality of consciousness for movement formation and success. It documents the presence of an organizational base, resources, and leadership for a women's movement long before the emergence of the feminist movement. Women built a sophisticated national network of volunteer organizations between 1890 and 1925 which rivaled that of the corporate business world. Many of the women's organizations involved in the contemporary feminist movement have been around for a long

time, including the BPW, AAUW, General Federation of Women's Clubs, YWCA, and League of Women Voters.

These organizations used their wealth of resources in members, financial backing, and expertise to promote women's rights. In 1940 the League, BPW, and AAUW, for example, had a combined national membership that totaled over 192,000 women. By 1950 these three organizations alone claimed 363,000 members; their combined membership increased to over 430,000 in 1955 and climbed to over 490,000 in 1965. Over 3 million women belonged to labor unions by the mid-1960s.[30] This growth in membership and in political expertise helps to explain why women's issues received increased recognition. But this traditional lobby could not, by itself, succeed in passing a broad spectrum of women's rights legislation.

The efforts of specifically feminist organizations, such as NOW, WEAL, NWPC, and radical women's groups, were critical to rallying the troops and forming the social movement needed to turn the concern for women's issues into action. These feminist organizations demonstrated public support for changing women's status, which prompted the more traditional women's lobby to join them in their fight for sex equality. The new feminist organizations, however, did not have the finances, membership, expertise, or networks to mount a national campaign on their own. The feminist groups were dependent on the resources of the traditional women's organizations to launch and sustain their movement.

Women gained from all these efforts an increasing ability to place their issues on the political agenda. Their access to elites, however, was not conditional on mass public support. Although women were indeed successful in getting politicians to support their bills during periods of heightened activism and public concern, such as the suffrage campaign and the contemporary feminist movement, legislators sponsored even more women's issues during the 1950s, when there did not appear to be a great deal of activism or public concern over women's rights, than they did in the 1930s, when women's groups were considerably more active. This historical fact is corroborated by the insignificant correlation between the degree of women's activism and the likelihood that legislators would place women's issues on the agenda ($r = .30$).

There is a strong correlation, however, between access to the legislative agenda and the passage of time ($r = .74$). This relationship represents the slow growth of an experienced women's lobby after suffrage. Anticipating a women's vote, legislators were open to introducing women's rights bills during the 1920s. Over 100 bills were placed on the legislative agenda in hopes of wooing this new constituency. When the promised vote did not materialize, women's groups lost a crucial political resource and were forced to use other

pressure tactics to gain legislative support. The women's lobby was quite active throughout the 1930s and early 1940s, but its ability to influence political debate was curtailed. Only 58 bills were introduced during the 1930s and 90 bills made it onto the legislative agenda during the 1940s. The absence of political support was due in part to the fact that women's groups were relatively new to the interest-group bargaining process and in part to the fact that there was a great deal of dissension within these groups about which policies to promote. In fact, women's groups often lobbied against each other to prevent the introduction of protective legislation or the ERA.

As women's groups gained political experience and promoted a more coherent but limited set of demands, their issues gained greater recognition. There were 236 women's rights bills introduced during the 1950s. This increased access was due in part to the fact that the main lobbyists for women's issues came from within both the government, via the Women's Bureau, and the political parties. As the women's rights network grew in size and sophistication to include not only women in traditional women's groups but also party activists and government employees, it was able to introduce legislation at relatively low cost.

Legislative attention to questions of women's rights increased dramatically during the early 1960s. By the end of the decade Congress had considered 884 bills that were largely devoted to curtailing sex discrimination. The coalitions of women's groups became increasingly successful in placing their issues on the agenda when other groups, particularly labor organizations, lent their voice to feminist demands.

Although women were able to place their issues on the legislative agenda, they were largely unsuccessful in getting them passed. Statistically, access and influence were unrelated ($r = .20$). Implementation of women's agenda depended rather on mass activism ($r = .76$). It took the presence of an active women's movement to prompt the Sixty-fifth and Sixty-sixth Congresses (1917–1921) and the Ninety-second through Ninety-sixth Congresses (1971–1980) to pass large numbers and proportions of bills directed at women as a group. Women's groups had gotten their issues on the political docket during the 1960s, but the emergence of the contemporary feminist movement was needed to get their agenda implemented. Only 10 women's rights bills were passed in the 1960s, as compared to 71 laws in the 1970s.

The presence of a mass movement was also central to achieving the goal of increased political representation. The number of women elected to political office, particularly at the state and local level, rose sharply. Women in state legislatures increased from 305, or 3.5 percent of all office holders, in 1969 to 991, or 13 percent, in 1983. Women elected to local government increased from 4 percent of all officeholders in 1975 to 10 percent in 1981. There were 10 women

mayors in 1951, 244 women mayors in 1971, and 1707 women mayors in 1981.

More women won political seats after 1970 because the women's movement publicized the acceptability of running for public office. The push for women office holders was not new. The League, BPW, and AAUW had long encouraged women to take more of a leadership role in public affairs. But it required a social movement in support of sex equality to get women to stop "lickin and stickin" for the election of men, to seek political office for themselves, and to get thousands more women to help them campaign. Yet most of the newly elected women did not belong to feminist organizations, nor did they draw on the organizational resources of the feminist movement in order to win their seats.[31] Feminist groups like the NWPC made a significant contribution through providing technical assistance and early money to start off a campaign, but they did not serve as the main base for women candidates. In fact, during the mid-1970s when the rate of increase in women legislators was the greatest, they were much more likely to come out of the League than out of NOW or NWPC.

Although the resources, organization, and leadership for a women's movement were around for a long time, the feminist movement could not emerge until the 1970s when there was a constituency which believed that women should have the same opportunities as men, that women were denied these options because of discrimination, and that the government is responsible for eliminating discriminatory practices. As a result of this new public concern about equality and justice for women, more women's rights legislation has since been implemented and more women have been elected and appointed to public office than at any other period in American history.

two

From
Housework
to the
Marketplace

Social movements attempt to create a new social world. Born out of a changing social universe, they in turn try to shape the folkways and institutions of the emerging order. A curious fact about social and economic change and the outbreak of political disturbance is that people seem to rebel as things are getting better. Alexis de Tocqueville marveled that the French Revolution was preceded by a period of prosperity. Karl Marx suggested that improved conditions preceded the upheavals of 1848.[1] The civil rights movement in this country emerged after objective economic and social conditions for minorities improved. Similarly, the women's movement followed a twenty-year period of greater access to employment opportunities for women than ever before.

When economic conditions are bad, people consume all their emotional and financial resources in order to just get by. In more prosperous times, even a small surplus of time, energy, and material resources can be committed to group action. As the income or occupation levels of a group improves, the resource base that can be used for collective action increases. General expansion of the economy also improves the material base of groups by increasing the amount of discretionary resources that can be contributed by outside sympathizers who want to help implement the group's goals.

As patterns of social and economic interaction change, people form new associations that can serve as the base for a political movement. Some organizational settings are strengthened, while others fade, replaced by new networks that meet the needs of the community. In

addition, changes in institutions leave politicians and business leaders with less control over sanctions, thereby providing others with greater opportunities for access to authority and reducing the risks associated with protest against existing arrangements. In short, changing economic and social conditions affect a group's ability to act by promoting the accumulation of new resources, competition for positions of authority, and new social networks.

Finally, changing social and economic roles challenge traditional notions of what is possible. They promote new attitudes, self-conceptions, and ideas, which together constitute a new consciousness. The development of this consciousness was the critical component for the transformation of feminist politics from an elite lobby to a mass movement.

Feminist consciousness was learned. It was formed, in part, in response to fundamental changes in women's work experiences, which presented women with new roles, rewards, and expectations about what women do and what they need. Women are currently demanding equal treatment because of the unraveling of traditional roles and the burgeoning of new roles.

The learning of feminist consciousness involved a two-stage process. The first stage entailed a breaking away from traditional work roles centered around home production, and the second stage required the incorporation of women into the labor force, providing an alternative definition of what it meant to be female.[2] At this point women could challenge previous perceptions of women's economic status as homemakers and evaluate women's options and worth in terms of their new roles as breadwinners. Under these new circumstances women were less apt to blame themselves for their economic problems and more likely to recognize the need for outside help. Once a new work norm was accepted, women could acknowledge that they faced discrimination and that something needed to be done to remedy the unfair treatment. At this stage, some women took direct action to fight discrimination, while others supported and applauded their action.

Labor Force Participation

At the beginning of the twentieth century, American women lived under very different circumstances from those experienced by their daughters and granddaughters. The contours of traditional life included a commitment to Kinder, Kuche, and Kirche. Women's life was characterized by a stable family relationship centering around children and domestic work. Women's place was in the home. Their occupation was classified as housewife, with the attendant social imagery of homemaker, wife, and mother. The distinction between

earning a livelihood, or being a breadwinner, and being a homemaker was central to the definition of masculine and feminine responsibilities.[3]

Women's contribution to the economy has changed dramatically over the course of the century. They now work outside the home. Trends in their labor force participation—that is, in the number of women employed as compared to the number of women eligible for employment—document their transformation from homemakers to breadwinners (Figure 2.1). The percentage of women engaged in employment at the turn of the century was fairly small (20 percent). At mid-century almost one-third of the eligible female population had commitments in the public sector. By 1980 over half (51.1 percent) of the relevant population was involved in behaviors that ran counter to traditional expectations.[4]

In some ways the simplicity of this trend belies the complexity of the redefinition of women's work roles. Women entered the twentieth century with the traditional responsibilities for managing the home and family. There was little ambivalence as to the meaning of femaleness. Women's roles were clearly defined, and women's sense of self-worth was reinforced by social arrangements that brooked few deviations from the traditional obligation of being a wife and mother. Novelists such as Stephen Crane and Theodore Dreiser wrote about women whose lives had few choices, while popular romantic melodramas dealt with self-sacrificing heroines who understood that, as women, they were expected to sacrifice and care for others. Women writers such as Mary Wilkins Freeman and Kate O'Flaherty Chopin,

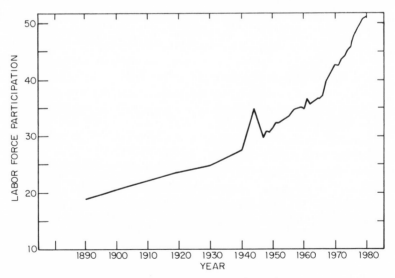

Fig. 2.1 Female labor force participation, 1890–1980

whose novels disguised feminist themes of independence, gained few sympathetic followers within their lifetime. Women who wanted a life outside the family or who wanted a share in the world of men were destined for idiosyncratic, troubled lives that ended in loneliness or suicide.[5]

Women's basic commitments to home and family remained largely unchanged over the first quarter-century. The number of working women increased slightly, from 20.6 percent at the turn of the century to 23.7 percent in 1920, but the female work force remained largely young and single.[6] Women's work experiences prior to marriage nevertheless challenged Victorian images of female frailty and dependence. The millions of young women who disembarked on American shores alone and begging for work spent twelve-hour days in factories and sweatshops. The expansion of white-collar secretarial work brought many daughters of the middle class into the work force for a brief taste of independence before marriage.

Ordinarily, women stopped working once they married. Then in 1917 when American men joined the fighting in Europe, their daughters, wives, sisters, and girlfriends were left to "man" their jobs. Women took over "male" jobs in munitions factories, steel mills, and charcoal plants to help keep the country running during World War I. At the end of the war they were commended for their patriotic efforts and asked to return to their rightful place, the home. But women had learned something about themselves from successfully executing male roles that could not be taken back.

Women's traditional work was largely displaced during this period. Most homemakers now purchased bread from bakeries, canned foods from local markets, and ready-made clothing from mail order houses or department stores, instead of preparing these goods themselves. As women's traditional functions, including education, came to be performed outside the home and largely by men, middle-class women swelled the ranks of social clubs and political movements in order to make their communities a better and safer place. This kind of activity did not challenge women's traditional role but rather expanded women's sphere to include the public arena.

The changes in women's role as homemaker had thus far been subtle. First, the context of women's responsibilities shifted from rural areas to cities, and women's contribution to family care diminished. Then, to compensate for this loss of work, middle-class women stretched the confines of their traditional roles to allow them out of the private realm of the home and into the public world of service and political reform. All this happened in the name of motherhood and female self-sacrifice for others, without making any direct challenge to traditional arrangements and expectations of women's responsibilities.

The distinction between masculine and feminine was finally strained

beyond endurance by the economic devastation of the Depression, which had a dramatic impact on gender-based arrangements in society.

Many women crossed over to the masculine sphere, seeking work to support their families in the face of escalating male unemployment. In the past, the large influx of women into the labor force had meant filling in while men fought to protect their country. In the Depression for the first time significant numbers of women, particularly middle-class women, actually displaced men or shared the role of primary breadwinner. As women succeeded in the male role of provider, it became harder to justify role divisions in terms of biological differences.

Challenges to traditional role expectations mounted in World War II when the nation once again turned to women citizens to help run the country while men were fighting. The war drastically transformed the picture of women's work experience. Its impact is indicated by the sharp rise in women's participation rate to 35 percent for 1944. Large numbers of women assumed their patriotic responsibilities and filled an unprecedented demand for a new labor supply. The female labor force almost doubled as six million women found jobs.

The war experience presented women with situations that they might not have opted for on their own. Working in the war industry facilitated new expectations by providing women with an alternative learning environment, which gave them access to new information and enabled them to develop new skills. Women were thus put in a position to question their own traditional assumptions. At the end of the war a survey of ten different employment sectors found that 75 percent of the women who entered the labor force during the war expressed a desire to continue working. A steel worker expressed women's sentiments simply when she said: "The theory that a woman's place is in the home no longer exists. Those days are gone forever."[7]

When the war ended in 1945, the public agreed that women had played a central part in bringing about the victory. Women workers were acknowledged to have met masculine standards for strength, endurance, and agility. Yet men and women were still not ready for an equal partnership in running the government, industry, and home. On the contrary, this was the era of the feminine mystique, marked by a full-fledged return to domesticity. The home became the symbol of the desired but elusive world of love and stability, and women were charged with the responsibility for creating and maintaining this sanctum.

When men came back from the war, however, women did not return to the home. Even though labor force participation by women

fell from 35 percent in 1944 to 29.8 percent in 1947, many women remained in the labor market. The postwar participation rate was higher than in 1940, and it continued to climb. Even during the resurgence of domesticity in the 1950s, women entered the labor force in large numbers. The accelerated growth pattern which had begun in 1940 continued until 1980.[8] The increase in women's labor force participation during those four decades was almost three times the growth rate of the first four decades of the century.

One reason for the escalated entrance of women into the labor force was that at the turn of the century women were segregated into particular occupations and professions which were numerically unimportant. In 1900, most women worked as domestics, farm laborers, unskilled factory workers, and teachers. Over the next forty years women's job opportunities expanded as women were hired for secretarial, clerical, and sales positions. In 1900 women comprised over 70 percent of the workers employed as stenographers, typists, secretaries, telephone operators, clericals, nurses, social workers, teachers, and waitresses—all occupations which demand that workers take care of others. As the nation's industrial growth increased between 1900 and 1940, the demand for labor also shifted from farming and manufacturing toward service occupations and industries. Women workers were thus concentrated in the expanding occupations, which helps to account for the large number of women who were absorbed into the work force prior to the 1940s. The subsequent sharp increase in female employment rates came as a consequence of the postwar economic growth, which escalated the expansion of the service sector and increased the demand for female workers. As the opportunity for employment grew, women were increasingly provided with an alternative to the traditional norm of a life-long, full-time homemaker.[9]

The fact that more women are working today than ever before represents a significant departure from traditional expectations. Women's lives have been substantially recast in that the changed employment process has penetrated into their traditional roles as wives and mothers. The composition of the female labor force is thus a clue to the changing work role of women.

The Employed Wife

At the turn of the century few married women were employed outside the home. Working women were young, single, and childless, posing no threat to traditional familial responsibilities. Family life in America during the 1920s and 1930s was based on the premise that women and men occupied different spheres. During the Depression, how-

ever, the high rates of male unemployment forced married women to cross into the male sphere in order to ensure their family's survival. As a result of the need to supplement or provide the family income, the percentage of married women seeking employment reached a new high.[10]

There are no data on the employment of married women during the 1930s, but the 1940 Census suggests some of the employment patterns of those Depression years. Comparison of the age and sex of the work force in the higher employment years, 1930 and 1950, with 1940 reveals that labor force participation was well below the average of the more prosperous times for every age-sex group with the exception of women 25 to 44 years old. Women in this age bracket made up almost half of the total female labor force in 1940. In addition, married women made up over a third of the female labor force at a time when there was a great deal of pressure against such behavior.[11]

The employment of these married women marked a major departure from traditional experience and permanently altered the composition of the labor force. Women were working when men were not; many women took on the male role of breadwinner. Given their ages, these working women probably had families to support. They provided new examples of female capabilities and potential, creating new role models for future generations.

The influx of married and middle-aged women into the labor force, begun during the Depression when women needed to work to support their families, persisted when war came and women needed to support their country. In part, the recruitment of married women was due to a scarcity of single women available to replace absentee male laborers. By 1944 married women made up a plurality (46 percent) of the female labor force. Single women comprised 41 percent, while separated and divorced women accounted for the remaining 13 percent.

The pattern of married women's employment between 1890 and 1980 suggests that the Depression and war years were part of a general acceleration in labor force participation by married women. World War II drew an impressive number of married women into the work force. The increase in the participation rate between 1940 and 1944 almost matched the total increase for the first four decades of the century.

Moreover this rate barely fell off following the end of the war. In 1949 the director of the Women's Bureau speculated that the country "was approaching a period when for women to work is an act of conformity."[12] In a few years, the employment of older, married women became a normal part of a woman's life cycle.

The initial wartime mobilization was sustained for the next forty

years. In 1940 married women accounted for 36 percent of the female labor force. Four years later the figure increased by 10 percent, and for the first time married women comprised a plurality. By mid-century over half (52 percent) of the female labor force was married. Almost 60 percent of women workers in 1980 were married.

The Employed Mother

By 1950 the traditional assumption that marriage precludes involvement in the labor force no longer held, inasmuch as married women formed the major part of the female work force. Over the next two decades traditionalism experienced a further decline as mothers, particularly mothers of young children, entered the labor force. The changing family configuration of working women showed up in the different rates of participation in the labor force by married women with no children living at home, mothers with children between the ages of six and seventeen, and mothers of preschool children. The very entrance of the last two groups represented a significant departure from women's home-defined responsibilities. The participation rates were limited to married women living in intact households, so as not to exaggerate the trends by the inclusion of women who did not have the traditional options implied by their marital status.[13]

The participation rate increased rapidly for all three groups of married women. By 1948 the employment rate for married women with school-aged children was very close to the rate for women with no children. In 1955, being a working mother was a reality for over a third of the women with children six years old and older. Twenty-five years later, 62 percent of mothers with school-aged children were working. At the turn of the century it had been highly unlikely that these mothers were employed outside of the home. Presently, they were more likely to be employed than not.

The entrance of women with preschool children into the labor force marked the death knell for the adage that a woman's place is in the home, with its implication of traditional parenting responsibilities. The increase in the employment of women with preschoolers began in 1950, when 12 percent of these mothers were employed. The proportion of this population in the work force increased rapidly to 19 percent in 1960 and 30 percent in 1970. By 1980, 45 percent of mothers with young children were in the labor force.

The work histories of different generations of women during the twentieth century dramatically illustrate the changes in the relationship between women's work experience and the family life cycle. The lifetime pattern of market activity for each generation was greater than that of its predecessor. This trend showed an increased work-

life expectancy. The average number of years of female employment expanded from six years in 1900, to twenty years in 1960, to twenty-eight years in 1980. Employment thus became an integral and important part of women's lives, an activity no longer reserved for periods prior to marriage or to the assumption of family responsibilities.

Increased participation rates and work life stability also reflected the rising proportion of multiworker families during the twentieth century. The proportion of these families increased from 9 percent in 1920 to 22 percent in 1950 and to 52 percent in 1980. Three-quarters of women in multiworker families in 1980 were employed year round. Working wives made a significant contribution to their families' incomes. For some families the pay provided by the working wife made the difference between poverty and a living wage. For many other families the second income allowed for a higher, comfortable standard of living.

American families underwent a fundamental change in the arrangements that they made for their economic welfare. The traditional model of husband-breadwinner and wife-homemaker held true for only 34 percent of husband-wife pairs in 1975, as compared to 56 percent twenty-five years earlier. This employment trend illustrates the dramatic changes that had taken place in the relationship between women's work experience and family responsibilities during a single generation.

The pool of employed women expanded beyond the traditionally preferred single female because, as the demand for female labor increased between 1940 and 1960, the supply of young, single women declined.[14] This sharp decline took place because of three factors: the cohort of young women was particularly small, owing to the low fertility rates of the 1930s; a decline in the age of marriage, particularly after 1940, reduced the pool of single women; and the high fertility of the postwar period increased the percentage of women with preschool children, which was the least desirable pool of women workers. The entrance of women with preschool children into the work force, which was brought about by the interaction of demographic and socioeconomic factors, marked the point of no return, or the "critical point," of the role transformation process. The work experience of large numbers of women drawn from nontraditional pools demonstrated the feasibility of employment at all points of the family life cycle.

But demand was only part of the reason that women entered the labor force. Women worked out of economic necessity, which ranged from providing food, shelter, and the bare necessities to earning money for a new home, a second car, or the children's future edu-

cation. A single income often proved insufficient because of increased inflation or rising expectations associated with suburban living. And a growing number of women sought employment for the personal rewards that the jobs conferred. For these women, the home as a workplace, isolated from the centers of public and community life, had become increasingly alienating and thus made the employment experience more desirable.[15]

Approval of Working Women

The increased demand for female labor was accompanied by a change in opinion about the kind of work that was desirable for women. When mass production made it easier and cheaper to purchase goods and services formerly provided by the homemaker, the value of paid employment escalated. The women's liberation movement, in effect, took root when men in factories began to take away women's traditional work.[16] Even prior to the twentieth century the value of women's traditional work had been reduced by the availability of factory-produced clothing, commercial laundries, and prepared foods, such as prepared cereals, canned vegetables, condensed milk, and bakery bread. The availability of precooked and frozen foods, TV dinners, fast food restaurants, permanent press fabrics, dishwashers, washing machines, diaper services, and summer camps which accompanied the expansion of the 1950s and the 1960s drastically cut into the economic value of the homemaker.

The objective reality of increased labor force participation by married women did not necessarily represent a challenge to traditional perceptions of the appropriateness and value of that behavior, as shown by official statements, journals, newspaper articles, novels, and public opinion surveys. The increased employment of married women during the 1920s was viewed as a dangerous aberration threatening the health and happiness of the American family. Government officials, employers, and public opinion leaders insisted that female employment was tolerable only prior to marriage. In 1923 the Secretary of Labor warned that the employment of married women in industry would lead to the destruction of the nation's economy. Literary treatments of women's role planted them firmly in the home. Popular magazines charged that working women presented a threat to the family. The happy ending in novels and short stories at the time usually consisted of the single woman wisely rejecting a career for a life of marital bliss. One of the most popular novels of 1922, *This Freedom*, by S. M. Hutchinson, attacked career women as traitors to their sex.[17] Even the Women's Bureau, an agency established to further the interest of women in the work force and educate the

public on women's economic roles, issued severe statements against the employment of married women.

Hostility toward the employment of married women escalated during the Depression because of the increasing levels of male unemployment. Employed wives were labeled thieving parasites who held jobs "that rightfully belonged to the God-intended providers of the household."[18] Public opinion indicated strong opposition to married women working when their husbands were capable of supporting them (Table 2.1). In 1937, when millions of men were unemployed and the labor force participation of married women was increasing rapidly, an overwhelming number (72 percent) did not approve of women holding jobs when their husbands could fill the role of breadwinner.

Legislators in almost every state introduced bills restricting the employment of married women. A Gallup poll conducted in 1939 suggested overwhelming public support for such legislation. Most people (66 percent) were supportive of a bill introduced into the Illinois legislature which prohibited the employment of married women if their husbands earned more than $133 a month. Disapproval of married women working was at such a high pitch that the AFL executive board resolved to encourage employers to discriminate against hiring these women.[19]

This high negative view of married women workers was overturned

Table 2.1. Attitudes toward employed married women, 1936–1978.

				Approve	
Year	Approve	Disapprove	Depends	Women	Men
1936	15%	48%	37%	18%	12%
1937	18	72	10	—	—
1938	22	78	—	25	19
1945	18	62	20	—	—
1967	44	27	29	47	40
1969	55	40	5	—	—
1976	68	29	3	70	65
1978	72	26	—	—	—

Source: Hazel Erskine, "The Polls: Women's Role," *Public Opinion Quarterly* 35 (Summer 1971): 282–287; "Opinion Roundup," *Public Opinion* 3 (Dec./Jan. 1980): 33.

a few years later when the government made a major effort to encourage women's entrance into the labor force. The Japanese attack on Pearl Harbor forced utilization of the nation's greatest labor reserve, women. By 1942 a national poll indicated that most people (62 percent) were in favor of married women working in the war industries. A greater majority (75 percent) supported the employment of married women if they had no children.[20] Rosie the Riveter and Commando Mary were national heroines, who provided new role models for the American woman. Newspapers and magazines exalted women's contribution to the war effort, carefully sidestepping the issue of woman's place.

Support for working women during this period was tied directly to the war effort. Once the war ended, this enthusiasm died. The experience did not reshape traditional notions of gender-related spheres of influence. Sixty percent of a cross-section of employed women in 1945 indicated that they planned to continue working after the war.[21] Yet these decisions were not commensurate with public opinion favoring such behavior. Unaware of the demographic and economic implications of the expansion of female-dominated occupations, the general public saw the issue of women's employment as women taking men's jobs. Upon announcement of the war's end, the print media thanked American women for their valiant efforts at jobs that were beyond their emotional and physical capabilities.

In 1945 public opinion on the advisability of the employment of women who could be supported by their husbands was very similar to opinions voiced in 1937. Only 18 percent of Americans supported married women's right to work. More people, however, were ambivalent about the issue in 1945 (20 percent) than in 1937 (10 percent). When the question was modified to take account of the prevalent fears of job scarcity, only 10 percent of the respondents questioned men's prerogative to the jobs.[22]

Public opinion nevertheless underwent some reshaping after the war. In 1946, 46 percent of women and 34 percent of men questioned in a poll approved of the employment of women whose children were older than sixteen.[23] The war experience had fostered an increased tolerance for the employment of at least a subpopulation which was distant from the traditional responsibilities of childbearing and childrearing but was still different from the traditional pool of single women.

General societal approval of married women's employment provided only one broad indication of changing attitudes during this period. Another sign of changes in the attitudes was women's own evaluations of the desirability and value of their outside work roles in comparison to their homemaking responsibilities. As of 1946, a third of the women interviewed in a poll felt that women who held

full-time jobs had a more interesting life than those who worked at home.

The increasing entrance of women into the work force was contradictory to the resurgence of domesticity in post–World War II culture. In the period between 1945 and 1960 most Americans subscribed to the feminine mystique. For the true woman, according to this mystique, happiness and fulfillment required total involvement in the roles of wife and mother. Advertisements during this period outlined the contours of woman's world—bedroom, kitchen, sex, and babies—all found in the home and not in the labor force.[24]

Women's magazines romanticized homemaking and motherhood. For a snapshot of the perfect woman, picture Louise Robbins, who "graduated from Smith College in 1942 and soon after married a young Boston lawyer. She lives in the suburbs with three children (happy that a fourth is on its way), two dogs, a cat, a busy schedule and, from all accounts, no frustration at all . . . She handles all the household work—laundry, beds, meals—and all the care of the children. Yet, she finds time to paint, to study music, and work in the local League of Women Voters, which is fortunate because her husband is also in local politics. When they go to plays, concerts, or parties, she re-emerges the glamour girl he married."[25] This typical portrait of the 1950s heroine was created by and communicated through the mass media for public consumption.

The desirability of a "feminine" woman was reinforced by popular songs of the times. Louise Robbins epitomized the desired object of Irving Berlin's "The Girl That I Marry." Written in 1946, this laundry list of glorified wifely qualities was a top hit in 1947 and again in 1957. Rodgers and Hammerstein's 1947 hit, "A Fellow Needs a Girl," glorified the helpmate role by emphasizing the joys of being the modern wife of an ambitious man. These composers returned in 1958 with another hit, "I Enjoy Being a Girl," which reminded the American woman that the hopes of a "female, female" was a future in the "home of a brave and free male."[26]

Attitudes toward women and work during the 1950s were characterized by a strident defense of housewifery against alternative lifestyles.[27] This defense was accompanied by an attack on the working mother as grossly unfeminine and frigid. The glorification of the homemaker served at least two functions. First, it facilitated the demobilization of women from the labor force in order to allow men to resume their rightful place and thereby avoid serious unemployment problems. Second, extolling the virtues of scientific homemaking represented an attempt to stimulate consumption so as to ward off an economic downturn after the end of war production. Although married women were working, few gains were made during this period in public support for the employment of married women.

The extent to which women found scientific homemaking a ful-
filling and important role was another matter. The large number of
women entering the labor force at this time suggested a lack of con-
sensus on the importance and usefulness of being a housewife. Only
half of the homemakers and even fewer working women (34 percent)
in a 1953 interview mentioned that housework provided them with a
sense of self-worth. At a time when the popular image of the working
women was unflattering at best, the majority of employed women
(56 percent) said that their jobs made them feel useful and important.
This sentiment was even higher (70 percent) among women employed
in professional and semiprofessional occupations. Apparently women
derived gratification from their occupational roles even when public
opinion was not supportive of such nontraditional behavior.[28]

This inherent paradox in the subscription to an ideology that em-
phasized the propriety of housewifery at a time when employment
was becoming integrated into women's life cycle did not go unnoticed.
Women experienced role conflicts and identity crises resulting from
the tensions between their modern and traditional roles. In 1947 *Life*
magazine featured a spread on the "American Woman's Dilemma,"
which noted the growing confusion and frustration resulting from the
conflict between traditional norms and women's increasing involve-
ment outside the home.[29]

The myth of the contented housewife became the subject of wide-
spread discussion in the early 1960s when Betty Friedan in *The Fem-
inine Mystique* exposed the "problem that has no name." Charging
that the marital fulfillment promised by the pursuit of hyperbolized
domesticity was a fraud, Friedan argued that the American home
had become a "comfortable concentration camp," breeding discon-
tent and unhappiness. This message, consumed by at least one million
purchasers, gave focus to the substance of women's discontent and
allowed for a discussion of the value of the work experience.

The contradictions in the images, expectations, and behaviors of
women from the late 1940s to the early 1960s were symptomatic of
a transitional phase in their role. Women were in a process of trans-
formation as they continued to pursue both traditional and uncon-
ventional goals. A transitional phase is one in which the seeds of
change are planted. In contrast to the feminine mystique era, in 1965
half of the people in a poll felt that a working woman with young
children was not harmful to American life.[30] By the late 1960s the
employed married woman had become an accepted part of American
society. The working woman was now the norm rather than the ex-
ception.

The decline in public disapproval of the employed married woman
allowed for the expression of dissatisfaction with women's employ-
ment situation. So long as women did not define themselves as work-

ers, unequal employment opportunities were not perceived as discrimination. But when market activities became more salient to women's lives and to their self-definition, issues such as female unemployment, low pay, low advancement opportunities, and the sex segregation of occupations became matters of great concern. The inequity of the marketplace did not itself lead directly to a cry for change; rather, the development of a new self-image of women as workers allowed for the recognition and rejection of unfair treatment.

The Decline of Motherhood

Motherhood has always represented the core of the female identity. The essence of being female has been characterized as a "biological, psychological, and ethical commitment to the care of human infancy."[1] The present-day feminist movement, in contrast, does not acknowledge child care as women's inherent responsibility. The Bill of Rights for Women drafted by NOW in 1967 called for increasing societal responsibility for child care and instituting services to expand women's life options. Among its articles were demands for the development of child-care centers to facilitate the entrance of women into the labor force and to allow for increased education; the extension of maternity leaves, social security benefits, and tax deductions for child-care expenses as a means of encouraging women to stay in the labor force; and the availability of birth control and abortion on demand to allow women to control their reproductive lives and to decide when and if they want to assume parental responsibilities.

The political demands expressed by the women's movement have challenged the sexual divison of labor in society. Support for this movement requires a recognition that men and women are equally suited to caring for children. Motherhood has three components: a biological one, involving gestation, procreation, and lactation; a social one, involving child rearing; and an ideological one, involving the value of mothering. For centuries, the biological reality that only a woman can bear children was manifested in a universal expectation that motherhood be her central role and responsibility. But the trans-

formation in women's roles also changed women's experiences as mothers. As a consequence, all three of the traditional components of motherhood were radically altered. Only after motherhood became less central in defining women's identity could a political movement in support of sex equality emerge.

The Biology of Motherhood

Technological advances have allowed for the transcendence of many biological limitations, but they have not yet brought about Huxley's *Brave New World*. Test tubes have not, to date, replaced the reproductive capabilities of the womb. The fact that only women can bear children has not changed. However, the ability to have children must be distinguished from the actualization of that potential. Fecundity, the number of children a woman is capable of bearing, is biologically determined. Fertility, the number of children actually borne, is a sociological phenomena.

Reproductive behavior has always been socially regulated because population control is critical for human survival.[2] Fertility patterns serve as a social barometer of the relative desirability and cost of children, registering people's responses to changing social and economic conditions. Birth patterns also demark changes in women's lives, indexing their varying time commitments to maternal responsibilities. The transformation of women's traditional lives is reflected in the changing patterns of family formation.

Women today have become unemployed by motherhood. This transformation was the result of a dramatic change in the degree to which maternal concerns defined women's lives rather than a rejection of marriage and children. Motherwork has two central components: mothering, which refers to the touching, reassuring, feeding, teaching, diaper changing, disciplining, and countless other activities required for the emotional and physical health of infants and small children; and housework, which refers to the extra cooking, cleaning, laundering, and shopping caused by an infant or child.[3] The parameters of the motherhood role include the number of years a woman commits to procreation, the size of her family, her age when child rearing begins, and the duration of her child rearing relative to her own life span.

Two of these parameters have the potential for changing family responsibility: the number of children per family and the number of years committed to child care. If women have fewer children, then child-care responsibilities demand less of their time. Alternatively, even if the number of children born remains high, early marriage and smaller birth intervals can effectively reduce the amount of time allocated to child care. As a practical matter, the age at which women

begin their families has implications for future family size. A woman who starts her family near the age of thirty is not likely to have a large family, while a woman who starts her family at the beginning of her childbearing years has a larger reproductive span, so the likelihood of a larger number of births, some unintended, increases. The general fertility rate, or annual number of births per thousand women aged fifteen to forty-four in the population, reveals shifts in both the child-related stages of women's life cycle and the size of completed families (Figure 3.1).[4]

Women's commitments to motherhood change at all three stages of maternal responsibility.[5] Early motherhood, which begins with the birth of the first child and continues as long as young children are in the household, represents the most intense period of motherwork. The arrival of the youngest child at school age signals the completion of this stage, when the direct and intensive form of mothering necessitated by small children involves less of women's time. This is the period of transition to middle motherhood, when women's direct involvement in child care decreases. At this stage the responsibilities of motherwork involve the augmented household chores brought on by an additional family member. As children continue to grow, there is a gradual disengagement from maternal responsibility. Motherwork is completed when the last child marries and leaves home to form a new family. The final stage of late motherhood marks the phase of a woman's life when she is no longer responsible for the care of her children.

Women's life expectancy and their median age at marriage, at the

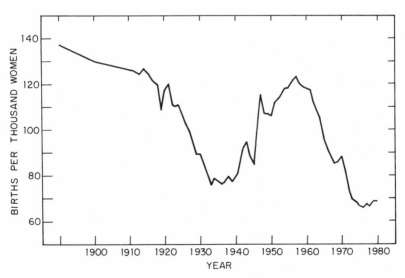

Fig. 3.1 Fertility, 1900–1980

birth of their first and last child, and at the marriage of their last child are the signposts used to determine the duration of each of the three stages of motherhood and hence the changes in women's commitments to motherwork (Table 3.1). For example, women in the 1900 marriage group married at the age of 21.4, and those who lived past 30 were expected to survive until the age of 66. Thus, their adult life consisted of 44.6 years. Their first child was born when they were 23 years old, and the last was born when they were 32.9. Early motherhood ended six years later, at the age of 38.9, when the last child entered school. As a result, women in this marriage group spent 15.9 years, or 35.6 percent of their adult lives, taking care of young children.

The fertility pattern of the United States has changed from large to small families. This evolution, which began in the early 1800s, paralleled the transition from a rural, agricultural economy to an urban, industrialized way of life and livelihood. At the beginning of the nineteenth century the average mother had seven children, but one in every five newborn infants died before the first birthday.[6] Fertility remained high through the first two decades of the century and then began to decline rapidly. The annual number of births per thousand persons in the population, known as the crude birth rate, fell from 55 in 1820 to 52 in 1840, 44 in 1860, and 40 in 1880. By the end of the century the crude birth rate dropped to 32 births per thousand persons.

Table 3.1. Time commitment to motherhood, 1900–1970.

	Born							
	1880	1890	1900	1910	1920	1930	1940	19?
					Married			
Marriage stages	1900	1910	1920	1930	1940	1950	1960	19?
Wife	3.6%	3.8%	3.9%	4.4%	4.1%	2.7%	2.5%	2.?
Early motherhood	35.6	33.4	30.1	30.7	30.0	30.3	26.2	23.?
Middle motherhood	36.9	37.2	34.8	32.1	31.8	31.4	30.5	30.?
Late motherhood	23.9	25.6	30.4	32.8	34.1	35.6	40.8	43.?

Source: Compiled from female life cycle statistics.

As more goods were made in factories, the home became less of a center of production, and consequently the importance of children as part of this work unit diminished. The growth of cities imposed crowded living conditions that also fostered smaller families. Between 1876 and 1885 only a third of the families were large, with 16 percent of mothers having five to six children, 11.6 percent having seven to ten children, and 5.5 percent having ten or more children. By the end of the century the average mother had four children.

Women marrying at the turn of the century committed the major portion of their adult lives to maternal responsibilities. These women began their families at the relatively late age of twenty-three years old, averaging 3.9 children over a twelve-year span. A significant segment (34 percent) had large families consisting of five or more children.[7] In addition, a high incidence of fetal and infant mortality meant that women endured a large number of attempted childbirths to ensure a moderate-sized family, while high maternal mortality rates meant that many women did not survive to care for their children.

Those women who did survive childbirth had a life expectancy of sixty-six years and spent the majority of their adult years taking care of children. Many women had small children in the household well into their thirties and early forties. At age thirty-nine, half of the mothers were still engaged in the intensive responsibilities of early motherhood. Their last child married when they were fifty-five years old, which left these women only ten years without direct responsibility for their children, although they often spent this time taking care of children other than their own.

Women born in the 1880s spent an average of 35.5 percent of their adult life on intensive child-care responsibilities. The empty-nest period, when they no longer bore direct responsibility for their children's welfare, comprised only 23.9 percent of their life. The lives of women who married at the turn of the century were thus constrained by traditional maternal responsibilities.

The fertility rate continued to decline in the early twentieth century and then flattened out during the Depression. The mother who married in 1910 averaged 3.1 offsprings. Large families were still common but on the decline.

There was also a drop in the fetal, infant, and maternal mortality rate during this period. The decline in the number of infant deaths meant a reduction in the time commitments to gestation necessary to ensure the survival of a desired number of children. Maternal mortality remained high, but the danger to women's health was greatly reduced. Still, 30 percent of the women born around 1900 and married during the 1920s did not survive to late motherhood.

Earlier marriage coupled with smaller families meant women committed fewer years to the consuming child-care responsibilities of early

motherhood. The median age for the birth of the last child dropped to 31 years old for women who married in 1920. Unfortunately, many of these women (24 percent) did not live to see their last child enter school. Those who survived spent 33.4 percent of their adult lives on the care of young children. The decreased time commitment to early child-care was coupled with an increased life expectancy, which resulted in the extension of late motherhood. The average mother who married in 1920 spent 30.4 percent of her adult life without child-care concerns, as compared to 23.9 percent for the average woman who married in 1900 and survived to late motherhood.

The young women who reached their primary child-bearing years between 1930 and 1945, expecting to marry and start families, found that the adverse economic conditions of the Depression, followed by the absence of young men during the war, meant the postponement of marriage and children. Half the women who married during the 1930s had not started their families by the age of 23.5, which was the highest median age at first childbirth for the century.

The fertility experience of these women represented a dramatic change from that of women who married at the turn of the century. Average family size dropped sharply from 3.9 to 2.9 children in the Depression households. Although couples had a relatively higher number of children at the later end of women's reproductive years in order to compensate for lost time, the contraction of the reproductive time span resulted in an increase in childlessness among married couples and a higher incidence of only children. Large families became less common, accounting for 17 percent of Depression families, as compared to 34 percent of families formed in 1900, while the percentage of single-child families increased from 16.8 percent to 25.5 percent.

The experience of Depression families illustrated the influence of completed fertility and the timing of the family in shaping women's commitments to motherhood. Family size alone cannot serve as a measure of the constraints of early motherhood because of the absence of equivalent child-spacing intervals. Depression families were small, but delayed births and wider spacing of children extended the period of early motherhood. The median age at birth of the last child rose from 31 to 32 years between 1920 and 1930, even though the previous marriage group had had larger families. This reduction in family size meant that early motherhood comprised a considerably smaller portion of the adult life of mothers in the 1930s than at the turn of the century (31 percent as compared to 36 percent). Mothers in the 1930s also spent more years without the responsibilities of child care. Increased life expectancy extended the amount of time spent in late motherhood from 24 percent of an adult woman's life at the turn of the century to 33 percent in 1930.

The young women who reached their primary child-bearing years during the Depression and World War II expected to spend their adult years taking care of children. Instead, many women found themselves childless or with small families that left them with many child-free years. Theirs was the first generation to confront what it meant to be a woman independent of mothering. This experience marked the first stage in the transformation of women's role as mothers.

The long-term trends of decreased family size, shrinking commitments to early motherhood, and extended periods of late motherhood were completely reversed by the fertility experience of American women after World War II. In 1945 there were 86 children per thousand women of childbearing age. By 1957 this figure had skyrocketed to 123 births. This period of unexpectedly high fertility is known as the baby boom.

The increased birth rate of the late 1940s partially reflected an attempt to recoup for lost time. The sharp rise in the general fertility is therefore misleading, because many of the babies born at that time would ordinarily have been fathered earlier in the decade. The absence of husbands during the war created a pause in people's family plans, which were actively resumed once the troops returned.

This postwar fertility revival occurred in Europe as well as in the United States. In most European countries the high postwar birth rates lasted for only one or two years, allowing enough time for couples to establish small-sized families. By 1952 fertility in Europe had generally returned to the low prewar level, whereas in the United States it continued to lurch upward.

At the end of the war the nation's economy experienced unprecedented growth, which continued through the early 1960s. During this period of prosperity the extension of new credit opportunities, increase in low-interest government loans, and expansion of health insurance programs meant that couples could afford larger families. Installment plans made it easier for large numbers of young people to get married because they could buy a house, furnishings, and a car. Having established a household with a relatively small cash investment, couples could begin their families at younger ages. These earlier families increased the length of women's reproductive life, which was accompanied by an increase in completed fertility. The move out of the city and into suburbia allowed for a lifestyle centered around larger families.

The improved economic conditions in this country fostered an increase in the number of young married couples. The newlyweds of the 1940s and 1950s also started their families at earlier ages than any previous generation since the turn of the century, in contrast to the delayed births of the Depression. Early marriage was coupled

with a continued decline in the median age at first childbirth. Whereas half the Depression wives had started their families by the age of 23.5, during the 1940s this age dipped to 22.7, and in the 1950s it dropped to 21.4.

The reshuffling of family formation patterns at both ends of the childbearing years did not account for all of the inflated birth rate during the baby boom. The high birth rate was also due to increased family size. In a dramatic reversal, mothers who began their families during the 1950s averaged 3.5 children, a number exceeded only at the turn of the century. Large families with five or more children, however, were far less frequent during the 1950s (19 percent) than at the turn of the century (34 percent), while the two- and three-child households became more common in the 1950s (53 percent) than at the turn of the century (37 percent).

Fertility patterns during the baby boom were a result of the interplay between family size and family timing and the saliency of women's maternal responsibilities. The marriage group of the 1950s began their families sooner and spaced their children closer together. The median age for the birth of the last child dropped to 31.2 years. This meant that they completed their families at younger ages than women in previous decades who had fewer children.

The Depression brides had been a transition generation, for whom for the first time the empty-nest period comprised a greater part of a mother's life than the child-rearing period. The next two marriage groups continued this trend toward increased child-free years. As shortened intervals in family formation forced the contraction of early motherhood, which in 1940 dropped slightly to 30 percent of an adult woman's life, increased life expectancy augmented the empty-nest period, which in 1950 rose to 36 percent. The probability that women would survive early motherhood increased from 81 percent during the Depression to 91 percent during the baby boom.

The women who entered middle motherhood during the baby boom represented a relatively new phenomenon, as they were the "products of medical technology that keeps women's bodies youthful and vigorous well into their middle years and beyond."[8] These women could look forward to a long and productive life which, despite the increase in family size, was no longer dominated by child care.

The 1950s was an anomalous period in the transformation of women's role as mothers. It was a time when women were once again told that motherhood was their primary obligation to society and that children were valued as the means to a better future. Family size increased during this period, and women's traditional expectations of their role as mothers appeared to be reinforced. So long as motherhood was cast as a biological role and valued as such, feminist arguments for role equality were resisted. Yet women's role as moth-

ers was changed even for the 1950s generation, who passed through the intense child-rearing period of early motherhood to face a long life of diminished child-care responsibilities. The initial reinforcement that these women experienced during the 1950s was not sustained in the 1960s and 1970s.

In the United States the baby boom was followed by the baby bust. The fertility rate declined from 118 in 1960 to 87.9 in 1970 and to 68.4 in 1980. The decline over these two decades was more rapid than the precipitous drop during the Depression. This accelerated decline in fertility was produced by a reversal of many of the factors that had led to the dramatic increase in births during the baby boom. The relatively low birth rates at the older and younger childbearing years combined with a decline in completed fertility to bring about the dearth of infants.

The trend toward early marriage and childbearing was also reversed during the 1960s. Delays in marriage and lower fertility among young women born since 1940 have led to a shorter procreative span, portending a decline in family size. Women who became mothers in the 1960s will probably average 2.8 children, a number that will decline further to an average of 2.5 children per mother of the 1970s.

Women who married from the 1930s through the 1950s shifted from a traditional life dominated by intensive child care to a long period of life having no direct responsibilities for children. This happened, however, through different family formation patterns. The duration of early motherhood is shortest when families are small and children are spaced closer together. The Depression mothers had small families but large intervals between births. Baby boom mothers had larger families spaced closer together. In the 1960s version of these two opposite patterns, mothers had smaller families and spaced their children closer together. This pattern continued into the 1970s.

The smaller numbers of births distributed over a shorter procreative span resulted in women completing childbearing at earlier ages. Half the women who began their families during the 1960s were finished with their reproductive efforts by the young age of thirty. According to projections of the female life cycle, the mothers of the 1960s will spend only 27 percent of their lives taking care of young children. This proportion is expected to fall to 23 percent for the women starting their families in the 1970s. The median age for beginning families is expected to rise from 21.4 in 1950 to 21.8 in the 1960s and 22.7 in the 1970s. This fertility experience is subject to revision since these women are still within their reproductive years.

Changed fertility patterns explain only part of this long-term reduction in active motherhood. Advances in medical science have increased longevity and extended human productivity well into the

later years. Having completed early motherhood by their late thirties or early forties, the daughters of the 1940s and 1950s can look to another thirty-five years of decreased child-care responsibilities. Maternal responsibilities are expected to end as these women enter their fifties, when their children will marry, leaving them another twenty years for doing other things. The increased time spent in late motherhood is expected to account for 41 percent of women's adult lives if they married in the 1960s and for 44 percent of their time if they married in the 1970s.

In sum, the pattern of maternal responsibilities at the turn of the century conformed to traditional expectations. A woman's life was dominated by active motherhood. Time spent in the absence of children was short, and few mothers survived to reap the benefits of old age. Childbearing was akin to Russian roulette, with different odds for the survival of the fetus, the infant, and the mother. Changes in the fertility and mortality patterns throughout the century inverted this pattern of motherhood. The saliency of active motherhood gave way to an adult life dominated by child-free years. Medical technology guaranteed the survival of more infants, reducing the necessity for large numbers of pregnancies to ensure having sons and daughters. Better maternal care meant the survival of more women following childbirth, and improved health and sanitation extended the life span far beyond the active years of motherwork. These changes forced women to recognize that child care was no longer the central focus for the whole of their adult lives.

The Sociology of Motherhood

Child care has been assumed for centuries to be a woman's responsibility. The parenting of children is believed to be a woman's biological destiny, a function of the maternal instinct. But this view confuses women's biological tie to infants through birth and suckling with an extended responsibility for child care. Female responsibility for child rearing is in fact a socially created phenomenon and thus subject to change. Awareness that the responsibility for child care is socially defined makes it possible to redefine maternal responsibility and to accept alternative child-care arrangements, which allow men to parent as well as simply to father their children.

Female responsibility for child care dates back to the origin of the family.[9] Family life involves cooperation between men and women through a gender-based division of labor. Throughout history, child care, household tasks, and crafts have been the province of women, while warfare, hunting, and government have been the responsibilities of men. Although the degree of rigidity associated with sex-differentiated behavior has varied, it has always existed.

The conditions that fostered the sexual division of labor persisted into the twentieth century. After the civil war changing patterns in fertility, longevity, and infant mortality drastically reduced the amount of time that women needed to commit to procreation. Yet child care still remained a woman's long-term responsibility, because the gender-based responsibility for child care was rooted in the prolonged period of suckling infants that physically tied women to children.

A mother's breast has long represented the life-line for human survival. For thousands of years the basic diet of most babies has been their mother's milk. The identification of motherhood with infant feeding is reflected in the fact that the Latin word for "mama" means both breast and mother.[10] Child rearing, particularly the care of infants, ceases to be biologically based once a baby's survival in its first years no longer depends on breast feeding.

In preliterate society women commonly nursed babies, who were not always their own, for a period of two to three years. In ancient Babylon, infants suckled for three years. Paulus, a seventh century European physician, recommended mother's milk as the sole diet for infants during their first two years of life. The same suggestion is offered in the *Koran*.[11] As of the early 1960s, many African, Asian, and Pacific Island babies still nursed into their third year. In Greenland and Mongolia, breast feeding continued for three or four years, while Eskimo babies were frequently nursed for six or seven years. The job of motherhood changed when this period of physical dependency between infant and mother was shortened or eliminated.

The introduction of bottle feeding as an alternative to breast feeding revolutionized women's relationship to their young by removing the biological aspect of infant care. The use of bottle feeding became possible with the development of safer water supplies and sanitary means of milk storage, the mass production of easily cleansed and sterilized bottles, and the ability to alter the curd tension of animal milk in order to ease digestion. Although controlled heating of liquid to eliminate bacteria was introduced in the United States in 1891, pasteurization did not become widespread until the early twentieth century when the introduction of the kitchen icebox made the storage of pasteurized milk feasible.[12] In the 1920s the sterile bottle, topped with a rubber nipple and containing a scientifically prepared formula, replaced the breast as a nutritional object, thereby shattering the traditional dependency of a baby on a lactating woman. Bottle feeding allowed for the total separation of child rearing from childbearing by making it feasible for men or others to care for infants.

The first viable alternative to maternal milk became available around 1920 with the marketing of evaporated milk, which gained increasing popularity with physicians. Commercially prepared milk-based formulas began to replace evaporated milk with the widespread mar-

keting of homogenized milk around 1940. By the early 1960s these baby formulas were the most popular mode of infant feeding. The sale of ready-to-feed formulas in disposable bottles grew rapidly after their marketing began in 1967. This latest innovation provides the ultimate in feeding convenience, eliminating the daily cleaning and mixing required by liquid formula.

The increased convenience of formula feeding resulted in a transition to bottle feeding as the dominant means of providing nourishment to the young. The proportion of women who were bottle feeding newborn babies rose to 35 percent by 1946 and escalated to 63 percent by 1956. By 1958 only 25 percent of week-old infants were breast fed, and by 1972 only 5 percent of American mothers breast fed their infants until the age of six months. Unlike the earlier times when the period of lactation lasted until the infant had completed teething, the modern woman who chooses to breast feed weans her infant away from breast milk and substitutes bottle-fed fresh cow's milk before her baby's first half-year birthday.[13]

The children of the baby boom were the first generation for whom the sight of a mother feeding her baby from a bottle rather than her breast seemed a natural act. By the mid-1950s cows probably fed more human babies than calves. Bottle feeding provided women with a tremendous amount of physical and psychological independence. Women beginning their families and children raised during this era were exposed to a greater variance in infant care and feeding practices than ever before. Mother and infant were no longer bonded together as a unit. If a woman was sick, employed, shopping, or engaged in civic activities, she could ask her husband, her children, her neighbor, or a baby sitter to attend to her infant's feeding needs. While this development did not remove child care from women's responsibility, it represented a first step in their withdrawal from total accountability for a behavior that had been tied to the definition of womanhood for centuries. It also made way for the recognition that mothering is socially defined rather than biologically determined.

Commercially prepared baby food was another innovation in infant feeding during this century which contributed to the reduction of motherwork and the separation of mother and infant. For today's parent the preparation of baby food usually entails selecting little jars off the supermarket shelf and following directions to twist open the lid, heat if desired, and spoon the strained nutrient into the baby's mouth. Advertisements suggest that the process is so simple even fathers can handle the job.

Compare this convenience with the eighteenth century recipe for a nutritious baby food, which indicates the amount of work that the preparation of infant food used to involve: "Take about one pound

of the best flour, tie it tightly in a muslin bag, and boil it continuously for 12 hours; remove it from the water; allow it to cool. When required for use, grate down about two teaspoonfuls into a fine powder; mix the grated flour with half a pint of tepid water; boil it a few minutes; cool it to blood heat; then mix with the gruel thus prepared the white of one small hen's egg, or the half, if it be a large one; sweeten slightly and feed the mixture to the infant."[14] This gruel provided a daily staple until the eighteenth or twenty-fourth month of the infant's life.

The preparation of infant food continued to be a major task well into the 1930s. Most recipes called for three hours of slow cooking and constant stirring in preparation of baby cereal. Upon completion of this lengthy cooking process, a small portion of the cereal was pressed through a sieve or strainer and fed to the baby.

When Gerber started producing baby foods for commercial use in 1928, the company offered infants a choice of five varieties. Because of the amount of work entailed in the preparation of infant food, commercially prepared cereals and strained meats, fruits, and vegetables rapidly became popular. The baby food industry showed an explosive growth rate of 3,000 percent between 1936 and 1946. Sales increased another 230 percent between the postwar period and 1960.[15]

Access to commercially prepared baby food displaced yet another traditionally female function and contributed to a decrease in home responsibilities which freed women to seek employment in the marketplace. Postwar gains in sales were due largely to the proliferation of infants during the baby boom, but this growth was partly a function of the increase of working mothers who no longer had time to prepare baby food at home. The phenomenal sale of baby food products reached such proportions that in 1972 every infant in this country was estimated to consume 72 dozen jars of baby food before switching at approximately eighteen months to adult menus. This increase in sales led to greater variety, so that a mother can now choose from over 160 different foods in planning her baby's diet.[16]

Women who today reject commercially prepared foods and opt for home preparation also commit much less time to this activity than did their counterparts earlier in the century. With the aid of a blender and double boiler, fresh fruits, vegetables, and yesterday's leftovers provide the essentials for a baby's meal. The more complicated recipes rarely call for more than an hour's worth of cleaning, boiling, chopping, simmering, or baking. Storage containers, refrigerators, and freezers obviate the necessity for a daily ritual.

These changes in infant feeding patterns allowed for the separation of the socially defined role of motherhood, which defines child care as a female responsibility, from the biological act of suckling. The initial merging of the two components stemmed from the extension

of the biological role through a prolonged period of lactation. A baby's dependency on maternal milk for its initial survival remained unquestioned far into the twentieth century, which explains why many women, including the suffragists, accepted the view that caring for children was their anatomical destiny.

In voicing his opposition to the ERA in 1930, Alfred Smith noted that since a man could not nurse a baby, the two sexes could not be treated equally.[17] If the former presidential candidate were alive today and chose to repeat this observation, he would probably be presented with a disposable bottle of ready-to-feed formula, a copy of Dr. Spock's book on infant care, a box of ready-to-mix baby cereal, and a word of advice: "If you can read, you can feed."

The radical transformation of infant feeding practices that eliminated the biological basis for women's responsibility for infant care was paralleled by an increasing recognition that child care is a social responsibility.[18] When the government in the mid-nineteenth century assumed responsibility for the education of the young, it displaced yet another service that women had once provided in the home. The growth of the public school system allowed for dramatic changes in child-care arrangements, leading to greater flexibility in the allocation of women's time and a diminution in women's responsibility for child care.

More children have attended school for a greater period of time in each succeeding decade of the twentieth century.[19] When the school bell rang in 1890, only half of the eligible population took advantage of the educational service. Those children who were enrolled in school attended an average of only 86 days. In an attempt to force the usage of educational facilities, many states passed compulsory attendance laws. By 1918 every state in the union mandated school attendance, and by 1920 school enrollment increased to 68 percent with an average attendance of 121 days. The enactment of the Fair Labor Standard Act in 1938 and of a 1948 amendment prohibiting the employment of child labor in farm work facilitated compliance with the demand for compulsory education. At mid-century, school enrollment increased to 81 percent, and the average length of attendance came to 158 days, almost double that of 1890. In 1980 almost all school-aged children (90 percent) spent an average of 178 days under the supervision of school personnel.

Over the 1970s, schools also gained importance as a child-care arrangement for younger children, which was a further encroachment on motherhood's assumed monopoly. The percentage of three- to five-year-olds enrolled in nursery school and kindergarten increased from 27 percent in 1965 to 38 percent in 1970. By 1979, 51 percent of children in this age group were enrolled in school. The enrollment

of five-year-olds alone in kindergarten increased from 52 percent in 1950 to 64 percent in 1960 and then to 77 percent in 1968.[20] This trend paralleled the increasing labor force participation of married women with children under six years of age. As more children entered school at earlier ages, the period of early motherhood was further reduced.

The promotion of compulsory education marked a major intrusion by the government into family life. Mandating school attendance required the recognition that institutions other than the family could share in the responsibility of raising children. While educators taught reading, writing, and arithmetic, they also shared in the socialization of the young and the molding of future citizens. After the First World War, schools accepted increasing supervision over children's welfare. Educational facilities began to provide vision and hearing tests, immunization programs, special classes aimed at correcting speech impediments or reading disabilities, and dental care. Concern over children's nutritional needs led in 1935 to the establishment of school lunch programs. By mid-century, guidance personnel to attend to children's mental health were increasingly common. With each succeeding decade, mothers shared a larger portion of their child-rearing activities with school personnel.

To rear children requires ensuring their health and safety and preparing them to meet the responsibilities of adult life. At the turn of the century a great deal of energy was already expended on health and safety, but as the century progressed, the responsibility of educating children became even more complex and difficult. Today both institutions, school and family, struggle to prepare children for their future responsibilities. Though not always optimistic as to their probable success, these institutions recognize their partnership in the effort.

The removal of children for six hours a day for 178 days per year freed women to engage in activities other than motherwork. During this child-free period many women, under the guise of economic necessity, entered the labor force. Others donated their time to voluntary associations. In 1965 at least 11 million women in the major child-rearing ages of twenty-five to forty-four served as volunteers, and these figures underestimate the number of women engaged in voluntarism because they exclude participation in political, religious, or fraternal organizations.[21] Women who were unable or unwilling to pursue nontraditional work patterns, filled their child-free hours by becoming involved in self-created work. Thus child rearing is no longer solely a family responsibility left to the care of mothers but a shared responsibility with government, which mandates public school attendance as a form of subsidized child care in order to help train future citizens.

The Ideology of Motherhood

Motherhood not only is the act of bearing and rearing children but also is a symbol of womanliness, love, and nurturance. The ideology of motherhood reflects the value that society places on children and on the mothering role. According to this ideology, being female is rooted in motherly qualities, so that women must mother to realize themselves. The primacy of motherhood to women's identity stems from the historical relationship between reproduction and human survival. The glorification of motherhood is age-old, appearing in the elaborate fertility and birth ceremonies of ancient civilizations and in the biblical tradition that motherhood is woman's destiny and her only means of redemption.

The ideology of motherhood emphasizes society's need for large families and places a moral prohibition on birth control. This ideology stood unchallenged throughout history until industrialization created a new economic system that did not require a high birth rate. The resulting changes in the value orientation toward motherhood showed up in the public's attitudes toward birth control and family size. Support for birth control represented the recognition that in an urban, industrial society large numbers of children are no longer advantageous. People could still desire large families even when economic constraints prevented them from achieving this ideal. The ideology of motherhood could be questioned only when large families were no longer viewed as ideal, allowing women to form new definitions of what it means to be female that are not rooted in women's biological role as mothers.

The belief that the destinies both of women and of society were linked to the natal experience was much in vogue when the nation entered the twentieth century. The long-term decline in fertility during the 1800s was a cause of great concern for policy makers. Abortions, which prior to the 1820s had been legal during early pregnancy, came under full-scale attack. In 1871 the *New York Times* railed against abortion as "the evil of the age."[22] In 1873, birth control was legally prohibited for the first time by the Comstock law, which banned the dissemination of obscene matter through United States mail.

Attacks on birth control and small families escalated as the fertility of white women dropped from 155 births in 1880 to 124 births in 1910. Alarmed by the sharp drop in the fertility rate of white women, President Theodore Roosevelt condemned the tendency toward smaller families as a sign of moral decadence which would ultimately lead to the subversion of home and family. Like others concerned with potential race suicide, he attacked women who avoided large families as "criminals against the race . . . objects of contemptuous abhorrence by healthy people." He spurned the "viciousness, coldness,

shallow-heartedness" of a woman who would seek to avoid "her duty." If women did not reproduce, "no material prosperity, no business growth," could save the race. Because the "whole fabric of society rests upon the home," the ideal home was a large family. Six children were advised as a minimal number for people of normal stock; those of better stock had a moral obligation to have more children. This image of the "womanly woman," enthusiastically engaging in maternal and allied activities, was sanctioned by community leaders and public opinion.[23]

The view that motherhood was vital to women's sense of identity was propagated by eminent women as well. In 1917, the president of the Washington, D.C., Federation of Women's Clubs observed that "Motherhood glorifies Womanhood and . . . any teaching that would tend to take from each woman the desire for motherhood is not ennobling to the race."[24] This positive reinforcement of traditional behavior was bolstered by severe sanctions against the pursuit of interests and aptitudes that were unsuited to the maternal role. Such behavior was branded as "dangerous," "abnormal," and "indicative of decay."

At the same time radical changes were taking place in sexual behavior, as shown by the soaring number of articles on birth control, prostitution, divorce, and sexual morality between 1915 and 1925. In a 1938 survey of 777 middle-class females, 74 percent of the women born between 1890–1900, as compared to only 31.7 percent of those born after 1910, experienced no premarital sex. According to the Kinsey study, a similar change happened during the flapper generation. These changes in sexual habits emancipated women from traditional patterns of sexual behavior and challenged the ideology of motherhood by allowing for sexuality independent from procreation. The increasing availability of birth control furthered the ability to make the distinction between sexuality and procreation.[25]

The idealization of large families was in part a response to the birth control movement, which began in 1914 and developed into a national movement in 1921 with the creation of the American Birth Control League. In 1927 the league had 37,000 dues-paying members from every state. Despite legal prohibitions, the organization succeeded by 1930 in establishing fifty-five birth control clinics which disseminated information in twenty-three cities covering twelve states. In 1938 a federal court decision removed the ban on birth control, ruling that contraceptive information did not constitute "obscene matter." The practice of birth control became socially acceptable at the end of the decade when ecclesiastical authorities for the first time approved the rhythm method. By then a majority of the public favored the birth control movement (60 percent), the distribution of

birth control information to married people (64 percent), and the provision of such information by government-sponsored clinics (62 percent).[26]

This growth in the support for birth control occurred in a period when the number of women living in urban areas increased from 47 percent to 57 percent and when the nation faced an extended economic crisis. Both of these circumstances forced recognition that increased family size presented severe hardships for most Americans.[27] Although the emphasis of the birth control movement on family limitation chipped away at the ideology of fertility, this movement was not a feminist movement. There was in fact no official feminist position on birth control during this period. The suffragists, who emphasized the nobility of motherhood, opposed birth control because of a fear that the widespread use of contraception would threaten the family and consequently challenge a major source of women's self-esteem. The American Birth Control League was concerned primarily with eugenics rather than with a woman's right to self-determination. Only 4.9 percent of all articles published in the *Birth Control Review* for the years 1921–1929 had any concern for the issue of self-determination. The emphasis of the journal was highly eugenic, and it treated birth control as a means of preserving the supremacy of "Yankee" stock.[28]

Birth control proponents crusaded to free women from the bondage of unwanted or unwarranted motherhood. Contraception was a means of improving motherhood by allowing women to have as many children as they could afford and no more. Everyone was to benefit from birth control: women would become better mothers, children would receive better care, and society would no longer suffer from the excessive fertility of the "unfit." In this sense, the birth control movement challenged the ideology of motherhood by introducing the discussion of "unwanted children" into the public forum, but it did not challenge the desirability of large families. If people of "better stock" could afford to support a large family, then they had a moral obligation to do so.

The motherhood mystique, supported by beautiful images of madonnas and earth mothers suckling their infants, assumed the desirability of large families. Yet from 1936 to 1980 the ideal family size in the popular view generally moved from moderate to small. During the Depression, when the fertility rate was low and families averaged 2.9 children, only one-third of the population envisioned a large family, one having four or more children, as the ideal number. At the end of World War II popular support for large families peaked at 49 percent. The percentage of Americans who believed that four or more children formed the ideal family dropped over the next

twenty years, although as late as 1968, 41 percent of the public still showed a preference for larger families.

The increased fertility of the baby boom was not a result simply of economic prosperity relieving the past hardships that had curtailed fertility. Larger families became more desirable because women's homemaker role had been diminished by the displacement of services out of the home and the increased mechanization of housework. Being a housewife without children or a mother whose children were all in school was no longer seen as a full-time, functionally efficient job.[29] Larger families provided women with a means of resolving the ambivalence felt toward their traditional role. Being a housewife became increasingly less satisfying, and its services less valued, while the role of worker threatened traditional mores. Motherhood served as an affirmation of women's worth and a reinforcement of traditional expectations. The importance of the motherhood role was applauded in the print media, which romanticized the natal experience and glamorized the creativity involved in forming a child's personality.

So long as men and women both desired large families, women's traditional roles were reinforced and arguments for sex equality were resisted. In 1945 when men returned from the war to fill their jobs and women were expected to return to the business of motherhood, the emphasis on "mom and apple pie" translated large families into a patriotic symbol. At that time 51 percent of American women and 48 percent of American men valued families with more than three children. But by 1959 significant sex differences had emerged, with 56 percent of women, as compared to only 43 percent of men, wanting large families. This decline in male support for large families signaled a changing orientation toward children and a challenge to the importance of motherhood.

The motherhood mystique of the 1950s was also challenged by the population explosion of the 1960s. This explosion was part of a long-term growth in world population: "The growth of the world's population can be likened to a long, thin powder fuse that burned slowly and haltingly through centuries of human existence until it reached the modern era . . . The population of this planet doubled between 1650 and 1850, a period of two hundred years. It doubled again between 1850 and 1930, a period of eighty years; and if it keeps going at its present rate, the third doubling of the world's population in the modern era will take place in less than thirty-five years."[30]

Population control meant an emphasis on smaller-sized families and consequently a de-emphasis on motherhood. During the 1960s the issue of population growth was placed firmly on the agenda of public concern. In 1965, 81 percent of the public favored the dissemination of birth control information to anyone desiring to control

reproduction, and by 1969, 69 percent felt that the rapid increase in world population presented a serious problem. The support for large families among both sexes declined precipitously, although sex differences remained acute. In 1966, 41 percent of women still wanted large families, as compared to 29 percent of men. In that year the issue of fertility control received the stamp of official approval when President Lyndon Johnson established a national family planning policy and Congress authorized the use of federal funds to finance family planning research programs.

By the end of the decade planned parenthood and zero population growth had escalated in popularity. The slogans "Planned Parenthood Is an Act of Love" and "Stop at Two" were plastered on billboards, television spots, and radio commercials. In 1969 the Committee to Check the Population Explosion sponsored the advertisement: "How many people do you want in your country? Already the cities are packed with youngsters. Thousands of idle victims of discontent and drug addiction. You go out after dark at your peril . . . Birth control is the answer . . . The evermounting tidal wave of humanity challenges us to control it, or be submerged along with all of our civilized values." In the same year President Richard Nixon and Congress set a historical precedent by establishing a commission to examine the growth of the nation's population and its impact on the quality of life in the future because, as Nixon noted, "one of the most serious challenges to human destiny in the last third of this century will be the growth of the population."[31]

In the past, motherhood and large families had meant survival. By the 1970s these images meant destruction, according to a demographer: "Once upon a time when children helped work the land to assist in supporting the family, every child was an economic necessity. This situation no longer exists. Neither does the need for procreation to ensure survival of the race . . . in fact . . . survival of our species is now dependent on decreasing the birth rate."[32] Such somber words attacked the very essence of the motherhood ideology.

Fears of uncontrolled population growth facilitated the emergence of the small-family ethos, a set of attitudes and values that favored smaller families than the traditional ideal. Popular support for families with four or more children dropped from 41 percent in 1968 to 25 percent in 1970. While women were still more likely than men to view larger families as ideal, for the first time since the 1940s less than a third of women were enamored of large families. By 1971 the decline in interest in large families reflected concern over the high cost of living, crowded conditions, overpopulation, and uncertainty of the future. In 1974 60 percent of women and 57 percent of men cited overpopulation as a reason for having small families.[33] By 1980,

only 17 percent of the population idealized larger families, and sex differences had disappeared.

The small-family ethos even penetrated to Roman Catholics, a decreasing number of whom viewed large families as more desirable than small ones. In 1968, 50 percent of Catholics and 37 percent of Protestants favored large families. By 1974 these differences had disappeared, with only 20 percent of Catholics and 18 percent of Protestants still valuing large families.

The birth expectations of wives in the primary childbearing years paralleled the attitudes toward ideal family size. Young wives eighteen to twenty-four years old exhibited a sharp increase in their expectation of having small families. In this group 37 percent expected two children in 1967, as compared to 56 percent in 1974 and 1980. The same trend characterized the birth intentions of married women between the ages of twenty-five and twenty-nine, in which group the number expecting only two children increased from 29 percent in 1967 to 53 percent in 1980.

Women also adjusted their family expectations over time. The wives who were eighteen to twenty-four years old in 1967 had reduced their birth expectations by 1974 when they were between the ages of twenty-five and thirty-one. In this group 45 percent expected a maximum of two children in 1967, and in 1974 the proportion intending to have small families rose to 66 percent. These women faced decisions concerning family formation at a time when the issue of population growth had first become salient.

The need for people to have any children at all was placed in question. A call went out for an end to Mother's Day: "OBITUARY: MOTHERHOOD. Died, as a symbol, a life role, a sacred institution, sometime in the early nineteen-seventies. Causes of death: concern over overpopulation; and the desire of many to live as free individuals, not nurturers of young."[34] In 1972 the National Organization for Nonparents was formed to destroy the pronatalist myth that nonparenthood led to a tragic and empty life. These attacks on the desirability and feasibility of children challenged the institution of motherhood itself, thereby removing a major source of women's status and self-worth.

In recent decades women have moved far down the road to a life in which motherhood plays only a limited role. Ironically, women who became mothers during the feminine mystique period spent less than a third of their adult years engaged in the intense responsibilities of early motherhood. The emergence of the small-family ethos challenged the morality of large families and devalued the importance of motherhood. As a result of these trends, motherhood came into question as women's primary vocation and measure of self-worth.

This challenge to women's traditional self-definition was a necessary precondition for the emergence of a feminist constituency in support of child-care centers, maternity leaves, and abortion. Only after women abandoned the assumption that they were biologically suited to motherhood and recognized that this role is socially defined could women look to new arrangements for child care.

four

Changing Patterns of Marriage

The idealized image of traditional family life assumes that men and women choose to be married and to remain with their partner until death. The marriage vows are irrevocable. The institution is permanent, allowing no exit. The permanence of the institution is central to the acceptance of traditional family arrangements as natural and unalterable. This assumption of stability is no longer realistic in the twentieth century, as shown by the trends in marriage, divorce, and remarriage.[1] This transformation in women's role as homemaker played a critical role in the emergence of support for the feminist movement. Women first had to learn that they could not depend on men for their economic support before they could listen to feminist demands for more egalitarian family arrangements and support feminist efforts to attain sex equality.

Marriage

The bridal gown, the boutonniere, and the exchange of vows are images laced with love and devotion. For most of history, however, marriage has been an economic arrangement. Love is a modern adaptation. The matchmaking, the marriage mergers, and the dowries may be gone, but the fundamental basis for marriage is still a division of labor, an exchange system.[2]

Ideally, men and women bring different things to a marriage. Women provide care by cooking, sewing, cleaning, and nurturing. They have learned skills that are supposed to create a healthy and happy home

for their spouse and children. Men have developed skills and knowledge that are supposed to allow them to make money and provide for their family.

The underlying assumption of this arrangement is that both partners bring equally valued and needed skills to the union. This equality may have been true prior to the industrial revolution, but since then, women's economic dependence on men has increased, while men have become less dependent on women for the production of goods and provision of care. Clothes, soap, and foodstuff that women used to make at home are now made in factories and bought in supermarkets or department stores. Women now need money to purchase the goods that they once were able to barter. Women needed to assume financial responsibility for themselves before they could reject the economic dependence embedded in traditional marriage and acknowledge their rights to equal partnership.

The proportion of women who remained single was highest among women born at the turn of the century, but even so, few women (8.8 percent) then did not marry. The number of women who never married dropped continuously to a low of 4 percent of marriageable-age women during the 1950s. Since then, a decline in the marriage rate indicates that the number of women remaining single for a long period will rise slightly. For example, life-long singleness is anticipated to increase to 6 percent of marriageable-age women in the 1960s and to 7 percent of such women in the 1970s.[3]

Most women still get married. What has fluctuated over the twentieth century is not the act of marriage but the timing of the marital decision, with all its implications for women's activities. Men and women born in the 1880s who prepared for marriage at the turn of the century were caught in a rapidly changing social and economic order. A major portion of the male labor force left the farms in search of employment in the cities, and young people could barely afford to establish a household, which forced them to postpone starting a family. In the period before marriage, most women worked at home. They produced goods and foodstuff in the home, supervised their siblings or elderly parents, and filled their hope chests. They helped take care of their family of origin, just as they hoped someday to care for their family of procreation. Few women, particularly middle-class women, ventured into the labor force during this period.

The economic prosperity of the 1910s and the 1920s meant that couples could afford to marry at an earlier age. The slow expansion of clerical positions provided many young women with suitable jobs, allowing them to deposit savings as well as blankets in their hope chests. Women thus got married progressively earlier in each of the first three decades of this century. This trend was dramatically reversed during the deep Depression years of 1930–1933, when ap-

proximately 800,000 couples who would have gotten married did not.[4] Severe economic conditions forced many couples to postpone marriage. These women, unlike their turn-of-the-century counterparts, had expected to be married by their twentieth birthday. Failing to find a husband to care for them, many women were forced to find work in order to support themselves and their families. This was the first group of marriageable-age women to confront the growing tensions between traditional expectations of what women should, would, and could do and the reality of the economic and social context in which they spent their adult lives. This group of women was the first to have a significant portion of their members who were partially self-supporting for a period of time prior to marriage. They learned that, contrary to traditional expectations, men could not always be counted on to support families and women could support themselves.

When economic conditions improved at the end of World War II, women once again began to marry at an early age. Over 85 percent of eligible women in the 1950s were married by the age of twenty-five. Half of these women married by the age of twenty, a much earlier age than any previous generation in the century. Unlike the women in previous decades, however, many of these women worked prior to and after their marriage.

As young, single women and their mothers continued to pour over the bridal magazines and novels that equated marriage with ultimate fulfillment, the marriage rate began a long-term decline in the mid-1950s. Approximately 30 percent of the women born between 1935 and 1939 were married by the age of eighteen, in contrast to 21 percent of women born between 1945 and 1949, and only 17 percent of women born between 1950 and 1955. The number of marriages did not keep pace with the growing number of people in the prime years for first marriage. In 1960 only 28 percent of women twenty to twenty-nine years old were still single, as compared to 32 percent in 1965 and 40 percent in 1975. This delay in marriage was due in part to the fact that between 1960 and 1970 college enrollment doubled among women in their twenties. Yet this delay was common to all young women, not only those going to college, and the greatest increase in delayed marriages was actually found among women who did not attend college.[5]

As the number of first marriages declined rapidly during the 1970s, the number of couples living together doubled. Approximately 1.3 million unmarried Americans shared living quarters with members of the opposite sex in 1975. Public opinion on the status of unmarried persons changed during this period. In 1957, most people (80 percent) had felt that a person who chose not to marry was sick, immoral, or neurotic. In 1976, less than a quarter of the population judged a person who chose not to marry as sick or morally flawed.[6]

Women who postponed marriage during recent decades were exposed to experiences rarely faced by past generations. The number of women and the duration of time in which they were self-supporting and lived independent of parents or husbands increased. Unlike her turn-of-the-century sister, who moved from her parent's house to her husband's and remained economically dependent on others, the modern woman who married at a more mature age was aware of her ability to cope as an individual, had socially valued skills and employment opportunities, and continued to be employed in order to contribute to the economic welfare of her family. This woman was more likely to demand equality than a woman who depended on men for financial support while assuming the responsibility for home and family.

Divorce

The changing experiences and consequently the changing demands that men and women bring to marriage have affected the stability of marital relationships. Traditionally, marriage was perceived as a lifelong commitment. The divorce rate during the course of the twentieth century suggests that marriage as an institution has become increasingly less stable.[7] Traditional images of womanhood were challenged when women were forced to assume male roles in order to survive economically. Forced to step out of traditional roles, divorced women learned that the homemaker was not valued and that male and female divisions of responsibilities were socially rather than biologically defined. As a consequence, they were now ready to support feminist demands for equality.

The rate of marital dissolution has actually been on the rise since the end of the Civil War. By 1900 nearly 56,000 couples ended their marriages in divorce. This figure, though a tribute to the stability of the American family of the past because it represents the minuscule divorce rate of four divorces per thousand married couples, was at the time a matter of great public concern.

By 1920, the number of divorces had more than tripled to 171,000, and public debate escalated on how to curb this epidemic, which seemed to threaten the future of society. In actuality, the divorce rate for this period was relatively low, or ten divorces per thousand married women 14 to 44 years old. This rate of instability was not a dramatic departure from traditional expectations of marriage as a permanent institution. Yet the increasing divorce rate and the public reaction underscored the fact that men and women might have to survive a marital separation and that an alternative to unhappy marriages was available. These trends foreshadowed the changing ex-

pectations and orientations of future generations that would lead women to support feminism.

Impervious to intensified public outrage, people continued to get divorced until the economic severities of the Depression forced a rapid drop in divorce proceedings. The number of divorces and annulments fell from over 201,000 in 1929 to a little over 160,000 in 1932. For some people the financial hardship of the time was a reminder that marriage was a valuable economic arrangement promoting the survival of the family. For other disenchanted and dissatisfied couples the Depression meant persevering in the relationship since they could not afford the high cost of divorce. This reprieve was temporary, for as the nation's economy improved, the divorce rate began to ascend. Many of the marriages that persisted through the Depression eventually ended in divorce. Of the women who married in the 1930s, 16 percent became unmarried, as compared to 14 percent of those who married during the 1920s.[8]

The incidence of marital disruption accelerated immediately following World War II. Many couples who had become reacquainted after a long absence or a short courtship decided to end their marriages and begin new lives. The incidence of divorce increased from an average of 14 divorces per thousand women from fourteen to forty-four years old between 1939 and 1941 to an average of 24 divorces between 1945 and 1947. Although rising divorce rates are not uncommon during postwar periods, the overwhelming numbers increasing from 269,000 to 526,000 divorces during this period symbolized a generation that openly disavowed the sanctity of the marriage contract.

As the nation recovered from the disruption wrought by the war, the divorce rate dropped in 1948 and then leveled off at a rate considerably higher than it had been in the period prior to the war, or an average of 16 divorces per thousand married women in 1953, as compared to 11 divorces in 1935. These were the family-oriented years of young marriages and large families. But they were also a time when many women were getting divorced, reaching about 388,000 divorces per year during the 1950s.

At the time it seemed that the divorce rate had reached a saturation point. Yet a social revolution was underway which was redefining the role of women in American society, and contrary to expectations, the divorce rate resumed its historical upward trend around 1960. The divorce rate doubled in the next fifteen years, climbing from 15 per thousand women in 1960 to 32 in 1975. The total number of divorced couples also increased by 10 percent each year between 1967 and 1975. The postwar peak of 24 divorces per thousand was finally surpassed in 1970, when the divorce rate hit 26.

The different generations also experienced increased marital instability during the course of this century. Only 6.5 percent of married women born between 1900 and 1904 had ended their first marriage when they were twenty-five to thirty-four years old. The disruption for this same age group increased to 13.1 percent for the Depression daughters born between 1930 and 1934, and it increased to 17.1 percent for the baby boom daughters born between 1945 and 1949.[9]

A greater percentage of women born between 1945 and 1949 were divorced in 1975 than the lifetime incidence of divorce for women born during the first two decades of this century (Table 4.1). Whereas 13 percent of the women born in 1900 to 1904 were divorced, 26 to 31 percent of the women born during the Depression are expected to be divorced, and 38 percent of those born between 1945 and 1949 are likely to have at least one marriage disrupted by divorce. Many of the women who married during the era of the feminine mystique have already been divorced. Of those who married in the 1950s, 21 percent have already been divorced once, and 11 percent have been divorced twice.

The increased incidence of divorce in the early 1960s marked a critical phase in the redefinition of women's lives, forcing them to question the permanence and viability of traditional marital arrange-

Table 4.1. Women with a first marriage ending in divorce, 1975.

Born	First marriage ended in divorce by 1975	First marriage may end in divorce[a]
1945–1949	17%	38%
1940–1944	20	34
1935–1939	21	31
1930–1934	21	26
1925–1929	21	24
1920–1924	18	20
1915–1919	16	17
1910–1914	16	16
1905–1909	15	15
1900–1904	13	13

Source: U.S. Bureau of the Census, *Current Population Reports,* Series p-20, 297 (Oct. 1976).

a. Predictions based on divorce experience of persons in older age groups between 1969 and 1974.

ments. At this time divorce was becoming increasingly common for all women, independent of their race, age, or class. A person's education, income, parental status, and age at first marriage had previously been highly associated with the probability of divorce.[10] People who were educated and well paid, married later, and had children had in the past been less likely to get divorced. The divorce rate in the 1960s, however, rose sharply right along with the aggregate increases in the level of education, income, and age at first marriage, all of which conditions were assumed to foster marital stability.

At the turn of the century, for example, there was a positive association between divorce and income. Divorces were most common among the rich who could afford them. This relationship changed, and divorces became more common among low-income groups as people moved to cities and worked in industry. The incidence of divorce after 1960, however, increased at all socioeconomic levels. Between 1960 and 1970, the proportion of divorced persons still remained highest for the relatively disadvantaged groups, but socioeconomic differences decreased.[11]

Conventional wisdom has it that children help keep a marriage intact. Until the Depression, there was a positive relationship between marital stability and parental status. The number of divorces involving children has since then increased. In 1948, 42 percent of the couples granted a divorce had children under eighteen years of age. By 1962, 60 percent of the divorces granted involved children under eighteen years old.[12]

Marital dissolution has also become more common throughout the life cycle. In 1965 a high proportion of divorces still occurred during the first five years of marriage, but nearly one fourth of all persons filing for divorce had been married for fifteen years or longer. The number of divorces granted to persons forty-five years or older almost doubled between 1964 and 1974, increasing from 164,000 to 315,000. The divorce rate for women thirty-five to forty-four years old increased steadily from 2.1 percent in 1940 to 3.2 percent in 1960 and 5.6 percent in 1970. The divorce rate also increased for women forty-five to fifty-four years old, from 2.2 percent in 1940 to 5.1 percent in 1970.[13]

This increased incidence of divorce has been attributed to the liberalization of divorce laws in the mid-1960s. Yet the divorce rate had been edging upward since 1890, and by mid-century had increased by 500 percent, despite increasing stringency in divorce legislation from 1890 to 1950. The escalated rate of divorce since the mid-1960s has also been attributed to the adoption of no-fault divorce. States with permissive divorce laws do indeed have a higher divorce rate than states with restrictive laws, but the divorce rate also climbed dramatically in states that did not reform their laws. The adoption

of no-fault provisions per se has not led to an increase in the divorce rate.[14]

The traditional expectation of a permanent marital arrangement has thus been under a great deal of challenge throughout this century, and the number of people ending a marriage has escalated. Public opinion about the sanctity of marriage and the acceptability of divorce has kept step with this development. In 1936 the public was still decidedly against divorce, with most people (77 percent) opposed to easing the divorce laws. By 1945 more people accepted divorce, but the majority (65 percent) were still opposed to less stringent laws. The large number of divorces during the postwar period presented a real challenge to traditional views. By 1954 over half (53 percent) of the public believed in divorce as a solution for an unhappy marriage. In 1966, when the incidence of divorce was increasing, a majority of Americans approved of divorce on grounds of adultery (58 percent), cruelty (57 percent), and nonsupport (54 percent). A portion of the population (25 percent) also felt that a two-year separation should be legitimate grounds for divorce.[15]

The constraints of traditional marital relationships were also increasingly acknowledged, even during the pronatalist, promarriage years of the 1950s. In 1951, 59 percent of married women felt that when a couple got married, the woman gave up more liberty than the man, whereas 34 percent of the men felt that marriage placed more constraints on women. In 1957, 49 percent of women and 38 percent of men admitted to having problems getting along with their spouses. By 1976, the percentage of people acknowledging marital problems increased to 62 percent for women and 58 percent for men.[16]

Other signs of the changing status of divorced persons include the formation of organizations specifically designed for their needs. Parents Without Partners, for example, was formed in 1957 to address the emotional and social needs of a large number of divorced people. This network has since grown and expanded, providing a milieu in which being a divorced person does not brand one as a failure.

Organizations aimed at dealing with the problems of divorced women in particular began to grow in the 1970s. Women in Transition, a Philadelphia-based crisis center founded in 1971 for divorced and separated women, worked with over 5,000 clients in a four-year period. Organizations were also developed in order to meet the special needs of divorced women living in suburbia. A member of one such organization, Women in New Scenes, recalled that when she was divorced in 1953, she used to say that her husband had died rather than tell people she was divorced. The stigma of being a divorcee has long since disappeared. Another divorced woman commented that, "There was a time when being a divorced woman in suburbia meant being a social shut-in faced with loneliness."[17] Such women

had to move to a city in order to survive. Now divorced women are staying in the suburbs, buying homes together, setting up businesses, and forging friendships among themselves. Such is the power of numbers.

Even in the Roman Catholic community, where proscriptions against divorce have been extremely strong, the divorce rate has increased since the 1960s. In 1975 there were over 6.5 million divorced Catholics, indicating a real penetration of prodivorce orientations. By 1967, 50 percent of Roman Catholics were opposed to church laws against divorce and 65 percent were in favor of allowing remarriage. Monsignor Kellegher, presiding judge of the marriage court in the New York Archdiocese, in 1968 publicly criticized church procedures on marriage cases. The 215 members of the National Conference of Catholic Bishops who met in 1969 overwhelmingly approved twenty-six reforms of existing marriage court procedures in order to ease the granting of annulments. In 1971 only 40 percent of Roman Catholic priests approved of the official church position on divorce.[18] Most of this activity predated the women's liberation movement. The acknowledgment that traditional marriages no longer met people's needs and expectations actually fueled the support for a movement that fought against perpetuating women's economic vulnerability and dependence on men.

The divorce figures from 1975 suggest that approximately 40 percent of all current and future marriages among young women now in their late twenties will end in divorce.[19] This high divorce rate, however, does not mean that women have abandoned or rejected the institution of marriage. The increased incidence of marital dissolution represents a challenge only to the traditional vision of marriage as a permanent arrangement.

Remarriage

The remarriage rate through the twentieth century closely parallels the divorce rate. The incidence of remarriage was low in 1920, numbering 98 remarriages per thousand widowed and divorced women fourteen to fifty-four years. It rose to a peak of 163 remarriages immediately following World War II, leveled off at 131 remarriages during the 1950s, and rose sharply through the 1960s and 1970s. The peak rate of remarriage right after World War II was surpassed in the late 1960s when the rate reached 168 remarriages. Remarriages of divorced persons accounted for nearly 14 percent of all marriages conducted in 1960. In 1975, 25 percent of all marriages involved a divorced person.[20]

A high proportion of divorced people remarry. While few of the women born between 1900 and 1904 divorced, 78 percent of the

divorced women from this generation had remarried by 1975. Almost 75 percent of the divorced women who were born in the 1920s and married during the 1940s were remarried by 1975. Of the divorcees from 1950s marriages, 75 percent had also remarried. Of the women born between 1940 and 1944, 20 percent were divorced as of 1975, and 64 percent of these divorced women were already remarried. It is estimated that 80 percent of currently divorced women will remarry.[21] The majority of these remarriages will take place within five years of the date of divorce.

The proportion of women who remarried after their first marriages ended in divorce or widowhood climbed over the past four decades. In 1910 only 50 percent of divorced and widowed women aged twenty-five to thirty-four were remarried. In this same age group 60 percent of divorced and widowed women were remarried in 1940. Over 90 percent of divorced and separated women who were twenty-five to thirty-four years of age in 1970 were remarried. The proportion of women who remarried at an early age also increased over the last three decades. The percentage of women who remarried by their early thirties increased from 3.8 percent in 1940 to 11.1 percent in 1970.[22] The high rate of remarriage suggests that divorce decisions do not require a choice between an unhappy marriage and life-long singleness. The increased availability of alternative partners, as indicated by the increased rate of remarriage at all ages, allows for a greater fluidity in marital commitments.

In short, the major change in traditional patterns of marital behavior over the century involves the permanency of marital arrangements. An increasing number of women have become wives more than once in their lifetimes, as shown by the number of divorces per hundred marriages each year (Figure 4.1). Because traditional marital arrangements did not countenance divorce, there was a low rate of marital instability at the turn of the century. There were 8 divorces for every hundred marriages performed in 1900. In contrast, marital instability reached a rate of approximately 25 divorces during the pro-marriage years of the 1950s. Disrupted marital arrangements took a sharp rise in the mid-1960s, increasing from 27 to 33 divorces by 1970. In 1975, another quick jump occurred to 48 divorces. Marital instability hovered around 50 divorces for every hundred couples getting married through the rest of the 1970s and early 1980s.

The postponement of marriage and the increase in divorce has resulted in a population in which one out of every three adults is single, widowed, or divorced. The net effect of these demographic trends is a growing number of female-headed households. The proportion of women who are self-supporting increased from 13 percent in 1955 to 17 percent in 1960 and 20 percent in 1970. The percentage of female-headed families increased by 32 percent between 1960 and

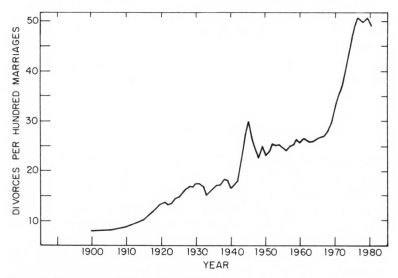

Fig. 4.1 Marital instability, 1900–1980

1971. Over 11 million children, or 15 percent of all children under eighteen years of age, lived in single-parent homes in 1970.[23] Since 1960, the number of such families has grown seven times as fast as the number of two-parent families.

These changing life conditions forced women to confront problems that few women had to address in the past. Single women found that their rights in financial transactions were limited by their sex and marital status. Getting credit cards often proved difficult if not impossible for unmarried women. Banks refused to finance homes and other major purchases. Landlords often refused to rent to single women, claiming that they posed a high financial risk. Public housing authorities were equally opposed to placing single female applicants.

The high divorce rate has shown the problems inherent in assuming that women were made to be mothers and homemakers while men bore the financial responsibilities to support them. The end of marriage often means the end to a woman's occupation as homemaker as well. This occupation, though acknowledged as invaluable to the welfare and economic stability of the national economy, accrues no health, retirement, or unemployment benefits. Displaced homemakers find it difficult to get employment because of their lack of vocational skills, their lack of experience and their age. Divorced mothers must also shoulder the burdens of child care, since few men continue to assume traditional financial responsibilities for children after a divorce. In 1975, for example, only 44 out of every hundred divorced mothers were awarded child support and fewer than 21 collected regularly.

Feminist organizations formed in response to these needs. They have demanded equal credit opportunity, economic compensations for displaced homemakers, greater protection for children of divorced couples, and day-care centers. They have also addressed the question of socialization practices by monitoring the content of school books, television, and the print media in an attempt to secure women options in the future and to alert them to the changing demands placed on women in a postindustrial society.

In voicing these demands and concerns, the women's movement is asserting that society must address women's needs and achievements as individuals rather than in terms of their obligations to men. The high rate of marital instability and the prolonged periods of singleness taught women that they cannot always count on men to care for them and their children. It forced women to cross into the male sphere of breadwinner and to confront the traditional assumptions about what is natural for women. As more women learned that they need to and can support themselves, they became open to demands for equal treatment. This change in women's self-definition, which came about in response to the failure of traditional marriages, contributed to the growth of the feminist movement.

five

The Rise of Feminist Consciousness

The emergence of a mass movement depends on the development of group consciousness. People need to reject old group images for new roles and to understand that the roots of their problems cannot be solved by their individual efforts before they will look to political remedies. This consciousness is learned. It usually arises out of changed social conditions and economic circumstances, which alter people's understanding of themselves and their lives.

Support for the women's movement derived historically from the social conditions that redefined the contours of women's lives. Changes in their traditional roles as wife, mother, and homemaker transformed the way women came to view themselves and encouraged women to reexamine their old assumptions of what they did and needed. Once women gained a new consciousness of themselves as a group, they formed a constituency for a social movement in demand of women's rights.

The key to the emergence of a feminist consciousness and the formation of a feminist constituency lies in the interplay among the three dimensions of women's roles that had changed since the turn of the century: labor force participation, fertility, and marriage. The separate trends in each of these areas tell only part of the story behind women's political activism. The interaction among them is what led to the growth of a feminist consciousness which in turn promoted the emergence of the women's movement (Figure 5.1).

The changes in women's roles led to two social movements for

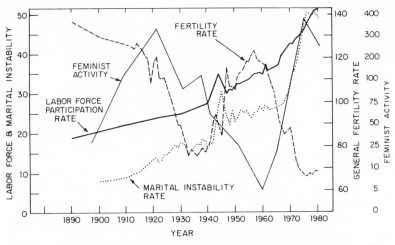

Fig. 5.1 Transformation of women's role and the rise of feminism, 1890–1980

women's rights, the suffrage movement and the feminist movement. Since consciousness is critical to the development of a mass movement, changes in women's understanding of themselves played an important role in shaping both of these periods of intense political involvement. The emergence of the two movements was similar in pattern. Each movement followed an extensive period of elite activity. A mass constituency emerged when women developed a new consciousness of their roles and problems in response to substantial changes in the social and economic contours of their lives.

The suffrage and the feminist movements differed, however, in substance and in scope. At the turn of the century women's new role consciousness was based on social conditions that had changed the context of women's lives. Women were forced to adopt behaviors that modified rather than rejected past roles. The solution that they sought for their problems, though radical, was limited to the vote. For most women, suffrage was a single-issue movement designed to reinforce, but at the same time to expand, their traditional sphere. In contrast, the feminist movement is based on a rejection of traditional roles in favor of equality, and it demands a broad-based agenda of changes in the fundamental arrangement of home and work.

The contemporary feminist movement and the suffrage movement both share the legacy of the first feminists who met at Seneca Falls in 1848. These women protested women's inferior economic, political, and social status and demanded sex equality. They saw the vote merely as one means of assuring women independence and equal

opportunity. Yet neither of their goals, equality or suffrage, found public support during the nineteenth century. So long as women's lives were centered around child care and home production they were unwilling to demand an extension of their rights.

The Suffrage Movement

The context of women's lives changed dramatically in the fifty years after Seneca Falls. When the demand for the vote had first been voiced, most of the country was rural and women provided the basic goods and services necessary for their family's survival. They spun, wove, and sewed clothing, churned butter, and canned and preserved food. A generation later all of these functions were taken out of individual women's homes and performed by others. By 1900, their traditional responsibilities were mostly transferred from the home to the workplace. Many families lived in cities. Women bought food and clothing often produced under unsanitary conditions and their children attended public schools administered by men who were independent of their purview. Nevertheless, women's lives were still dominated by home and child care.

Women's ability to carry out their traditional responsibilities also changed during the last half of the nineteenth century as government involvement in providing social services expanded. In 1850, the main task of government had been to conduct foreign affairs and to promote a national industrial economy. By 1900 the government was more active in providing for the public welfare and legislating in areas that were traditionally in women's domain, including the production of food and clothing, health, sanitation, and education. The modifications in women's roles that resulted from the growth of an urban industrial economy and the expansion of government's role in providing for the public welfare allowed for the growth of a women's consciousness based on "social housekeeping." According to this expanded vision of women, they thought of themselves as the housekeepers not merely of the home but also of society. The nation was seen as a macrocosm of the home that needed women's special abilities to cope with human problems. This new consciousness fostered a constituency for the suffrage movement.

When women had lived in rural areas where they did not have to worry about such issues as garbage disposal, congested housing, adulterated food, and contaminated water, they believed that they neither needed the vote nor had any special knowledge to aid government. This was no longer the case, however, when women lived in cities and their traditional tasks were carried out in factories or by public services. As government increasingly took responsibility for tasks

previously performed by individual women, women were forced to look to politicians to address problems that they had previously solved themselves.

The suffrage movement had initially been championed by only a small group of elite women who tenaciously maintained their right to political equality. Their organized effort to grant women the vote was remarkably unsuccessful, beginning in 1867 with a state referendum in Kansas that failed, and by the turn of the century the movement had almost disappeared. Then suddenly in 1907 suffrage was revived and a mass movement was organized, which finally secured ratification of the Nineteenth Amendment in 1920. The vote, which was not an acceptable demand in 1867, was suddenly an acceptable, indeed desired, demand in 1907.

The reason for this change was the evolution of the ideology of social housekeeping. The vote became acceptable when the suffragists stopped demanding suffrage on the basis of basic rights and equality and articulated the need for suffrage in terms of women's duty to contribute their special skills and experiences to government as part of a notion of social housekeeping.[1] Most suffragists argued for the vote on the basis of this expansion of women's traditional responsibilities. Elizabeth Cady Stanton and Jane Addams, two leaders who spanned the beginning and the end of the movement, illustrated this change in justifications for the vote.

In 1892 Stanton informed Congress that before woman was a citizen, woman, or wife, she was a human being possessing a unique soul that demanded freedom of thought and action. Women had two kinds of rights. First, she had "what belongs to her as an individual in a world of her own. Her rights under such circumstances are to use her facilities for her own safety and happiness." Second, "if we consider her as a citizen, as a member of a great nation, she must have the same rights as all other members, according to the fundamental principles of our government."[2] To Stanton, a woman was first and foremost an individual with rights and responsibilities equal to those of men. Most other women in Stanton's time, however, viewed men and women as inherently different and thought them ordained by religion and biology to occupy different spheres of responsibility. Thus, women at large not only failed to support equality but were hostile to it.

While women at the turn of the century were not concerned about equality, they were concerned about food inspection, sweatshop sanitation, street cleaning, and public schools. Many were active in efforts to reform society and address these problems. As it became clear that initiatives and referenda for laws to prohibit child labor, excessive working hours for women, exploitive working conditions,

impure food, liquor traffic, and white slavery could be promoted only by those with the right to vote, these women turned to suffrage. For them it was a means not to secure equality but rather to reform society and help women to perform their traditional duties. In 1909, for example, Addams warned that women could no longer ignore the world of public affairs if they were to remain good mothers: "Women who live in the country sweep their own dooryards and may either feed the refuse of the table to a flock of chickens or allow it innocently to decay in the open air and sunshine. In a crowded city quarter, however, if the street is not cleaned by the city authorities no amount of private sweeping will keep the tenement free from grime; if the garbage is not properly collected and destroyed a tenement house mother may see her child sicken and die of disease from which she alone is powerless to shield them. In short, if woman would keep on with her old business of caring for her house and rearing her children she will have to have some conscience to public affairs lying quite outside her immediate household. The individual conscience and devotion are no longer effective."[3]

This demand for political rights on the basis of separate spheres had all the elements of an emerging consciousness. It was based on new roles that grew out of an urban, industrial economy, and it recognized that individual women could no longer solve many of their families' problems by themselves. The displacement of traditional activities outside the home required that women shape legislation addressing their families' needs.

The suffrage movement bloomed once the vote was promoted as a form of social housekeeping. Membership in NAWSA grew from 13,150 in 1893 to 17,000 in 1905 and more than doubled to 45,501 by 1907. In 1910 when suffrage won its first victory in fourteen years, NAWSA had 75,000 members, and the organization grew to an estimated 2 million members by the height of the ratification drive. The level of women's rights activism paralleled this growth in organizational support, with the number of prosuffrage events increasing from 18 in 1907 to 64 in 1908 and then surging to 110 in 1910 and 173 in 1915.

Once the vote had been won, some suffrage groups tried to use the vote as a means to achieve equality through passage of the ERA. Other groups, however, like the League of Women Voters, rejected equality and tried to use the vote to maintain women's special need for protection, on the principle that there were inherent differences between the sexes. The groups that abandoned women's rights as their main focus wanted to continue with the reform efforts that had already brought them the suffrage and expanded their traditional sphere. Without a public constituency willing to demand sex equality,

the feminist groups lost out to the social reformers who accepted women's roles as social housekeepers. It took another fifty years for a feminist movement demanding sex equality to emerge.

The Women's Movement

The formation of a feminist constituency required a radical change in people's understanding of women's experiences. It demanded a rejection of biological explanations for women's roles and an acceptance of the inherent equality between men and women. It also required a recognition that women faced discrimination that prevented them from becoming economically and emotionally independent. But this feminist consciousness, based on a belief in equal roles and an acknowledgment of discrimination, could not be acquired until the objective circumstances of women's lives had been transformed. And the transition to new social roles and expectations was a disruptive, confusing, and arduous process. As traditional marital, fertility, and labor force experiences changed, people nevertheless tried to fit their new experiences into the existing frame of reference, so that their world could continue to make sense.

The transition to a feminist consciousness began in the Depression, when women were forced to cope with unintended singleness, childlessness, and employment. Young women who had every expectation that they would soon marry or start their families were disappointed as marital plans and children had to be postponed. Many women crossed over to the masculine sphere by seeking work to support themselves and their families. Some women actually displaced men as the primary breadwinners. Suddenly women were forced to confront what it meant to be female outside the context of traditional roles.

The message that men and women were not, by nature, suited to different spheres was apparent from these objective circumstances, but people were not receptive to this lesson. The unraveling of traditional patterns is complicated by people's understanding of their experiences as much as by the objective circumstances of their lives. Men and women generally opposed the radical changes in gender arrangements taking place at the time. Most people thought that married women should not be allowed to work and favored laws delimiting their job opportunities. Although women were actually supporting their families, men were still acknowledged as the rightful breadwinners. Traditionalism was reinforced by the substantial number of people who regarded large families as the ideal, despite the precipitous drop in family size during this period, and who also adamantly opposed the easing of divorce laws, despite the prevalence of desertion and separation of families.

People held on to the past by interpreting the present in a way that conformed to past expectations. For over a decade they saw that women could be and might need to be independent and that men could not always be counted on to provide for their families' economic needs, but they viewed these changes as temporary and unusual, brought on by depression and war. Mothers continued to raise their sons and daughters to assume their respective traditional masculine and feminine roles, even while they themselves served as role models of women as breadwinners and survivors. The children of the Depression were the first generation to grow up at a time when large numbers of married women were working and men were unable to fulfill their provider role. Yet an even longer period of repeated exposure to alternative situations was required before the new patterns could be recognized and internalized, allowing new expectations to form.

Challenges to traditional expectations mounted in World War II, when the nation once again turned to women citizens to help run the country while men were away fighting. In the Depression, the working mother had been a pariah; during the war she was welcomed as a patriot, successfully performing male roles in order to preserve freedom. However, she was only welcomed for a limited engagement and was expected to go back to the home at the end of the war.

The traditional ideal of womanhood, resting on home, marriage, and children, teetered in the postwar period, shaken by women's work, education, and marital experiences. The size and composition of the female labor force changed dramatically to include a majority of married women, a majority of women with school-aged children, and a third of all adult women in the population. While women married at young ages and began their families immediately in order to create the ideal home with its attendant images of love, warmth, and stability, these marriages did not in fact ensure permanence, as the number of divorces increased. Children did not guarantee permanence either, as the number of divorces involving children increased annually as well.

Despite these revolutionary changes, women failed to become politically active to end the discrimination that prevented them from becoming fully integrated citizens. The recognition of discrimination builds on a rejection of traditional images and rationales for the group's status quo. There was little support for feminism during the postwar period because women adhered tenaciously to their traditional idealized image of themselves as mothers, the core of female identity. The historic reversal of declining birth rates reinforced motherhood as the traditional basis for women's identity. For the first time in over twenty years, women's lives were once again shaped by extensive periods of child-care commitment. Women married at an earlier age, started their families immediately, and averaged more

children than any previous generation since 1900. The feminine mystique glorified motherhood and promoted the family as the basic fabric of society, which provided positive reinforcement for maintaining this hold on traditionalism.

The 1950s was a decade of increasing role strain and inconsistency. Contradictory experiences, based on conflicting values and inconsistent cues, produced more anxiety over women's proper role. Objectively, women spent a greater part of their lives in the work force, as they were encouraged to do by the economy's demand for labor, the family's need for additional income, and women's own desire to move beyond the confines of the home. Yet the cultural images still defined women's place as in the home and rewarded the homemaker, while branding the working mother for many social ills, including divorce and juvenile delinquency.

To some extent women resolved these contradictions by justifying their new work roles in traditional terms, as designed to ensure the survival of the family and the good of the children. Just as in the early phase of industrialization the male laborers who had ventured to the city to earn money for their families had expected to return home, in the postwar period the women who entered the labor force also expected the stint to be brief. Even though many of these women stayed on, they did not believe that outside work was their proper sphere. And as long as they did not regard themselves as a normal part of the permanent labor force, they did not compare their treatment to that of men's, who were presumed to be in their proper sphere.

Old images had to be discredited before a new definition of womanhood could be embraced. In the 1950s motherhood still lay at the core of women's self-esteem. Traditionally, mothering was the standard for self-definition and self-worth that was most deeply internalized and most resistant to change. So long as mothering was culturally reinforced, women could not relinquish this province and define themselves as workers, even though such a redefinition was needed if women were to recognize that they were mistreated or that the double burden of home and work was unfair. In other words, there could be no perception of inequity and thus no movement for equality so long as women believed that their primary role was motherhood and that men and women's roles were biologically determined.

People were aware of the detrimental aspects of women's conflicting and confining roles. While most people still favored large families and condemned those who remained single, they were sensitive to the difficulties of marriage and supported divorce as a reasonable solution to an unhappy marriage. Even the *Ladies Home Journal* recognized that marriage had not fulfilled all its promises, although women were still expected to take responsibility to make the rela-

tionship work. The majority of women, as compared to a minority of men, felt that marriage placed greater constraints on women's liberties.

Girls raised during the postwar period were exposed to large numbers of women who combined nontraditional with traditional roles. The environment in which these young women learned their appropriate sex roles no longer provided a monolithic vision of womanhood. In fact, many of the external values of society, such as money, status, and power, promoted nontraditional behavior. As a consequence, young women were less likely to internalize traditional definitions. As traditional standards for self-reinforcement became less central to women's personal identity, these standards became more vulnerable and open to challenge. The shift in emphasis toward nontraditional experiences was often encouraged by mothers who felt that their daughters should have more options than they themselves had been offered.[4]

The contradictions of the postwar period created the groundwork for the future acceptance of an alternative definition of womanhood. Working, divorced, or unhappily married women were more open to questioning the biological basis of role division than were previous generations. The resocializing effects of work and marital instability took a steady toll on older women's understanding of their lives and needs, while the younger women started out with much less attachment to traditional images. Although women were moved to question why they did not have the same opportunities as men, they failed actually to voice this question because they still accepted traditional motherhood as the focus of their self-definition.

By the end of the 1950s, many women were living a lie. Some were playing out the coveted suburban housewife role without finding happiness and fulfillment. Others were leaving their homes and children in order to work without abandoning their belief in the superiority of domesticity. These contradictions presented women with a problem, known variously as role strain or identity crisis. Women felt that their lives did not make sense. They clutched onto a hyperbolized image of motherhood to try to force the present into resembling what they had learned to expect in the past. But the meaning of womanhood had changed.

The shaky foundation for women's lives collapsed when fertility dropped precipitously in the 1960s. Mothering, the linchpin of femaleness throughout the century, became less central to women's lives. Motherhood took on a new perspective when older mothers found themselves suddenly free of primary child-care responsibilities and when younger women found school and work more attractive than early marriage and family responsibilities.

The saliency of the motherhood ideology diminished in the face

of public concern over the population explosion and the shift in public policy from opposing family planning to promoting and subsidizing birth control. The availability after 1960 of both highly effective, if not necessarily safe, oral contraceptives and expanding birth control clinics meant that women could take control of when and how often to assume the mother role. The decline in fertility was accompanied by other dramatic changes in women's lives. Mothers of young children under six years old entered the labor force in increasing numbers. Marital instability erupted.

The confluence of these nontraditional experiences marked the critical point in the process of role transformation for women, when the old norm was rejected and a new image of femaleness was adopted. The nontraditional behaviors were integrated into a coherent new lifestyle that was diametrically opposed to women's former lifestyle. At this point there was no turning back to woman's traditional social identity or to the way things used to be. From now on women's new roles were increasingly accepted and rewarded.

With the formation of an alternative norm, the majority of the public could at last begin to accept women's new roles. Public opinion on the employment of married women and the desirability of large families shifted to favoring less traditional arrangements. Support for the employment of married women increased dramatically from 25 percent in 1945 to 44 percent in 1967 and to 64 percent in 1972, while support for large families dropped from 45 percent in 1960 to 35 percent in 1966 and to 23 percent in 1971. Sex role attitudes shifted substantially toward nontraditional role definitions in the decade between 1964 and 1974. These dramatic shifts toward egalitarian positions suggest that society was providing the impetus for changes in sex role attitude well before the rise of the women's movement.[5]

The adoption of a new role for women at this time was illustrated by shifts in public support for a woman President. In 1936 when people had been asked if they would vote for a woman for President "if she was qualified *in every other respect?*" only 31 percent said that they would. When this question was rephrased in 1949 to omit "in every other respect," which in and of itself indicated a change, 48 percent said that they would vote for a woman. By the mid-1950s a majority of the public (52 percent) affirmed that they would vote for a qualified female candidate. This support increased to 57 percent in 1967 and to 66 percent in 1971.[6]

Once women had discarded the perception of their status as being biologically determined and separate from that of men, they came to evaluate their opportunities and self-worth on the basis of their new lives, which were premised on sex equality. For the first time in history large numbers of women were now willing to argue that they should have equal roles with men and that society denied them these op-

portunities. It was at this juncture, and not before, that a feminist movement demanding sex equality could find a mass constituency to support and further its claims.

Political consciousness requires that the acceptance of social equality be coupled with a recognition and rejection of unequal and unfair treatment. In 1946, most women (72 percent) had believed that there were sometimes good reasons to pay women less than men for the same job. Only 29 percent of people felt that women should have an equal chance with men for any job regardless of whether they were self-supporting, while 49 percent believed in equal opportunities only for women who had to support themselves, and 17 percent felt that men should always have preference over women.[7]

By 1968, support for equal treatment had grown, since 66 percent of women now favored giving women the same job opportunities as men. But when probed as to whether women had equal opportunities for advancement in business, only 33 percent acknowledged the fact of unfair treatment. In 1970, just a month before the Women's Strike for Equality, 54 percent of women did not think that women with the same abilities as men stood an equal chance of becoming a corporate executive. A substantial number of women also felt that they faced discrimination in obtaining executive positions in business (50 percent), obtaining top jobs in the professions (40 percent), and getting skilled employment (40 percent).[8]

Increased recognition of sex discrimination was also shown by the number of complaints found valid by the federal government. The legal battle for ending wage discrimination began in 1963 with passage of the Equal Pay Act. The number of underpaid women employees awarded compensation under that act increased from 960 in 1965 to 6,633 in 1966 and then more than doubled to 16,100 in 1969 and to 17,719 in 1970. The number of complaints filed under Title VII of the 1964 Civil Rights Act, which also protects women against economic discrimination, followed a similar trend toward increased recognition that women faced discrimination in the workplace.[9]

People were well on their way to supporting gender equality, the essential element for the emergence of the women's movement. By the end of the 1960s the majority of women were in favor of nontraditional roles based on social equality, and an increasing number felt that women faced discrimination. By 1970 a substantial minority (42 percent) were already in favor of changing and strengthening women's status.[10] Only after public opinion had shifted toward the belief that women should have, but did not have, equal opportunity could large numbers of women become active and form the women's movement. The movement, which had started tentatively with 14 events in 1966 and built to 26 events in 1968, suddenly came to life with 165 events in 1970.

The women drawn to feminist activism had many nontraditional role characteristics. These activists were young, educated, employed, and lacking in strong religious attachment. The majority were married, often to professional men, but a substantial minority were divorced or separated, and a sizable number were never married. Career oriented, these feminists valued achievement, self-advancement, and independence, and they saw sex discrimination as barring their opportunities to achieve these aims.[11]

The number of women leading nontraditional lives increased markedly in this first decade of the feminist movement. By 1980 the majority of women were working, marital disruption was high, the birth rate was near an all-time low, and more women were entering college than men. At this stage the working mother who played a critical role in supporting her family was clearly the norm.

Attitudes toward women's roles continued to move in an egalitarian direction. By 1980 many people (60 percent) believed that society, not nature, taught women to prefer homemaking to work outside the home. The traditional assertion that women's place was in the home, which was already a minority position (31 percent) in 1972, had even less support (25 percent) by 1980. By then, most people accepted married working women (72 percent), divorce as a solution to a bad marriage (61 percent), and a woman for President (78 percent), while few wanted large families (17 percent).[12]

The resistance to changing traditional family arrangements weakened considerably over this period. By 1980 a majority (51 percent) preferred a marriage where husband and wife shared home responsibilities over the traditional division of labor into separate spheres. Most men and women agreed that they should have equal responsibilities for grocery shopping (76 percent), laundry (60 percent), and cleaning the house (73 percent), although few men frequently did the shopping (45 percent), dishes (32 percent), house cleaning (29 percent), laundry (23 percent), or even their own bed-making (27 percent). Men and women increasingly defined child care as a shared role. In 1970, a third of the public felt that men and women should share responsibility for the care of small children. By 1980 over half (56 percent) favored role sharing, although only 38 percent of married couples said husbands actively helped care for children.[13]

The shift toward nontraditional experiences and egalitarian values also made women more aware of discrimination. By 1980 the majority of women felt that they did not have an equal chance with men in becoming business executives (57 percent), getting a top job in government (55 percent), entering prestige professions (52 percent), or obtaining loans and mortgages (51 percent). More women felt that they were excluded from leadership responsibilities in 1980 (45 percent) than in 1970 (31 percent), and the sense that women had less

access to skilled jobs grew from 40 percent in 1970 to 48 percent in 1980.[14]

The growth in feminist consciousness was a consequence of the educational efforts of the women's movement as well as of the continued integration of women into a nontraditional lifestyle. Feminist leaders incorporated their sentiments into a coherent ideology, which defined sex discrimination as women's problem, held the government responsible for ending this unfair treatment, and offered a plan of action to ease women's burdens. The movement had a great impact on sustaining public support for feminism. In 1980 most people (64 percent) supported efforts aimed at strengthening women's status. Members of the public were by then considerably more certain that the efforts of women's organizations were helpful (53 percent) than they had been at the beginning of the decade (34 percent), while support specifically for women's liberation increased from 49 percent in 1972 to 60 percent in 1979.[15]

The response to women's changing roles nevertheless remained contradictory. In the 1950s, the discrepancy had been rooted in an adherence to traditional values in the face of increasingly nontraditional experiences. In the 1970s the contradiction had a different twist, with the public subscribing to role equality and the egalitarian, symmetric family while continuing to practice traditional arrangements, in which women bore the primary responsibility for raising the children and maintaining the home in addition to sharing in the financial support of their family.

In sum, the transformation of women's roles and of women's understanding of their roles throughout the century culminated in a feminist consciousness. The content of women's experiences changed radically, resulting in the creation of a new lifestyle centered around work rather than the home. Not until the emergence of this alternative norm, based on the integration of nontraditional experiences, were people willing to think about women's rights as workers and as individuals outside their family responsibilities. Once traditional rationales based on the biological roots of women's roles no longer made sense, women increasingly believed in equality and recognized impediments to achieving equal status. This feminist consciousness provided the constituency needed for the long struggle toward sex equality.

Sex and Feminism

Common sense argues that expressions of political discontent are motivated by self-interest. People who are having a hard time look for ways to get other people, or the government, to help them solve these problems. This, however, is not the case. Having a hard life or even being a member of an exploited group does not in itself lead to political unrest.

When the women's movement emerged in 1970, many people ridiculed its efforts and dismissed feminist activists as man-hating, unfulfilled, and selfish. Despite this negative image, public support in defense of women's rights exploded during the decade. Polls monitoring the public pulse registered a rising commitment to feminism, with growing numbers of people, both men and women, favoring sex equality, objecting to sex discrimination, and looking to feminist organizations to address women's problems and the government to solve them. The public was increasingly tolerant of sex equality and supportive of efforts to end discrimination and strengthen women's status.

The experiences that reshaped women's lives were evaluated by both men and women. While most of the activists in the feminist movement were women, many of the bystanders whose support was critical to the success of the movement were men. These men acknowledged that women faced many problems due to inequitable social arrangements rather than to individual shortcomings or unalterable biological determinants. They promoted the ERA, day care, and equal economic opportunity as ways to address these inequities.

Yet their support could hardly have been based on either self-interest or group consciousness.

Self-interest and group consciousness are only two of three possible motives for the advocacy of social change. Ideology is the other possible reason to support social movements and their agendas. These three concepts assume three different routes to political activism (Figure 6.1). Self-interest rests on John Stuart Mill's assumption that people are rational actors seeking to maximize their own benefits. Group consciousness reflects both Marx and Weber's emphasis on group solidarity as a belief that shapes action. And political ideology rests on Emile Durkheim's notion of a universal moral order that leads people to protect rights rather than their own individual interests or the concerns of their group.[1]

The utilitarian notion of rationality presumes that people look out primarily for their personal self-interest. Interests are rooted in experience and translated directly into action without any need to legitimize demands in terms of either shared problems of the group, as in the case of consciousness, or shared political values of the society, as in the case of ideology.[2] People driven by self-interest decide whether or not to support a movement by calculating how

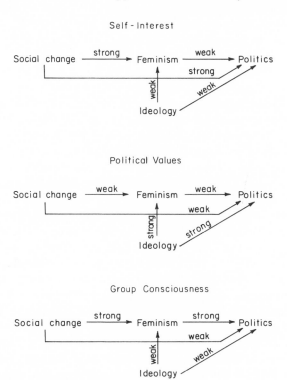

Fig. 6.1 Motives for political action

much this support will cost as compared with what it is likely to gain. From this perspective, women in nontraditional roles who are denied the benefits of traditional financial support and protection but pay the economic costs associated with discrimination have a concrete material incentive to support feminism. Self-interest is measured by the degree to which a woman leads a nontraditional life. Nontraditional experiences lead directly to feminist politics without any need for the mediating effects of either consciousness or ideology.

Tensions between the rights and obligations of individuals and the responsibilities of government lie at the heart of the ideological debates that shape American politics. The ideological route to political action assumes that people respond to political claims in terms of their long-standing predispositions about how the world should work. Political action comes from the struggle between a "right" way of life and an unacceptable alternative. Group demands for rights are evaluated in terms of images of justice. The concepts of rights and values that people acquire as they grow up serve as filters through which political messages are screened, determining whether people will support or oppose the appeals of new groups who are trying to enlist their aid in setting the political agenda. Political support is rooted in abstract judgments independent of any need to see the problem as relevant to the group or as rooted in personal experience.[3] In the case of feminism, supporters are people who believe that social equality is desirable and possible and who hold the government responsible for ensuring that people are provided with equal opportunities. This predisposition is measured by their adherence to liberal ideology. The ideological basis for political activism allows men to be feminists, because their evaluations of women's claims can be rooted in liberal ideology independent of their own personal experiences or exposure to discrimination.

Finally, people look to political solutions for private problems when they realize that their personal difficulties are shared by other similar people, the group. When the focus for one's problems shifts from personal failure to social injustice, people are willing to challenge the status quo. Women were forced through personal experience to acknowledge discrimination and to recognize that the traditional ways were no longer viable. Because feminist consciousness is rooted in women's experiences, it galvanizes action for sex equality on the basis of personal exposure to discrimination rather than out of a general ideological concern for equality. Thus, for women, feminist activism is a matter of group survival which is then justified in terms of political values such as equality, justice, and liberty.[4]

All three motives prompted support for the feminist movement in the early 1970s, but in different degrees. Men and women took different paths to feminism. Women embraced feminism as they de-

veloped a group consciousness while men supported feminism because of the ideological concerns and values expressed by the movement.

The protest movements of the 1960s had lacked the zero-sum perspective of, say, Marxist class conflict. People outside the group did not constitute a class enemy. Men, whites, the rich, or owners were not the evil parties who needed to be eliminated, although they did receive criticism. In spite of separatist sentiments such as those expressed by the Society to Cut Up Men (SCUM) or the Black Muslims, the actions of feminist and civil rights groups were aimed for the most part at eliminating status and power distinctions rather than people. This was accomplished by bringing pressure on institutions to change their discriminatory practices. Affirmative action programs, secondary boycotts, community control, constitutional amendments, and government subsidies were ways of channeling group opposition into efforts to change the rules by which resources were distributed and to gain control over the implementation of these rules.

People outside a group can in fact be sympathetic to its goals and grievances. Such nonmember sympathizers expand the group's resource base, legitimize the moral critique raised by the contesting group, and enlarge the audience to whom decisionmakers need to attend. Men were a part of the movement for women's rights, just as white people have been active in the black civil rights movement and intellectuals have participated in the workers' movement. People outside the group supported the goals of these movements because the group's criticisms and appeals were expressed in terms of the values of the larger society.

The public support for feminism, by both men and women, was determined in a national study of the electorate conducted in 1972 to assess the public's views on women's rights and its support for feminist politics. The study included 2,705 individuals, both male and female, eighteen years and older. It covered their attitudes toward women's roles, their perceptions of sex discrimination, and their evaluations of political strategies, candidates, and parties, as well as the demographic characteristics associated with these positions.[5]

Stages of Feminism

There are three stages of commitment to feminism. The first is an acknowledgment that women constitute a group and an affiliation with women, illustrating a concern for their welfare. For women, feminism begins with a growing recognition of shared problems. Group membership is often based on ascribed characteristics. Individuals may form a social group but fail to acknowledge or define themselves in terms of group membership. Minority group status differs from minority group membership; in other words, social category differs

from social group. Status is an objective fact, whereas membership is usually subjective, involving an identification with and a commitment to other people in the group.[6]

A social movement cannot emerge until the aggrieved individuals bond together as a group. Over the centuries, most women failed to view themselves as a group. Their primary affiliations were familial, ethnic, or religious but not sexual.[7] Only when women recognized that they faced common problems just because they were women could there be a strong feminist movement. Similarly, mass advocacy for the needs of the elderly has been hampered because old people refused to identify as elderly. Members of the working class have often failed to recognize the class divisions or else have chosen to identify with the middle class. Minority status can also foster competition among group members, encouraging them to see their problems in personal terms and to seek solutions as individuals even though their problems have social roots, such as discrimination.

The first stage of feminism, a feeling of belonging to one's group, was in place by 1972. Women exhibited at least a rudimentary level of consciousness. Almost half (46 percent) expressed some feelings of community with other women. Yet only a few (9 percent) indicated that women were their closest or primary group. Closer groups were middle-class people (21 percent), young people (15 percent), and older people (14 percent). Women's attachment, moreover, was to an undifferentiated group of women, not to feminists, who were trying to redefine the meaning of women as a group in nontraditional terms. Support for the women's movement grows out of having nontraditional experiences, but traditional women felt as strong an attachment to other women as did nontraditional women. Almost half of both housewives and employed women felt some commitment to women as a group. Furthermore, women who were members of traditional organizations were just as likely as women who did not belong to such organizations to express a closeness to women.

Men's feminism is not rooted in group membership, but for men to be feminists, they also need to acknowledge that women constitute a social group for which they feel some affiliation and concern. Men by and large did not have a sense of affiliation with women. However, a small but significant number of men (19 percent) felt some closeness to women. Men may not feel close to women as a group, but they do feel close to women in their families. They depend on women's love, support, and income. In these instances, men's personal welfare is indirectly linked to what happens to women. This interdependency based on family bonds may prompt men to be attentive to women's concerns and sympathetic to feminist arguments even if they do not feel close to women as a group.

To lead to political action, the psychological attachment to the

group must be coupled with a new group definition which rejects traditional rationales for the group's status in society. Every society has a set of ideas about what people are supposed to believe and how they should act. These expectations are communicated through social roles. The content of this proper, natural behavior, depends on attributes of the person, such as class, age, occupation, or sex. Traditionally, girls were brought up to be dependent, emotional, and passive; boys were expected to be independent, unemotional, and aggressive. Women were taught that their natural instincts lead them to take care of children, and in turn men learned that they must take care of women and children. Women's roles were not associated with values such as success, influence, control, or adulthood, because men monopolized these roles. Men and women, in short, lived different lives because of the roles they assumed.[8]

Traditional roles act as a means of social control. The roles of minority groups, by constraining their expectations for power and privilege or for access to self-determination, maintain the advantageous position of dominant groups. Women and men, for example, who believe that women belong at home will not question why women are not represented in business, government, academics, or the arts.

Political activism demands that people reject the limitations in traditional role prescriptions. In order to get minority group members to act and people outside the group to support their efforts, it is necessary to refute the traditional characteristics associated with women, blacks, poor people, or the elderly and to provide new images that stress positive attributes. Pride and purpose are essential to affirmation of a new sense of group. Whether the slogan is "Black Is Beautiful," "Women Are Wonderful," or "Gay and Proud," the construction of a new identity means replacing negative images with positive ones. One way of doing so is to resurrect historical and cultural contributions.

Refuting the justifications behind traditional role prescriptions is another vital part of creating an alternative definition of a minority group. The sexual division of labor is justified in terms of biological determinism. It is "natural" for women to be mothers. Their "natural" place is in the home. Their "nature" is inherently passive, nurturing, and dependent. Challenging this notion of biology as destiny, feminists underscore that society, not biology, defines what it means to be female. Once freed from the restraining concept of a "natural" order, women can envision a future outside the private sphere of the home.

The traditional view that becoming wives, homemakers, and mothers is women's natural destiny was by 1972 no longer a matter of consensus. Close to a majority of the women (41 percent) felt that they should have an equal role with men in the public sphere, as

compared to only a quarter who argued that women's place is definitely in the home. Women were almost evenly divided on the issue of biological determinism, with a sizable number (43 percent) believing that society defines women's roles. When faced with the possibility of employment layoffs, half the women demanded equal treatment.

This acknowledgment of a new female identity and reaction against old rationales was not limited to women. Men were in fact slightly more willing (44 percent) to believe that women's roles were socially defined, that women should have an equal role in running business and industry rather than being confined to the home (44 percent), and that equal treatment was required when layoffs were necessary (58 percent). When these views of what it means to be female were scaled from 1 to 10, with a traditional view receiving a score of 1 and a feminist view given a score of 10, men and women expressed slightly more feminist than traditional role orientations: 6.1 for men, 5.8 for women. Men, in short, were slightly more accepting of a nontraditional view of women's roles than women were for themselves.

Because of the increased numbers of women in the labor force as of 1972, as well as the increasing marital instability and the decreasing commitment to child care, many women fell into the categories of being unmarried, working, and taking care of children. This development threw into confusion the once-defined women's role. Most people were ambivalent as to how to evaluate women's relationship to the private world of marriage, children, and homemaking and the public world of business, industry, and government, although they leaned toward the nontraditional option.

To lead to political action, the new group definition must go beyond a sense of belonging and of shared interests to encompass the third stage, the idea of challenge. The objects challenged are social institutions, the old ways. However, the acceptance of the new identity does not automatically translate into political protest. An alternative group image merely provides a framework for new social comparisons. It facilitates the questioning of past criteria for the distribution of resources.

People need to see themselves as objects of collective discrimination or as victims of inadequate social institutions before they can become politically active. The third stage toward politicization thus begins with the realization that personal survival or a decent standard of living is a question not simply of individual effort. This shift in criticism from the self to social institutions allows problems that were once thought to be personal to be seen to have a social cause and probably a political solution as well.[9]

As women began to express their feelings and experiences to one another, whether at a PTA meeting or in an encounter group, they

learned that what seemed to be idiosyncratic behavior was in fact a consequence of prescribed social roles. Women discovered that their failure to be the perfect wife, daughter, or lover—to be a good girl in effect—was shared by other women. Finding this similarity led them to uncover the political nature of their problems. As a woman in a consciousness raising group observed: "God, when I saw that what I always felt was my own personal hangup was as true for other women, well, that's when my consciousness was raised." And as one activist put it, "Feminism is learning where to put the blame." Believing that women's problems are not due to personal failure acts as a catalyst for demanding change.[10]

This final stage in the development of feminism, a sense of injustice, was also evident by 1972. Women acknowledged that discrimination, not drive, ability, or ambition, kept them from holding the top jobs. When the question of discrimination was implicit, most women (57 percent) agreed that many qualified women could not get good jobs while men with the same skills had much less trouble. More than a third (36 percent) felt that discrimination, not male drive and ambition, was the explanation for women's having no high status positions. Over a third of the women (36 percent) were also dissatisfied with their level of influence in the political sphere. Many women (42 percent) ascribed at least some of their problems to society rather than to themselves, and these women were politicized on women's issues.

People outside the group also need to attribute blame for the group's problems to society in order to support group action. Men were equally politicized on these issues. They were just as likely to reject justifications of differential power and success based on men's natural ability, drive, and ambition (55 percent) and to blame sex discrimination for the absence of successful women in business and industry (34 percent). Only in the political arena did men not perceive as great a degree of discrimination. Approximately one quarter of the men (26 percent), in contrast to slightly more than a third of the women (36 percent), felt that women did not have enough political influence. Men as well as women saw these problems in political terms.

People's willingness in 1972 to assert that men and women should have equal roles did not automatically translate into a readiness to acknowledge discrimination. People who were perfectly comfortable with women becoming doctors, lawyers, or construction workers also denied that access to these occupations were ever closed to women. The correlation between new role definitions and perceived discrimination was high (.48 for men, .52 for women), but far from perfect. In the past, working women often accepted differential pay scales and advancement opportunities because they viewed men as the pri-

mary breadwinners and saw their own work roles as secondary. Women failed to view their absence in management positions as a sign of discrimination. They attributed it rather to chance and ability. Their husbands, fathers, and brothers often shared these opinions. People who did not regard women as objects of collective discrimination were not going to see the need for political action. By 1972, a significant number of people of both sexes felt that women's absence from positions of power was due to discrimination and a lack of political influence (40 percent), but the majority still attributed women's lack of access to their own inabilities. However, while men were slightly more amenable to role equality, women were more likely (42 percent) than men (35 percent) to place the onus for women's troubles on society.

There was little difference in how men and women defined women's roles or acknowledged sex discrimination in 1972. Only on the question of affiliation did women clearly outdistance men in expressing solidarity with other women. Affiliation represents a rudimentary commitment to women, the first step in recognizing one is a member of a group. The fact that men subscribed to new roles for women and recognized that women did not have equal opportunity without having had that affiliation suggests that ideology as well as experience can galvanize concern over women's rights.

In addition, women's attachment was to both traditional and feminist women, which influenced whether their affiliation fostered a new role orientation and acknowledgment of discrimination. On the whole, both women in traditional organizations and housewives who felt close to women did not have a feminist outlook (Table 6.1). For these women, aligning with women as a group did not lead to advocating a new role identity or a belief in sex discrimination. Bonds to other women did make a difference for less traditional women. Working women who felt close to women were more likely to acknowledge sex discrimination than were working women who expressed no attachment to the group. Among the women who were not integrated into traditional organizations, those who felt close to other women were also more likely to favor nontraditional roles and to pinpoint sex discrimination as the root of women's problems than were women who were not close to other women.

Among the women who felt close to other women, those with nontraditional characteristics were much more feminist. Working women opted for less traditional roles and criticized society for discriminating against women much more frequently than housewives, even when both felt close to women. The organizational context made a similar difference in whether women who felt close to women opted for nontraditional views of womanhood and acknowledged discrimination. Closeness to women is therefore not a primary measure of

Table 6.1 Women's attitudes toward role and discrimination,
1972.

Attitudes	Not close to women	Close to women	Not close to women	Close to women
	Housewives		Working women	
Women's role[a]	4.8	5.0	6.2	6.4
Sex discrimination[b]	1.0	1.3[c]	1.3	1.6[c]
	Members of traditional organizations		Members of other organizations or none	
Women's role[a]	5.1	5.1	5.6	6.4[c]
Sex discrimination[b]	1.0	1.2	1.2	1.6[c]

Source: CPS 1972 National American Election Study.
a. Range: 1 (very traditional) = 10 (very nontraditional).
b. Range: 0 (no discrimination) = 3 (much discrimination).
c. Significant $p \leq .03$.

shared interest, for men had feminist sympathies despite the fact that they did not feel close to women, and traditional women who felt close to women were not feminist.

Support for Feminism

Feminism, then, is based on the belief that men and women should have equal roles and on a sense of social injustice, but it is not a discrete condition that is either wholly absent or wholly present. It is rather a continuum, representing varying degrees of commitment to these two views. The interaction between the two views is shown by multiplying each individual's commitment to nontraditional roles, ranging from 1 to 10, by his or her perception of discrimination, ranging from 0 to 3, which results in a measure of feminism ranging from 0 to 30. Anyone who felt that women did not experience discrimination is not a feminist. By 1972 most people had some feminist sympathies. Less than a third of the population (31% of men, 25% of women) refused to acknowledge that women's status was in need of change, while a quarter of the population of both men and women (22 percent) were strongly feminist, having scores of 20 and above

on the feminism index. The majority were confused about women's status but leaned toward the feminist explanation for women's problems.

Moreover, the support for feminism was not based on a perception of antagonism between the sexes. When people were asked whether they felt that men and women usually agreed or disagreed on major issues, most people felt that they agreed. Neither sex viewed the other as an adversary, although women were more likely to feel disagreement with men (37 percent) than men with women (28 percent). In addition, people who felt close to women, who favored nontraditional roles, or who believed that women faced sex discrimination did not perceive a greater degree of conflict than did those taking antifeminist positions. In short, criticism of women's roles and perceptions of unfair treatment did not lead women to feel antagonism toward men.

This firm showing of support for feminism among men and women in the early years of the women's movement reveals that the roots of gender politics were firmly embedded by 1972. The significance of women's support for feminism differs, however, from that of men's. For women, feminism is part of their personal identity or consciousness. For men, feminism is an abstract issue of rights and obligations. Since both men and women come to feminism from different paths— personal experience in one case and ideology in the other—feminist views are likely to have a greater influence on women's political views than on men's. Women initiated the discussion of their rights and demanded political solutions to their problems. It was only after women mobilized for sex equality that men began to support feminist goals.

Men's concern for feminism is similar to the concern that whites express about race discrimination. It is important for whites to support civil rights, but the burden of keeping the public and politicians aware of minority concerns rests on blacks. Having sympathy for a group is different from having group consciousness. Sympathy, as in men feminists and white civil rights proponents, is based on ideological concerns that encourage people to evaluate issues placed before them. Consciousness, as in women feminists and black civil rights proponents, is derived from personal experiences that prompt people actually to change the political agenda. Such action then allows sympathizers to join the cause.

seven

Paths to
Feminism

The shift from traditional to new life experiences shaped people's outlook toward women's status. As women's labor force participation increased, commitments to child care comprised a smaller portion of their lives, and marital arrangements became less stable, they allowed for an alternative understanding of women's roles and opportunities. These changes not only promoted a sense of solidarity among women, they also elicited support from men. After all, men lived with women who faced the double burden of home and work, confronted issues of marital instability, and recognized the declining significance of large families. Yet men and women take different paths to feminism.

Women were forced through personal experience to acknowledge discrimination and to recognize that the traditional ways were no longer viable. This knowledge was incorporated as part of their self-definition, their consciousness. Men learned about these issues vicariously, through watching and listening to women. Men were sympathetic to feminist arguments because of their own general concern for issues of justice and equality. These issues, however, did not touch men directly. Men did not feel threatened by the status quo; women did. Sex segregation in the workplace, the double burden of homemaking and employment, sexual harassment, and reproductive freedom were not issues that confront men in their day-to-day lives or constrain their future options.

The 1972 national election survey reveals why people supported feminism during the early years of the women's movement. A look

at people's views toward feminism on the basis of their age, ideology, religious ties, and life experiences points to two distinct paths to feminism. One is based on personal experiences and expectations; the other is based on ideology and exposure to alternative lifestyles. The life circumstances that prompt support for feminism include marital status, occupation, education, living in a large city, having a mother who worked, growing up in an urban area that exposes one to many different lifestyles, and the historical context during which appropriate sex roles are learned. Because the root to feminism traveled by men is based on abstract learning rather than direct experience, their views constitute sympathy for feminism. In contrast, women's views, learned through personal experience, are internalized to form a feminist consciousness.

Marital Status

In order to become feminist, women need to experience nontraditional roles that challenge long-held expectations and allow for a rejection of biological explanations for women's roles and a recognition of discrimination (Table 7.1). The traditional division of labor where the husband is the breadwinner and the woman the homemaker begins with the marriage contract. Both men and women are expected to get married. The significance of this event, however, differs for each sex. Marriage marks the beginning of women's adult life, the first step toward motherhood. It also symbolizes women's economic security. Work, more than marriage, represents men's adult status. A good woman makes a good marriage; a good man makes a good living. As a consequence, getting married has traditionally been more critical to women's sense of personal success than to men's.

In 1972 men who were single or faced marital disruption because of separation or divorce appeared somewhat more sympathetic to feminism than married and widowed men ($r = .13$). However, most of these men were also young, and younger men were more supportive of feminism ($r = .24$). Indeed, once the influence of age is removed, there was no significant relationship between men's marital status and their support for feminism ($r = .06$). Men's feminist perspective is a function of their age. The nontraditional nature of this experience does not lead men to feminism.

In contrast, being single, divorced, or separated forces women to take on obligations traditionally assumed by men. Divorce and separation mark the failure of traditional arrangements. Many women whose marriages are disrupted had expected to be part of a life-time partnership involving complementary roles. Now they find themselves taking on nontraditional responsibilities in order to survive. These experiences lead them to question traditional views of women. Single,

Table 7.1. Nontraditional roles and feminism, 1972.[a]

Roles	Women	Men
Marital status		
Traditional	8.68 (697)	8.19 (533)
Nontraditional	13.68 (188)	11.13 (142)
Eta	.21	.13
Housewife		
Yes	7.79 (392)	7.02 (312)
No	11.26 (495)	10.21 (384)
Eta	.17	.17
Occupational status		
Low	7.99 (549)	6.99 (226)
High	12.21 (305)	9.05 (424)
Eta	.21	.21
Education		
Less than high school	6.54 (267)	5.27 (184)
High school graduate	9.26 (357)	7.14 (212)
More than high school	13.59 (263)	12.09 (300)
Eta	.28	.32
Role integration		
Traditional	6.76 (445)	5.92 (229)
Ambivalent	11.00 (225)	6.77 (159)
Nontraditional	14.39 (182)	11.44 (261)
Eta	.32	.28

Source: CPS 1972 National American Election Study.

a. Mean scores on the feminism index: 0–30. Number of cases is shown in parentheses.

separated, or divorced women were significantly more feminist than widowed or married women in 1972 ($r = .21$). The greater social conservatism of married women also shows up in the fact that more of them (52 percent) than of single women (16 percent) evaluate conventional marriage with children and no full-time job as the ideal life.[1] Being single, divorced, or separated promotes feminist consciousness because the rewards of marriage are stripped away.

Yet being single is a nontraditional status only for older women. The age at which a woman gets married has an influence on whether she has a traditional outlook, because women who remain single past their early twenties are faced with supporting themselves and meeting the challenges of being independent. Young women who were single prior to the median age of first marriage for women born in the 1950s

(21.2 years) have yet to face the problems that draw single women to feminism. In 1972 young, single women, age seventeen to twenty-one, were no more feminist than their married contemporaries. At this age, being single was appropriate or expected rather than non-traditional. In contrast, older single women, aged twenty-two to thirty, were considerably more feminist than their married counterparts. For these women, being single meant taking on financial and social re-sponsibilities that had traditionally been assumed by men.[2]

Women in nontraditional roles, however, are more feminist be-cause they are younger, and younger women are more likely to be confronted with situations that challenge tradition. Although in 1972 younger women were more likely than older women to be feminist ($r = .29$), the relationship between marital status and feminist support was slightly reduced but remained significant at all ages ($r = .14$). For women, unlike men, facing nontraditional responsibilities rather than simply being young is what leads them to feminism.

Occupation

Women's traditional role also presumes that they work at home. Housewifery, once the only full-time job open to most women, is now only one of several sex-segregated occupations, such as secre-taries, clericals, grade school teachers, and nurses. Most women work in hopes of earning an income and gaining status, but working also brings women in contact with new information and opportunities. As a consequence, women who took on economic responsibility for themselves and others in 1972 were more likely to be feminist than were women who worked at home ($r = .17$).

Consciousness is stimulated by positively reinforced nontraditional roles. However, not all forms of employment provide a stimulating learning environment, sufficient status, or adequate pay. Women in low status occupations are not likely to applaud their opportunities for employment, although they need the jobs. If they are working for financial survival in jobs that are unrewarding, women may resent the double burden of home and work and envy the opportunity to stay at home. Women employed in higher status jobs in 1972 were somewhat more political in their views of women's status than women engaged in less rewarding jobs ($r = .16$).

The support of housewives for feminism was equivalent to that of women in low status, low paying jobs, such as private household workers, waitresses, barmaids, and hairdressers, which are tradition-ally female occupations.[3] Women in more rewarding higher status occupations, such as secretaries, clericals, bookkeepers, and lab tech-nicians, as well as teachers, business managers, accountants, and scientists, were considerably more feminist ($r = .21$). Moreover, the

relationship between work status and feminism was totally unaffected by age. Positive work experience stimulated feminist support among all working women, not only among the young.

The support of men for feminism was also shaped by occupational status, but the influence of a more rewarding job on feminism was considerably weaker ($r = .11$). However, this relationship was not due to higher status occupations promoting feminism, as in the case of women, but to the predominance of traditionalism among low-status male workers. Women employed in higher status occupations were significantly more feminist than their male counterparts (a mean of 12.2 for women, compared to 9.1 for men), which illustrates the importance of nontraditional experiences for the development of women's consciousness.

Because men are raised to define personal success in terms of supporting a family, men working in lower status jobs lacked the inherent rewards associated with higher status or interesting work. For these men, job satisfaction and personal worth were derived from earning money, fulfilling their role as breadwinner. They, like housewives, were invested in the values imbued in the traditional division of labor. They resisted feminism because it challenged their views of themselves as the sole or primary provider, the good man who takes care of his family. This conservatism was not isolated to older, unskilled workers. Younger men in lower status jobs were just as likely to feel threatened.

Despite the resistance to feminism found among low-status male workers who performed the sole provider role, men who had working wives and departed from their traditional role were not less feminist. Sharing the role of breadwinner with one's wife represents a nontraditional status for men, which challenges their primacy in the work force and could lead to antagonism to feminism, but the positive aspects of sharing responsibility for the family's financial security countered the status withdrawal experienced as women took on economic obligations. Men with employed wives were more sensitive to women's rights and the need to end discrimination ($r = .17$) than were men whose wives were homemakers.

The importance of nontraditional experiences for the growth of feminist consciousness, as compared to sympathy, is reflected by the stronger relationship between occupational status and feminist support found among women than among men. Higher status occupations were not associated with feminist views, although having nontraditional goals leads women to pursue careers. Labor force participation increased rapidly for over a decade before attitudes toward working women became favorable, which suggests that feminism is more likely to result from nontraditional behaviors rather than the other way around. In addition, working women develop nontraditional views

during the course of their years in the labor force. Employment since 1968 was a stronger predictor of nontraditional role orientation in 1972 than was sex role orientation in 1968. Labor force participation of married women between 1962 and 1977 was strongly related to changing role perceptions. Women with extensive employment experiences were more likely to shift in the egalitarian direction.[4]

Women's attitudes toward employment nevertheless influence their behavior.[5] In fact, the formation of an alternative lifestyle for adult women, acknowledging work as a personally and socially valued act, changes the context in which they make labor force decisions. As a result of this new climate, the occupational goals of recent and future entrants into the labor force are likely to be influenced by whether they are feminist. For most women in 1972, however, economic considerations were probably more prominent in drawing these women into the labor force. Once they entered the labor force, they learned that they were capable workers who were not given the same opportunities as were men, and they embraced feminism.

Education

The expansion of public education has also dramatically changed the learning opportunities open to women and allowed for the growth of consciousness. The percentage of women age twenty-five to twenty-nine who had not finished high school fell from 45 percent in 1950 to 18 percent in 1975. College entrance among women in this age group increased during this period from 16 percent to 36 percent. Education provides concrete skills that serve as the doorway to upward mobility, higher income, and higher status. Women who complete high school and those who enter college are also exposed to new ways of interpreting their world. They gain an ability to understand new materials, seek out information, and tackle new roles. College students of the 1960s became more egalitarian during their college years. In addition, education was weakly related to gender role attitudes in 1962, but completed level of education in 1962 was strongly related to increased nontraditional orientations by 1977.[6]

The higher a woman's education, the more likely she is to reject traditional constraints on her choices. Having been successful along achieved dimensions, educated women in 1972 were more likely to attribute lack of advancement opportunities to sources external to their own efforts ($r = .27$). The relationship between education and feminism was due in part to the higher education of younger women, but the link remained strong at all ages ($r = .21$).

The liberalizing effects of education are not limited to women. Education is a conduit to change for both sexes. Learning about other people, places, and times exposes students to views that challenge as

well as reinforce their traditional ways. Increased education also fostered men's feminist sympathies in 1972 ($r = .32$). It facilitated an understanding that roles are socially learned rather than biologically determined. Higher education expanded men's definition of what makes them a good person by providing them with a broad set of resources for meaningful work and community involvement that goes beyond their role of breadwinner.

The ability to attain a college education is a nontraditional experience for women more than for men. The strong association between education and men's feminist views shows that education leads to feminism because it promotes tolerance rather than simply because it is a nontraditional experience for women. But the expansion of women's educational opportunities since World War II has meant that more women are being exposed to this liberalizing influence than ever before. As a consequence, more women are open to feminist arguments.

Role Integration

Nontraditional marital status, occupation, and education each represents an alternative role open to women that challenges traditional learning. The integration of these various nontraditional experiences into a nontraditional lifestyle led to the formation of an alternative definition of womanhood and thus prompted the growth of feminism. This kind of integration involves more than just a summing up of the number of nontraditional roles a woman has assumed. It is not simply a matter of getting so many points for being educated, so many points for a higher status occupation, and another few points for not being married. Role integration means that there is an interactive relationship among women's experiences in which each role reinforces the other. Thus, there is an exponential growth in consciousness as the layers of nontraditional roles increase, making it easier for women to abandon conventional definitions of womanhood. This interaction of demographic characteristics can be expressed mathematically as the product of a woman's occupation (scored 1,2), marital status (scored 1,2), and education (scored 1,2,3). The resulting measure of role integration ranges from 1 for a housewife who has not completed high school to 12 for a college-educated, unmarried woman employed in a higher status occupation.

Women exhibited three distinct combinations of role experiences in 1972, ranging from traditional to nontraditional. About half the women (52 percent) led traditional lives centered around home and family. More than a quarter of the women (27 percent) had assumed both traditional and nontraditional roles, resulting in role ambiguity and ambivalence. The rest of the women (21 percent) had consistently

nontraditional characteristics. The less traditional a woman's life experiences, the more feminist her perspective ($r = .32$). Women with nontraditional life experiences tended to be younger ($r = .22$), but the influence of nontraditional roles remained high for women of all ages ($r = .27$).

These different lifestyles or forms of role integration have little relevance for men. Education is the only common experience promoting feminism among men and women. The nontraditional aspects of women's lives represent men's expected responsibilities in a traditional division of labor. Ironically, for women to have a college education and high status occupation means that they have achieved at nontraditional roles that for men would represent success in their traditional responsibilities. The positive relationship between role integration and feminism among men ($r = .27$) showed the influence of age and education and thus disappeared once those aspects were removed. The integration of nontraditional experiences leads women, but not men, to feminism, pointing to the importance of direct experience for consciousness. The meaning of these experiences for the two groups is quite different.

Direct experience with nontraditional roles is only one factor promoting feminism. Changes in marital, education, and occupation patterns also provide men and women with alternative role models that lead people to feminism vicariously through watching the experience of others. Whether people are able to learn about feminism through exposure to alternative lifestyles depends on the size of the community where they currently live and where they grew up, the nature of the mother's work, and the degree of their traditional religious ties (Table 7.2).

Community Size

Urban areas have been the center of change for most of this century. Living in a city exposes a person to a multiplicity of ethnic traditions and a wide base of social and economic opportunities, which challenge conventional views. Women living in urban areas were less enamored with the traditional division of labor (38 percent) than were rural women (53 percent) and more likely to support efforts to change women's roles (62 percent) than were women living in towns (55 percent) or rural communities (46 percent). The diversity of city life offers men and women a large array of nontraditional role models, thereby facilitating an openness to nontraditional arrangements. As a result, men and women living in more densely populated areas in 1972 were more feminist than people living in smaller communities ($r = .20$).[7]

Table 7.2. Social characteristics and feminism, 1972.[a]

Social characteristics	Women	Men
Current community		
Small	7.78 (313)	6.21 (234)
Medium	9.68 (367)	9.76 (287)
Large	10.78 (134)	9.80 (125)
Very Large	16.36 (73)	12.64 (50)
Eta	.21	.19
Community of origin		
Country	6.75 (263)	5.35 (220)
Town	9.87 (236)	8.80 (161)
Small City	11.45 (170)	9.05 (141)
Large City	11.82 (218)	13.00 (172)
Eta	.19	.30
Mother employed		
No	8.44 (564)	7.29 (461)
Yes	11.98 (323)	11.69 (235)
Eta	.17	.22
Frequency of worship		
Every Week	6.76 (268)	6.20 (177)
Almost Every Week	9.53 (119)	9.43 (75)
Once or Twice a Month	10.54 (105)	8.10 (78)
A Few Times A Year	10.91 (264)	8.87 (224)
Never	12.94 (131)	11.89 (142)
Eta	.22	.21

Source: CPS 1972 National American Election Study.
a. Mean scores on the feminism index: 0–30. Number of cases is shown in parentheses.

The urban setting defining the day-to-day experiences of the adult is likely to have an even more dramatic influence on the expectations and experiences of young men and women as they form opinions on an appropriate female identity. The aggressive pace of city life does not reward ladylike behavior. Boys and girls raised in a city are likely to be less conventional than those growing up in a rural setting. They are more likely to come from a smaller family, to see their mother or a friend's mother go to work, and to have opportunities to try out new experiences.

Men and women raised in urban communities were in fact more

sympathetic to feminist criticism. Early exposure to a wide array of role models played a stronger role in shaping men's views ($r = .30$) than it did for women ($r = .19$). Men learn women's roles through example, whereas women shape their views by direct experience. Thus, exposure to a variety of lifestyles while they are growing up leads men to accept feminism. For women the past is less relevant to their feminist position. Their present circumstances are what leads them to support or oppose feminism.

Mother's Work

The mother is one of the primary models for learning appropriate female behavior. The working mother presents her children with an alternative view of women's adult responsibilities. Having a working mother left both men ($r = .22$) and women ($r = .17$) more open to feminism. But once again, the impact of vicarious learning was stronger for men.

Religious Ties

Religion plays a major role in shoring up traditional values in a time of change. This stabilizing influence was critical to the maintenance of traditional womanhood as the transformation of women's lives brought serious challenges to personal and familial relationships based on male dominance. In the midst of increasing role confusion, religion offered a coherent ideology justifying women's place in God's scheme. This reinforcement of traditional ways in general and of women's role in particular provides both men and women with a sense of order and self-worth that is not easily countered by the changing definition of womanhood.[8]

Religion also provides a traditional community where like-minded people can express their needs and concerns and receive approval for their traditional orientations. Those who in 1972 attended religious services regularly, male and female, were much more resistant to feminism than were those who rarely attended services or had no religious affiliation ($r = .22$). The regular religious observers accepted women's status as part of a natural order and failed to adopt a systemic view of women's problems.

External Rewards

People's willingness to reject traditional roles also depends on the behaviors being rewarded by the larger society. When nontraditional behavior brought monetary rewards and social status, it influenced people's evaluations of women's past experiences and future options

and encouraged the acceptance of a new role definition. Women leading both nontraditional and traditional lives may come to resent the social constraints that seem to limit their alternatives once they recognize the changes in external rewards. This resentment leads them to feminism.

Women who in 1972 felt that they had been held back from achieving their full potential (28 percent) cited a lack of encouragement, poor guidance, failure to obtain a proper education, and discrimination as the major drawbacks that they experienced. The perception of limited opportunities characterized all women, not just those engaging in nontraditional activities.[9]

Women who felt that they had been held back were slightly more predisposed toward feminism ($r = .10$), but men who felt that they themselves had been treated unfairly were not supportive of women's rights. Perceptions of curtailed job opportunities also influenced women's openness to feminism. A number of working women (11 percent) felt they had personally faced discrimination as regards their job choices, salary, and chances for promotion. These women were more likely to be feminist than women who did not feel they personally experienced unfair treatment ($r = .27$).

Ideology

The women's movement gained momentum from a long preceding period of debate involving issues of social equality. Having struggled with similar questions during the civil rights movement, people supported or opposed feminist claims on the basis of their overall views of political rights and responsibilities. By 1972 people with liberal political views were more open to charges of sex discrimination and the desire to redefine women's roles than were people with moderate or conservative political views. This link between feminism and liberal politics was much stronger for men ($r = .33$) than for women ($r = .22$). The distinction between sympathy and consciousness is illustrated in the fact that men were more likely to become feminist because they were liberal, while women who supported feminism came from a broader spectrum of political views.

Men and women become feminists for different reasons—women because of personal experiences that lead them to reject the traditional division of labor and which are internalized as a feminist consciousness, men because of ideological concerns and exposure to alternative lifestyles that lead them to feel a feminist sympathy. The difference between consciousness and sympathy is illustrated in the differing influence of role integration and liberal political views on men's and women's support for feminism, quite apart from the contributions of religious worship, the size of the community in which

one was raised or currently lives, having had a working mother, and age (Figure 7.1). A liberal political orientation had a stronger influence in 1972 on whether men favored feminism ($b = .25$) than it had on women's feminist views ($b = .13$). In contrast, the integration of nontraditional employment, marital, and educational experiences, which reflect a direct exposure to the transformation of women's roles, had a stronger impact on drawing women to feminism ($b = .24$) than it had on men ($b = .16$).

Women became feminists largely because the day-to-day experiences of a nontraditional lifestyle led them to reject traditionalism and demand equal opportunity. Women's views toward feminism were shaped by their current circumstances, such as their role integration, where they lived ($b = .12$), and how often they attended religious services ($b = .14$), rather than by their childhood experiences. Role integration had the strongest impact of all the factors that influence whether women support feminism. Growing up in an urban area ($b = .04$) or having had a working mother ($b = .04$) did not directly influence women's views. The socializing effects of earlier experiences probably shaped consciousness indirectly by influencing the potential for having nontraditional adult experiences. Women who grew up in larger communities were in fact somewhat less traditional as adults than were women who grew up in less urban areas ($r = .17$). Having a working mother did not increase the likelihood of women's leading a nontraditional life, which may reflect the fact that many women were drawn into the labor force out of necessity independent of whether they thought it appropriate. This points to the importance of women's current experiences rather than to events in their past for becoming feminist.

Women's perceptions of their role and status were also shaped by their general outlook on the world. A religious view of social relationships or a conservative approach to politics hindered the development of consciousness. If a woman had a liberal political orientation,

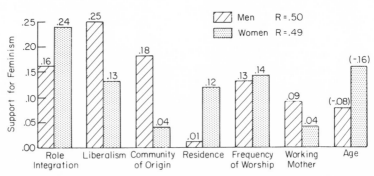

Fig. 7.1 Social characteristics of feminism, 1972

she was already predisposed to changing roles and stressing society's responsibility to solve these problems. This relationship between liberal ideology and consciousness reflected in part the historical period, in which issues of minority rights, civil liberties, and government responsibility sensitized many people to the question of equality. But even in this time of heightened awareness, role integration had almost twice the influence of a liberal political orientation.

Liberal political views lead men to feminism. For the most part, men who accept feminist arguments are extending their support for social equality to women's rights. Feminism is yet another cause in the fight for social justice. But men's support for feminism is largely rooted in abstraction rather than in experience and therefore is less central to how they evaluate their daily experiences or political judgements. Unlike women, whose views were shaped by their day-to-day experiences, feminist men were influenced by their earlier socialization. Exposure to the diverse opportunities of urban life during men's youth left them more open in 1972 to demands for women's rights ($b = .18$). Having had a mother who worked to help support the family also fostered some understanding of sex discrimination ($b = .09$). This understanding, however, is gained by observing what has happened to others rather than by personal experience.

Historical Context

The success of the women's movement is owed in part to its ability to mobilize young women effectively. Young women, who are less invested in traditional female roles ($b = -.16$) than are older women, are free to adopt alternative goals and pursue status and monetary rewards. Yet older women who face divorce, the empty-nest period, or a need to support themselves also become feminist. The process of social change is thus not merely one of new generations replacing the old, since older women have many of the same nontraditional experiences.

The historical context during which women are exposed to nontraditional experiences plays a critical role in translating new behaviors into consciousness. The pursuit of alternative goals had a resocializing effect among women raised during periods when traditional experiences were strongly reinforced. These women had to unlearn traditional explanations for the differences between men and women before coming to believe in sex equality and roles that promote new experiences. Nontraditional experiences led these women to be more sympathetic to feminism, but the fact that they had to redefine appropriate behavior made it more difficult for them to reject traditionalism in comparison to women who learned to value alternative options from the outset.

The evolution of feminism results from the interaction between nontraditional roles and the historical context at the time that appropriate sex roles are learned. The influence of this interaction on women's feminism varied for women born during four distinct historical periods—the eighteenth century, turn of the century, Depression and World War II, and post war period—independent of whether they were liberal, lived in urban areas, did not attend church regularly, or felt that they experienced discrimination. Age and nontraditional experiences alone do not have an independent influence on this process of becoming feminist.[10] Nontraditional experiences promote feminist views, but the ease with which women embrace feminism is influenced by the prevalence of traditional values at the time that they develop their role identity (Figure 7.2).

Women born before the turn of the century formed their self-image during a traditional period. Nontraditional experiences did not foster a feminist outlook among these women ($b = -.02$). Raised at a time when the traditional role was the only viable and valued option for women, most of these women went on to lead traditional lives. Even those who divorced, entered the labor force, or became educated were not feminist because the values of society strongly stressed the traditional division of labor as natural and right.

The opportunity for exposure to nontraditional events increased for the women born during the second period of women's role transformation from 1900 to 1925. As a consequence, these women were more open to the resocializing potential of later unconventional experiences. While women born during the first quarter-century were more likely to support feminist views if they were currently in nontraditional roles, the resocializing effects of these experiences were relatively weak, because these women spent most of their lives learning about femininity rather than feminism ($b = .12$).

Women born during the third period in the evolution of a nontraditional norm, from 1926 to 1945, were raised at a time when alter-

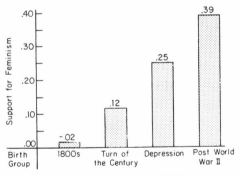

Fig. 7.2 Generations, nontraditional roles, and feminism

native cues were becoming increasingly common. The Depression and World War II dramatically redefined women's lives. As adults, these women had a broader range of opportunities to pursue unconventional goals. Nevertheless, traditional values were still rewarded during this period. To some extent, nontraditional adult experiences have a resocializing effect on how these women view their roles and status. The relationship between role integration and feminism was twice as strong ($b = .25$) for women born during the Depression and the war period, when sex role stereotypes were undergoing rapid change, than for those born during the first portion of the twentieth century.

Among the women born during the fourth period in the evolution of an alternative definition of womanhood, from 1946 to 1954, the congruence between nontraditional expectations and experiences had the strongest influence on shaping consciousness. The postwar birth group is the first generation exposed to an alternative model of womanhood as they were growing up. When these women were becoming young adults, an alternative definition of what women do was being formed. These women decided to seek employment or a college education at a time when such choices enhanced rather than detracted from a woman's status. As a consequence, these women were most likely to be politicized by exposure to nontraditional experiences ($b = .39$). These women were more likely than any of the previous generations to find feminist arguments compelling.

Feminism, however, was not limited to this younger group. During the recent past, older women have entered or reentered the labor force in large numbers, have experienced increased marital disruption during the empty-nest years, have survived to enjoy a long span of time removed from child-care responsibilities, and have continued their education. Many of these women are strong feminists. Still, these women were raised during a more traditional time than younger women who are less invested in traditional values and therefore more inclined to demand equal rights.

Housewives

Just as feminist commitments were not limited to the young, they were also not limited to women integrated into nontraditional lives. Housewives in 1972 were strong feminists (21 percent). These women, defined as traditional by their marital status and work roles, became feminists because they had experienced discrimination in the past, hoped to be employed in the future, or did not value the housewife role (Figure 7.3).

Women in a traditional role, such as being a housewife, develop a feminist consciousness if they believe that traditional arrangements

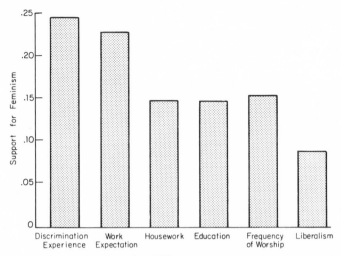

Fig. 7.3 The feminist housewife, 1972

hinder their personal opportunities to achieve goals and gain status. Some housewives in 1972 expected to work in the future (30 percent) or had experienced job discrimination in the past (14 percent). Feminist housewives tended to be those that had experienced discrimination ($b = .24$) or expected to work ($b = .22$). A housewife's evaluation of housework, which includes cooking, sewing, and cleaning but not child care, also determines whether she becomes a feminist. Housewives who did not enjoy housework (35 percent) indicated that a major aspect of their role was not fulfilling or rewarding; this evaluation left them open to feminism ($b = .15$).

However, working women are not happier or more satisfied than housewives. According to national surveys conducted between 1971 and 1976, both housework and employment outside the home have equal benefits and costs attached to them.[11] Educated women were also less tied to conventional roles and therefore more open to feminism ($b = .15$). These nontraditional experiences and expectations, rather than a liberal political perspective ($b = .08$, not significant), brought women in traditional roles to feminism. Because these views are rooted in personal experience rather than ideology, they form a feminist consciousness.

The significance of alternative life patterns was also apparent in the formation of the civil rights movement. The experiences of blacks over the past century reveal a dramatic transformation in the definition of what it means to be black in America. Historically, the experiences of blacks was limited to a rural, Southern, agricultural pattern. The migration of blacks to Northern cities which began during World War I marked a major watershed in their history. In 1910,

most of the black population lived in rural areas (75 percent) and in the South (90 percent). A half-century later most blacks lived in cities (75 percent) and outside the South (49 percent). This transition represented a radical change in black lives.[12]

The urban migration was accompanied by increased opportunities for educational advancement and skilled employment. The number of blacks aged twenty-five to twenty-nine who completed high school, which was 12 percent in 1940, doubled by 1950 and doubled again to 50 percent in 1965. High school completion rates for whites increased from 43 percent in 1940 to 73 percent in 1965. The number of black college graduates also increased from less than 2 percent in 1940 to 7 percent in 1965, while the number of white college graduates increased during the same period from 6 percent to 13 percent.[13]

There were occupational shifts as well. At the turn of the century most blacks worked in agriculture. By 1940, service work was the main occupation open to blacks (47 percent of men, 87 percent of women), and a few had entered skilled jobs (17 percent for men, 8 percent for women). By 1960 the number of black service workers had been reduced (19 percent of men, 50 percent of women), and more blacks had found jobs in skilled occupations (27 percent for men, 23 percent for women).[14]

These social changes produced new behavior and expectations similar to those that characterized the feminists. Civil rights activists were more likely than nonactivists to be educated, to be employed in skilled jobs, and to have grown up in urban areas.[15] These new experiences fostered perceptions of discrimination and led blacks to see social arrangements as the root of their problems.

Whites too are sympathetic to issues of race discrimination. In 1972, both whites (26 percent) and blacks (66 percent) saw race discrimination as standing in the way of black advancement. The difference between the races, as between men and women, lies in the fact that blacks' perceptions of discrimination were rooted in personal experiences, thereby forming a group consciousness, whereas whites' judgments were based on ideology and hence were vicarious and abstract.

For blacks, the recognition that race discrimination posed a major obstacle to obtaining a decent standard of living was based on day-to-day experiences independent of any larger liberal political views. Living in larger communities ($r = .28$), increased education ($r = .16$), and higher occupational status ($r = .21$) promoted political consciousness among blacks, just as they did for women (Table 7.3). In contrast, liberal ideology ($r = .30$) rather than life experience was the main reason for whites to acknowledge race discrimination as a pervasive social problem.

In sum, nontraditional experiences helped foster a new group iden-

Table 7.3. Perceived race discrimination, 1972.[a]

Social characteristics	Whites (n = 1443)	Blacks (n = 118)
Education	.14	.16
Occupation status	.01[b]	.21
Community size	.05[b]	.28
Frequency of worship	.07	.20
Liberalism	.30	.07[b]

Source: CPS 1972 National American Election Study.
a. Pearson's product moment correlations (*r*).
b. Not significant *p* > .01.

tity and recognition of discrimination for both blacks and women, establishing the causal link between social change and group consciousness. In contrast, the support for minority grievances among people outside the minority group, whether among whites or men, stemmed from a vicarious understanding of how social institutions constrained people's lives. Their sympathy for people outside the group was based not on personal experience but on moral judgment.

The transformation of traditional life patterns promotes both feminist consciousness and sympathy for feminist ideology. Women learn to be feminists when they assume nontraditional roles within a social and political environment which demands that they continue to assume traditional responsibilities while at the same time both denying them the social services needed to address this double burden and failing to ensure them equal opportunities within the traditional male sphere. Because women's support for feminism is rooted in personal experience, it plays a central role in shaping how they view the world. Feminism becomes for them a group consciousness. Men learn to be feminists vicariously, by evaluating women's claims in terms of abstract commitments to rights, equality, and social justice. The conditions that trigger men's response are external to their daily expriences and therefore do not persistently shape how they view the world. As a consequence, the intensity of their commitment to feminism is not as strong as is women's.

eight

The Women's Movement

The success of the women's movement rests in part on getting people with feminist sympathies to see that collective action is needed if sex discrimination is to be eliminated. A feminist orientation, the belief that discrimination exists and that sex roles should be equal, does not automatically translate into support for collective action or for the women's movement. People who support feminist goals may differ in their choice of appropriate strategies to achieve these ends. There are two main strategies for handling discrimination and promoting social change. According to one, based on the view that moral discipline, hard work, and ambition are rewarded, individual advancement is the way to change the status of the group as well. According to the other, group action is the only way of ending discrimination.[1]

Minority groups rarely have enough initial resources to influence political decisions directly. They need to expand the scope of the conflict to include sympathetic members of the general public in hopes that they too will exert pressure on politicians to address the concerns of the group. Minority groups most often resort to protest tactics in order to get the media attention needed to bring their grievances to the public's attention. In order to translate public opinion into political pressure, the audience viewing the conflict must agree with both the claims of the group and its strategies and tactics.[2]

Yet group action goes against the prevailing sentiment in a democracy that "anyone who tries hard can succeed." Americans gen-

erally place greater emphasis on individual achievement than on collective action. Horatio Alger's heroes embody the essence of this dream of success, which is achieved through hard work and perseverance. In order to get ahead, deprived groups, such as blacks, women, and the poor, simply need to work extra hard. Efforts aimed at benefiting the individual are assumed to benefit the group as well. The argument that problems can be solved only by people working together challenges this belief in the triumph of the individual.

When in 1970 women came together for the Women's Strike for Equality, they rejected the viability of individual effort and instead embraced group protest to solve their problems. After this strike, membership in feminist organizations mushroomed, and public opinion in favor of strengthening or changing women's status in society increased.[3] But the public support for the goals of feminism did not necessarily mean that the public approved of the protest tactics used by the women's movement. Despite the value that is ordinarily placed on self-help and the conventional channels of getting ahead, people with feminist sympathies needed to recognize that collective action rather than individual achievement was the best strategy to fight discrimination if the women's movement was to be successful. The feminist public would help the women's movement only if they supported the movement's use of protest tactics, such as demonstrations, sit-ins, and marches, as appropriate means of influencing policy makers.

The 1972 national study of the electorate reveals the degree to which the public supported the strategies and tactics of the feminists during the early years of the movement. The study ascertained whether the public agreed that collective action was the best strategy for ending sex discrimination, approved of the specific tactics used by the women's movement, and accepted the use of protest tactics to influence politicians. In addition, the study reveals the extent to which a feminist orientation has different political consequences for women than for men, again illustrating the difference between consciousness and sympathy.

By 1976 the women's movement had attained important gains, and the public was enlightened about women's issues. A national study of the electorate conducted in that year reveals the long-term implications of being a feminist woman or a man with feminist sympathies on politics. This later study, based on 2,559 individuals eighteen years and older, ascertained people's opinions on appropriate tactics and strategies for feminist politics, which can be compared to people's assessments in 1972. It demonstrates a growth of public support for the use of collective action to end sex discrimination, an improved assessment of the tactics used by the women's liberation movement,

and an increased tolerance for the use of protest to gain access to politicians.

The Movement in 1972

Support for the women's movement in 1972 was reflected in the degree to which people accepted the use of collective action as a strategy to end sex discrimination, favored the specific tactics the media attributed to the women's liberation movement, and recognized that protest tactics were sometimes needed in order to get political rights. One way to end sex discrimination is to have each woman get the best training she can, and another is to have women organize and work together. When forced to choose between these two strategies in 1972, most people (79 percent) favored individual training and achievement. However, a fair number (21 percent) of men and women believed that collective effort was the only effective way to end sexism. The feminists who recognized that collective action was the best strategy for ending sex discrimination represented a sizable constituency with a great political potential. While these people were not necessarily active in the women's movement, they were part of the movement's support base that forced politicians to address feminist demands. While men were just as likely to support collective action as were women, feminist women were somewhat more supportive of collective action ($r = .34$) than were feminist men ($r = .29$).

Support for collective action and protest movements also derives from political ideology. People who advocate policies for greater social equality are more likely to include protest as a means of influencing political decisions than are the defenders of the status quo. Perceptions of the government's responsibility to end discrimination and to help minorities are usually associated with liberal political views. Liberals were more likely to see the need for collective action ($r = .19$). When the influence of ideology on assessments of appropriate strategies was removed, the importance of feminist concerns on women's judgments remained largely unchanged ($r = .32$), while the importance of feminist concerns for men's assessments was reduced ($r = .21$).

Accepting collective action as the only way to end sex discrimination does not necessarily mean support for the women's liberation movement. Men and women who support feminism do not necessarily approve of the tenor or tactics specifically employed by women's liberation. The women's liberation movement is an umbrella term for a large number of feminist organizations and their supporters who criticize women's traditional status, press for the elimination of sex discrimination, and lay out tactics for implementing these goals. In

its initial phase the movement was characterized as antimale and antifamily. The public's image of the women's liberation movement was shaped by the media's focus on demonstrations and sit-ins. They characterized feminists as angry, silly women who carried placards proclaiming "Starve a Rat—Don't Cook Dinner" or "Marriage Is a Form of Slavery." Despite this radical image, feminist organizations successfully mobilized women in support of ERA, day care, and abortion and in opposition to sexual abuse and job discrimination. By 1972 the women's movement was a recognized political force.

During this initial period of high visibility, a fair number of men and women (42 percent) either did not think about the women's movement or were not interested in women's issues. Some, however, were either quite hostile (23 percent) or highly favorable (27 percent) toward feminist politics. These people formed the backers of the feminist and antifeminist movements. Once again, men were just as likely to favor the women's movement as were women, but feminist women were more favorable ($r = .40$) than were feminist men ($r = .33$). Liberals were also more favorably disposed to the women's movement. Removing the influence of ideology did not really diminish the importance of feminist concerns in shaping women's judgment ($r = .38$) but significantly diminished the importance of feminism for men ($r = .27$).

The success of political protest depends on public support for ending the problems faced by women. In order to gain this endorsement, however, the public must accept the legitimacy of the group's political tactics as well as its grievances. The unconventional methods used by feminist activists to express women's grievances, including strikes and demonstrations, show that feminist activists accepted the need for protest. In contrast, most people (58 percent) in 1972 did not approve of disrupting government activities through sit-ins, mass meetings, or demonstrations if all other methods had failed. Some people felt that the justification for such tactics depended on the circumstances (34 percent), but few unequivocally supported protest action (8 percent). Once again, men and women gave conditional approval to unconventional actions in approximately equal proportions. Feminist women, however, were more likely to approve of protest ($r = .35$) than were feminist men ($r = .29$). When the fact that liberals were more approving of protest ($r = .19$) was addressed by removing the influence of ideology, the influence of feminism on protest approval remained high for women ($r = .32$) but was diminished for men ($r = .21$).

Though men and women share similar feminist views and are equally supportive of collective action, the women's movement, and the rise of protest, men, who come to feminism out of abstract ideas, are not conscious of feminism in the same way as women, who hold these

views because of personal experience. For women, feminism serves as a catalyst for protest, while for men it serves as one of several reasons for acknowledging the strategies and tactics of protest movements. Men's support for feminist protest rather derives from a general ideology about rights and attitudes toward a broad set of social issues rather than the specific plight of women. Feminism has different political consequences for both women and men.

Feminism and ideology are two of several motivations that underlie the support for protest politics in general. Personal dissatisfaction is another primary social psychological motivation for political activism. Collective behavior is an expression of anger aimed against people in power. This anger comes from failed expectations rather than from objective social conditions. Dissatisfaction plays a major role in civil disorders. Discontent with one's present circumstances prompts demands for change. Lower-class leftist radicalism is commonly viewed as dependent on frustration with life situations.[4]

Challenge to traditional authority also stems from the assessment of one's personal ability to effect change. People who feel that they cannot control what happens to them in life or that their hard work is not rewarded feel powerless to engage in political action. People with a strong sense of personal competence are most likely to engage in direct action, because they believe their efforts can be instrumental. Participants in and supporters of the urban riots of the late 1960s were generally characterized by a sense of personal competence. In Detroit and Newark black riot participants had a stronger sense of personal control. Black high-school students in Detroit exhibited a strong relationship between personal control and approval of riot activities. Similarly, attitudes of self-pride and efficacy distinguished black militants and nonmilitants among black urban dwellers. Yet successful people can also be more reticent to acknowledge discrimination. Having effectively handled their own lives, they favor individual or conventional political efforts rather than collective action to solve problems. The powerless are the ones who voice their discontent through expressive, short-term, protest activities.[5]

The strategy adopted for promoting change also depends on one's evaluation of political institutions, their responsibility and effectiveness. People acknowledge that individual efforts and achievements cannot solve problems and that group action is thus needed when the grievances being raised are legitimate ones, the government is held responsible for solving these problems, and the people cannot influence the political decisions addressed to these grievances.

Perceptions of discrimination act as a justification for pursuing collective solutions to people's problems. Most Americans see hard work and self-sacrifice as the keys to personal and material satisfaction. This emphasis on individual effort assumes equal access to social

rewards. Anyone who works hard can succeed. When people are systematically denied equal opportunity or access through discrimination, it blocks their opportunities for individual achievement, which leaves few alternatives to collective action. In 1972 many people (70 percent) believed that discrimination was a problem in this country. This sense of injustice predisposes people to support collective action.

People also band together to change public policy when they believe that public officials have not responded to their needs.[6] Support for protest comes from a recognition that the traditional channels of redress do not work. When people believe that the political decisionmakers express their concerns, they have no need to alter the public agenda through protest. When they feel, however, that the democratic process is not responsive to citizen demands, they may support the use of extralegal means of voicing grievances. Half the people in 1972 did not see the political system as responsive to their needs. Disaffection from the traditional channels of political expression sensitizes people to the need for collective action.

All these motives for collective action derive from either self-interest, political values, or group consciousness. People who support collective action and protest tactics because of a strong sense of personal dissatisfaction or a lack of ability to control their lives act out of concerns that focus on their individual well-being rather than concerns for their group or a sense of how society ought to be. Ideology and evaluations of American society, such as perceptions of discrimination or the responsiveness of politicians to the people, illuminate the ways in which political values shape support for protest politics. Support for feminism is based on people's support for social equality, or values, as well as on the extrapolation of personal problems to the group, or consciousness. Since both men and women have feminist sympathies, part of what is called women's consciousness is based on values. The unique influence of feminist consciousness that derives from personal experience rather than a belief in social equality is captured by comparing the impact of men's feminist views on support for the politics of the women's movement to the impact of women's views. Men's views are based on values thus the difference between men and women captures the unique contributions of feminist concerns based on personal experience.

Self-interest, values, and group consciousness each had an impact on whether people opted for collective action, supported the women's movement, and approved protest tactics. In 1972 people supported protest politics for a variety of reasons, from having feminist concerns and being liberal to feeling the government was not responsive to the public and a belief that they can control their lives. The study also showed that men's support for movement politics was based on values

while women's support was rooted in group consciousness (Figure 8.1).

Collective Action

People turn to joint action as the only way of ending sex discrimination primarily because they are feminist. They blame women's problems

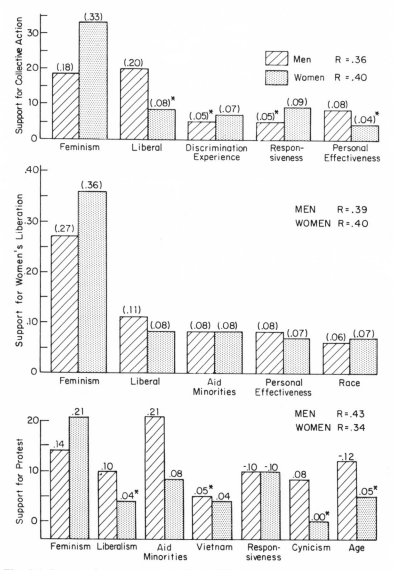

Fig. 8.1 Support for movement politics, 1972

on social customs and institutions, which they argue cannot be re-shaped by the efforts of individuals. People cannot work hard and be successful until equal opportunity is a reality. Until then, group effort provides the only way of demonstrating political clout.

While feminist men and women are both likely to favor collective action, their approval is strongly affected by gender. Men and women can be equally supportive of women's rights, but women in 1972 were much more likely to translate these concerns into support for group action ($b = .33$) than were men ($b = .18$). The impact of feminism on men's support for collective action to end sex discrimination shows the degree to which their feminism derives from an ideological concern independent of personal experience. The difference in the importance of feminism for women's evaluations in comparison to men's is quite large, illustrating the added significance in the meaning of feminist concerns for women. Thus consciousness facilitates support for collective action among group members, while ideology brings sympathizers to the feminist cause.

Unlike women, who opted for collective action over individual effort as a consequence of their feminist concerns, men supported collective action because they recognized the need for expanded political efforts to change society. For men, this decision was rooted in liberal ideology ($b = .20$). In contrast, liberal political beliefs had an insignificant impact on women's choice of strategy for effecting change ($b = .08$).

Men and women also differed in other ways as to why they favored a collective effort to end sexism. Women endorsed the need to work together when they felt that people were generally denied equal opportunity ($b = .07$) or that government officials were not responsive ($b = .09$), but the impact of these opinions on the mobilization of a feminist constituency among women was small relative to the influence of feminism.

The women who challenged sexist customs and discrimination in 1972 were not, as the media suggested, militant simply because they were unhappy, unattractive, or incapable. Feminist women were no more dissatisfied or lacking in self-confidence than were nonfeminist women ($r = .07$). Feminists were rated as having an attractive appearance by the interviewers conducting the 1972 study. Frustration and personal failings also had nothing to do with the choice of political strategy ($b = .04$). Women supported collective action because they had experienced the limitations imposed by role constraints and discrimination.

Men favored collective efforts to change social institutions primarily because they were liberal. The expansion of women's opportunities was one dimension of the liberal agenda. Being profeminist has far less influence on men's choice of strategy than on women's.

Men's judgments were not based on other aspects of the political climate, such as perceptions of discrimination as a national problem ($b = .05$) or the responsiveness of public officials ($b = .05$), which predisposed women to choose one strategy over another. Personal characteristics, however, played a small but significant role in shaping men's views. Men who felt that they had little control over their lives argued that women cannot change things simply by working hard ($b = .08$). For these men, life did not work that way.

Women's Liberation

People's support for feminist politics is also defined by their support for specific protest tactics used by the women's liberation movement. The media portrayed "Libbers" as angry, flamboyant women who were not serious about politics. Reactions to the women's movement are based on whether people favor changing women's status. Traditionalists in 1972 were hostile (40 percent) or at best neutral (40 percent) toward feminist efforts. Feminist men (64 percent) and women (74 percent) provided the support base for the movement. Still, a fair number of men (36 percent) and women (26 percent) who supported feminist arguments did not sympathize with the women's liberation movement because of the image that the activists were attributing to feminism.

People favor or oppose women's liberation for a variety of other reasons. Feminists were likely to be liberal ($r = .27$) and to favor civil rights ($r = .28$). Since the women's movement echoes concerns of the civil rights movement, people in favor of government aid to minorities also favored a movement that pressured officials to ensure sex equality ($r = .19$). The women's movement drew support from liberals as well ($r = .19$).

Feminism is nevertheless the most important determinant of support for the women's liberation movement. People's support for the women's liberation movement is based on specific women's rights issues rather than on a general effort to bring about social justice. The mobilizing potential of feminist views is also tempered by gender, as in the case of support for collective action. Feminist women were more likely to support the women's liberation movement ($b = .36$) than men with feminist views ($b = .27$). This difference in the impact of feminist concerns in generating support for the women's movement illustrates the significance of experience as compared to ideology alone. The women's movement also found political allies among liberal men ($b = .11$) and, to a lesser extent, among liberal women ($b = .08$), and some people translated their feelings of personal helplessness to a need for a political movement ($b = .08$ for men; $b = .07$ for women). But once again, the degree to which these personal and political views

stimulate support for the women's movement is weak in comparison to being feminist.

The growth of the feminist movement was fostered by the emergence of feminist consciousness. The importance of consciousness for support of the women's movement underscored the fact that even though women's organizations had lobbied for the ERA since 1923, they were unable to mobilize public support for this amendment prior to the early 1960s when traditional attitudes had changed. Furthermore, attitudes toward traditional sex roles and equal opportunity changed rapidly during the 1960s, allowing for public discussion of the women's liberation movement.[7]

Although the development of consciousness preceded the women's movement, the efforts of the movement in turn facilitated the growth of feminist consciousness. Once the mass movement was established in 1970, the relationship between consciousness and feminist activism reinforced each other. Attitudes toward women's roles have become more consistent since the women's movement has been educating people on how to think about women's problems.[8]

Positive evaluation of the women's movement can also reflect support for movements to ensure equality across the board rather than for women per se. Since consciousness reflects women's evaluations of political efforts on their own behalf, it exerts a different priority in shaping women's attitudes toward the women's movement in comparison to feminists' evaluations of the problems of other groups. Women's feminist views do not influence attitudes toward other contemporary protest groups, such as radical students and civil rights leaders, the same as they influence evaluations of the women's movement; they do not reflect a concern for social equality rather than a feminist consciousness.

Women's support for the women's liberation movement in 1972 was based primarily on their feminism ($b = .38$). In contrast, women's feminist views played no part in their evaluation of the legitimacy of radical students ($b = .06$) and exerted a relatively weak influence on their assessment of civil rights leaders ($b = .13$), (Figure 8.2). Women support other social movements because they are liberal, believe that government has a responsibility to aid minorities, and find that people's lives are hampered by discrimination. The influence of feminism on men's evaluation of protest groups was relatively constant, playing a salient role in their support for both the women's movement ($b = .22$) and civil rights leaders ($b = .21$) and a lesser role in their evaluation of radical students ($b = .10$).

Feminist men's and women's evaluations of women's liberation and other protest movements further illustrate the special role played by consciousness in mobilizing group conflict. For men, feminism is an abstract assessment of women's unfair treatment. This value judg-

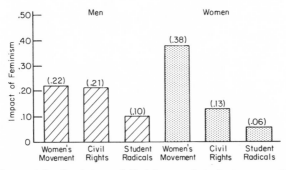

Fig. 8.2 Support for feminism, civil rights, and student power, 1972

ment is part of a general support for challenging conventional customs and authorities that also translates into support for civil rights and student power. The link of feminism to daily experience explains why it is a much stronger influence on women's evaluation of their own movement. For feminist women the question of social justice is coupled with issues of personal survival that propel them to support the women's movement.

Protest Tactics

The success of protest movements in the 1960s and early 1970s depended, in part, on public approval of protest tactics to raise political grievances. While the protest tactics of the women's liberation movement were not always treated favorably or taken seriously, the public did recognize that there are times when protest is necessary. Women approve the use of such tactics for different reasons than men. Women supported protest efforts in 1972 because they were feminist ($b = .21$). Feminism, rather than a liberal perspective ($b = .04$), endorsement of civil rights ($b = .08$), or opposition to the war in Vietnam ($b = .04$), was the primary and overriding reason for tolerating demonstrations once conventional methods fail. Men were most likely to approve of protest if they felt that the government should help minorities ($b = .21$). Being liberal ($b = .10$), young ($b = -.12$), feminist ($b = .14$), and skeptical of public officials ($b = -.10$) also led men to accept mass action in 1972. The fact that women evaluated political grievances on the basis of feminist concerns to a greater degree than men once again illustrates that their feminist concerns form a political consciousness that is central to how women evaluate protest politics in general as well as feminist efforts specifically.

The emergence of the contemporary feminist movement is typical of the mobilization of rights-seeking groups in general. Thus the role of consciousness, which plays a critical role in creating a feminist

constituency, is just as critical for other social movements, including the civil rights movement. The constituency mobilized by the black movement in 1972 was about as large as the constituency for the women's movement (22 percent of the electorate). While both men and women were equally supportive of direct action to end sex discrimination, blacks were much more convinced of the need for pressure-group politics to end race discrimination (38 percent) than were whites (20 percent). Yet even in the context of the civil rights movement, the ideology of individual achievement as a vehicle for social change predominated. The majority (62 percent) of blacks did not think that group pressure and social action were the best ways to overcome discrimination.

Blacks who felt that racism thwarted their efforts to work hard and fit in were most likely to argue that collective action was the only viable strategy ($r = .46$). Whites who acknowledged discrimination also saw the need for pressure politics but were less supportive of collective action ($r = .33$). As in the case of feminism, nonmember sympathizers favored action because they had liberal political views ($r = .26$).

Race-based differences in the perception of discrimination and support for collective action provide further evidence that consciousness is a catalyst for group mobilization (Table 8.1).[9] People who deny that race discrimination is a problem do not organize around this issue. The number of people likely to favor collective action increased considerably among both blacks and whites who argued that racism deprives blacks of economic opportunities, even after the

Table 8.1. Race consciousness and collective action, 1972.[a]

	Support for collective action	
Awareness of race discrimination	Whites (n = 1299)	Blacks (n = 106)
None	14%	6%
Little	22	20
Some	31	43
Lot	43	69

Source: CPS 1972 National American Election Study.
a. Predictions based on probit estimates from multivariate equations.

influence of ideology and positions on Vietnam and sex equality were removed. Although few whites (12 percent) consistently argued that racism explained why blacks faced economic hardship, those whites who did were likely to see pressure politics as the only solution. However, blacks who believed that they faced substantial discrimination were much more likely to favor collective action (69 percent) than whites (43 percent). This large difference in support among sympathizers and group members demonstrates the importance of linking abstract principles to daily experience in order to mobilize support for collective action on behalf of minority groups.

When women or blacks see themselves as victims of discrimination, they see their personal achievement as tied to group action. Men and whites may agree that the only way to end discrimination is through collective effort, but their lives are not directly hampered by the discriminatory customs and laws. Nongroup members are motivated by value judgments and ideological concerns. Their activism is not linked to a sense of survival. While they form an important part of the sympathetic audience needed to pressure politicians to bring about change, the absence of personal urgency means that discrimination is not central to their understanding of how to change the political agenda in order to address minority group concerns.

The Movement in 1976

Consciousness involves more than a concern for women's issues. It is central to women's political self-definition and therefore has long-term implications for group politics. Feminism needs to continue to influence women's future involvement in politics for consciousness to have real political significance. The political consequences of feminist consciousness were not limited to the early 1970s when feminism appeared as a new issue. Women's rights continued to provide a political stimulus once the feminist movement was underway.

During the four years following the 1972 elections, issues associated with women's role received increased attention. Sex discrimination charges were filed against major companies, educational institutions, and unions. The first national convention held by the NWPC was attended by over 1,500 women. NOW membership grew from 750 to more than 40,000 members. Policy positions on problems of job discrimination, day care, displaced homemakers, and violence against women were discussed in legislatures, on television, and the home. Legislative landmarks included the Women's Education Equity Act and the Equal Credit Opportunity Act.

By 1976 the women's movement had matured. Vietnam was a moot point, and the civil rights movement was dormant. Tolerance of pro-

test in general increased during this period of "normalcy." Most people (70 percent) accepted the use of protest for specific causes. Men and women were equally likely to support such protests.

There was also increased acceptance of the feminist critique and the women's movement. The mean level of feminist orientation increased for both men (10.9) and women (13.0), but unlike 1972, women were significantly more feminist than men. The mean level of support for the women's liberation movement also grew over these years, with women showing significantly more enthusiasm for the movement (56.0) than men (53.9). A public poll found that many people (85 percent) felt that women's lives had improved over the years. Moreover, the majority of women (84 percent) attributed this improvement to the efforts of feminist organizations.[10]

Though the women's movement was no longer new, feminists continued to see unconventional politics as necessary strategies for attaining sex equality, and the sex differences observed in 1972 persisted in 1976 (Table 8.2). Feminist women were more likely to see collective action as the only way to end sex discrimination ($b = .29$) than men were ($b = .19$), even after the influence of ideology, evaluations of American society, and assessments of personal abilities were removed. Feminist concerns persisted in having a stronger influence on women's evaluations of collective action than they did on men's, illustrating the greater saliency of political views that arise from personal experience. The women's liberation movement still found support among feminist men, but the gap between feminist men ($b = .27$) and women ($b = .44$) had grown wider. Once again, the fact that after four years feminist concerns had a stronger impact on women's as-

Table 8.2. Feminism and protest politics, 1972–1976.[a]

	1972		1976	
Approval	Men	Women	Men	Women
Collective action	.18	.33	.19	.29
Women's liberation	.27	.36	.27	.44
Protest	.14	.21	.03[b]	.25

Source: CPS 1972 and 1976 National American Election Studies.

a. Standardized coefficients for feminism controlling for liberalism, aid minorities, government responsiveness, personal effectiveness, and age. For full equation, see Tables A7–A9.

b. Not significant $p > .05$.

sessment of the women's movement illustrates that consciousness persists in having a stronger impact on political assessments than does sympathy. Feminist women are much more supportive of the women's movement.

While both men and women were more supportive of protest politics in 1976 than they had been in 1972, feminism did not influence men's approval of using protest tactics ($b = .03$) once the drama associated with women's rights subsided. Men supported protest tactics if they were young ($b = .17$), liberal ($b = .08$), and in favor of civil rights ($b = .12$), independent of whether they were feminist. Feminist women were much more likely to approve the use of unconventional methods than traditional women ($b = .15$).

Women with feminist views provide the core of support for the women's movement. In 1972 feminist women had been more likely to support collective action to end sex discrimination, favor the women's liberation movement, and give conditional approval to the use of protest tactics in order to make politicians responsive to new grievances. Four years later, feminism continued to play a primary role in shaping women's attitudes toward protest. The influence of feminism on men's views, however, was greatly reduced. These dramatic differences illustrate that feminist consciousness has a greater impact on long-term evaluations of protest politics than do feminist sympathies based on ideological concerns.

In short, people who recognized the need for collective action and accepted the use of protest tactics provided a critical base of support for protest movements of the 1960s and early 1970s. Their concerns were used to reenforce the claims of protest groups by expanding the number of people who felt strongly about issues such as peace, civil rights, the poor, and women's rights, and about pressuring politicians to address these concerns. By 1972, a substantial segment of the public was supportive of feminist claims and strategies for addressing women's grievances. Men and women were equally feminist in their orientations and equally supportive of the need for collective rather than individual action to end sex discrimination, the specific efforts of the women's liberation movement, and the need to use protest tactics such as demonstrations when conventional methods fail.

Feminist orientations influenced the political views of both men and women but to a different degree. The fact that feminist women were much more supportive of group action and the women's liberation movement underscored the importance of consciousness. People who were not members of the minority group could be sympathetic to the demands of that group. They could also become politically active when the group's issues were placed before them. But as more issues got raised, nonmembers had an expanded set of problems over which they must divide their time.

Support for women's rights and feminist protest grew until by 1976 feminism was clearly on the political agenda as a legitimate concern, partly as a consequence of mounting public support. As the nature of women's problems received increased coverage, sex differences began to emerge, with women moving in the feminist direction more rapidly than men. By 1976 women were more feminist in their orientation and more favorable to the women's movement than were men.

There are multiple reasons why people lend their support to protest politics. These motivations include self-interest, political values, and group consciousness. Each of these factors played a role in gaining support for feminist protest. The reasons that people lent their voice in support of the feminist movement, however, were shaped by gender.

Self-interest, personal dissatisfaction with one's life, or a sense of inability to control life's outcome played a minor role in motivating support for protest. For men, a sense that they were unable to shape their own lives did provide some motivation to seek collective rather than individual solutions to women's problems in both 1972 and 1976. Men who felt that they had little control over their lives were also slightly more favorable to the women's movement in both years. For women, self-interest, in terms of either having life satisfaction and control or having nontraditional roles that require economic independence and prompt women to demand change in order to improve their own circumstances, played almost no role in determining their evaluations of protest politics. Only in evaluations of the women's movement were women who felt that they lacked control over their own lives somewhat more favorable than were women with a greater sense of personal ability.

Men supported feminist protest because they believed that the government has a responsibility to ensure social equality. Liberal political views and a belief that the government has an obligation to help minorities had a stronger impact on why men supported collective action to end sex discrimination and the general use of protest in both 1972 and 1976 than did their specific concerns for women's rights. Men evaluate the legitimacy of protest groups in terms of the political values they raise. Concern for women's rights did lead men to support feminist protest in 1972 and to lesser extent in 1976, but feminism was only one of several value filters that men used to determine whether women's protests were legitimate.

The political power of the women's movement grows as people increasingly accept the strategies and tactics used by feminist activists to attain sex equality. The continuance of this support and influence relies on the vigilance of women. While men also support feminist

politics and lend political clout to women's protest efforts, their support is more tentative than women's, since women confront the difficulties of sex discrimination in their daily lives. The growth of a feminist consciousness assures that women will continue to place feminist issues before the public and to seek political solutions to women's problems.

nine

The Women's Vote

Despite their dissatisfaction with traditional strategies for change, feminist organizations have not abandoned conventional politics. After all, this movement is rooted in the century-long struggle to win women citizens the right to vote. A sympathetic electorate provides feminist organizations with an essential political resource. The success of the women's movement depends in part on its ability to translate concerns for women's issues into votes.

A women's vote is not necessarily a feminist vote. A women's vote is shaped by sex differences in party preferences, policy options, and candidate choice. Throughout the 1970s men and women differed on issues of violence, militarism, and the environment. When these issues influence men and women's choice of candidate they contribute to a women's vote.

A feminist vote emerges when issues of women's rights such as ERA, abortion, day care, and improved employment opportunities for women influence one's candidate choice. A feminist vote is not limited to women. Feminist concerns may influence men's vote decision as well. But because of the power of group consciousness, feminist concerns should have a much greater impact on women's vote choices than on men's. The emergence of either a women's vote or a feminist vote has important political implications because it forces politicians to recognize that women form a political group or constituency and provides pressure to have women's concerns taken seriously.

A women's or a feminist vote determines how voters decide upon the appropriate candidate. This voting decision is based on at least three different factors: party affiliation, policy preferences, and candidate preferences.[1] A women's vote emerges if men and women have a different understanding of what is best for the country or what is best for women and these sex differences in concerns are reflected in their candidate choice. Since party identification provides a guide for understanding political issues and evaluating candidates, a women's vote can also result if women become more allegiant to one party in greater proportions than men. If women, like blacks and blue collar workers, become more identified with the Democratic party, there can be a party basis for the women's vote. And because the vote decision also represents a choice among different policy options offered by the candidates, a women's vote emerges if women vote for a candidate for reasons different from why men vote for their candidate. There can be a women's vote even when men and women vote for the same candidate so long as women vote for that candidate for reasons that are different from men's reasons. Blacks, blue collar workers, Jews, and the elderly tend to vote for the Democrats but for different reasons. If women vote for the Democrats because of the party's position on social services or defense spending while men support the Democrats because of unemployment and labor issues, there is a women's vote irrespective of the fact that both men and women voted for the Democrat.

A feminist vote emerges when people take the candidates' positions on women's rights issues into account when making their vote choice. For example, if a candidate's position on ERA or equal pay influences whether men or women vote for him or her, there is a feminist vote. The feminist vote illustrates the political importance of a sympathetic electorate for the success of protest movements. Politicians respond to minority group demands once public opinion supports their grievances. The emergence of a feminist vote provides a way of sustaining legislative pressure for addressing women's rights. When feminist concerns have a stronger influence on how women vote than on men, it illustrates the bridge that consciousness provides between personal experience and political action.

The importance of a women's vote in general and of a specifically feminist vote in shaping American politics is determined by studying the vote decision in the three Presidential elections following the emergence of the women's movement in 1970. The national studies of the electorate conducted in 1972, 1976, and 1980 reveal the party, policy, and candidate preferences of voters in each election. These voters' views help to determine whether men and women approach

politics from a different perspective and whether feminist concerns shape people's political assessments.

The Women's Vote, 1920–1968

The claims for the women's vote have differed through history. The suffragists first claimed that the women's vote would make good mothers. Then they argued that the vote would help women to reform politics and to protect the family by supporting legislation for improved sanitation conditions, consumer protection, and restrictions on child labor. The opponents of woman suffrage also feared the influence of women at the polls. The liquor industry, for example, worried about prohibition, while urban machines dreaded the potential for "clean-up" campaigns.[2]

Both sides thought that women would vote as a cohesive group. The suffragists based their hopes on scanty evidence, which included their helping elect a reform mayor in Chicago in 1915. In 1918 they helped defeat the antisuffrage candidacy of John Weeks for Senator in Ohio and registered 21,000 new voters to defeat an incumbent Ohio mayor of sixteen years.

After passage of the Nineteenth Amendment in 1920, female reformers were at first very successful in their legislative efforts. Congress passed a health care education bill for mothers, a consumer protection bill, a bill reforming citizenship requirements for married women, and a bill upgrading the Civil Service by implementing a merit system. These pieces of legislation were passed largely in anticipation of a women's vote.

But the women's vote failed to materialize. Women did not vote in great numbers during the 1920s. The sex difference in turnout ranged from 20 percent to 30 percent in Chicago in both the Presidential elections of 1916 and 1920 and the mayoral elections of 1915 and 1919. Only a third of the eligible women voters actually cast a ballot in their first Presidential election in 1920. Many women who eventually participated (24 percent) waited until the 1928, 1932, or 1936 elections to cast their first vote.

Throughout this period, sex differences in turnout were greatest in groups where sex role differences were most marked. Immigrant, rural, Southern, and poor women voted in considerably smaller numbers than did men, while the turnout rate of native-born, middle-class women was much closer to that of men. In both the 1920 general election and the 1923 mayoralty race in Chicago native-born women, particularly those who were middle class, voted at rates only slightly lower than those of men, while the participation rate among ethnic women was substantially below the male rate. The immigrant women

were far more likely than native-born women to believe that women's place was in the home and men's business was to attend to public affairs. As the years passed, women remained politically inactive. Moreover, those women who did vote tended to vote like men. Party affiliation, religion, class, and ethnicity, not sex, influenced voting choice.[3]

Women did not vote in great numbers until after the Depression. New Deal Democrats deliberately appealed to women and mobilized them to support Roosevelt's domestic policies. In 1936 Eleanor Roosevelt and Mary Dewson, who served as head of the Women's Division of the Democratic Party from 1932 to 1937, organized 60,000 women to canvass for the Democrats door to door. Even with this effort, women's voting rate in 1940 was still considerably lower (49 percent) than men's was (68 percent). Indeed, the voting turnout among women remained noticeably lower than that among men for the next quarter-century. As late as 1960, women's participation rate was 11 percent below that of men.[4]

Voting is a type of behavior that is learned through repetition. Having voted once, a person is far more likely to vote again. But the development of this habit requires time and experience. Many older women raised prior to women's suffrage, when women had been taught that politics was men's domain, never crossed that barrier against electoral participation. By the end of World War II, however, the next generation of women were more politically active. A majority of eligible women voters (59 percent) cast a ballot in the 1948 election. They were just beginning to move into range of the higher male turnout rate (69 percent).

Twenty years later, the tide finally turned when women's voting rate caught up with that of men. In 1968 roughly the same proportion of the eligible male electorate (69 percent) and the eligible female electorate (66 percent) voted for either Richard Nixon, George Wallace, or Hubert Humphrey. Women comprised slightly over 50 percent of the eligible voters in this election. Women were less likely to vote for Nixon (40 percent) than for Humphrey (46 percent). Working women were most supportive of Humphrey's candidacy (52 percent). Since Nixon's victory was extremely close, by a margin of only 510,000 popular votes, the outcome could have been reversed if women's turnout had been higher.

As the 1972 election approached, pollster Louis Harris noted "many signs that women are now playing for keeps in politics more than any time in the past." Changing attitudes toward women's status pointed to "growing confidence, determination, and bitterness that combine to make a political explosion of woman-power in American politics." The stage was set for women's activism to influence electoral outcomes.

The 1972 Election

The major problems addressed in the 1972 campaign explain Nixon's landslide victory as well as the rise of the feminist vote in that year.[5] Both McGovern, the Democratic candidate, and Nixon, the Republican, saw the Vietnam War as the most critical issue of the election. McGovern held Nixon responsible for prolonging the war by invading Cambodia in 1970, giving United States air support to the South Vietnamese invasion of Laos in 1971, and bombing Hanoi and Haiphong in 1972. Morally opposed to any further involvement in East Asia, McGovern tried to make the election a referendum on immediately ending the war. Nixon also campaigned on ending the war, but he focused on a negotiated peace treaty. Stressing that he had inherited the war from the Democrats, he cited the reduction in United States troop involvement during his first term from 549,500 to 139,000 to prove that he was indeed getting the soldiers home.

By 1972 most Americans had given up on military victory and were looking toward a diplomatic solution short of surrender. McGovern counted on strong support from women because he shared their commitment to peace. However, both men and women favored a nonmilitary solution to the problem. Women leaned only slightly more strongly toward immediate withdrawal (28 percent) than men did (24 percent).

The economy was another critical issue for each candidate. Unemployment had risen to 5.6 percent, and the inflation rate was 4 percent. Nixon declared a readiness to adopt wage and price controls in order to take command of events. He pressed for a family assistance program in order to reduce the welfare lines, and he promoted revenue sharing as a means of distributing funds to state and local governments. McGovern's economic policies underscored the hardships facing the poor, and he stressed the need to redistribute wealth, guarantee jobs, and provide a decent standard of living. The welfare system was to be replaced with an income maintenance program. In part, the revenues needed to run these new programs would come from cuts in defense spending.

Most of the American electorate (58 percent) thought it imperative for the government to take action to alleviate the financial hardship facing American families. But while people felt that it was appropriate for the government to interfere in managing the economy in order to end inflation, they did not feel that it was the government's responsibility to provide jobs and a decent standard of living. Traditionally, women are viewed as more concerned about social programs than men are. McGovern hoped that women's compassion for the needy would lead them to vote for these programs. But women were only slightly less inclined (32 percent) than men (39 percent) to maintain that people should have to get ahead on their own rather than

relying on some form of government assistance. For the most part, the electorate favored some middle ground.

Race relations also played a prominent role in this election. Nixon became the first Presidential candidate from a major party since the Brown decision of 1952 to campaign actively against forced busing. Nixon wanted a society in which people had both the ability and the right to choose where and how they lived. McGovern strongly supported busing to achieve civil rights.

Most of the voting public at this time was adamantly opposed to taking children out of neighborhood schools (78 percent). But this consensus against forced busing did not reflect a rejection of all government responsibility to aid minorities. Many people (63 percent) still felt that the government should take at least some steps toward improving the social and economic positions of minorities.

Representation of minority interests, which included women's rights, was a serious issue for both major political parties in 1972. The Democrats altered their nominating procedures to allow women, minorities, and young people a greater voice in the Presidential selection process. Taking less formal measures, the Republicans also increased women's participation in their national convention.

Feminist organizations supported McGovern in 1972 because of his role in drafting party reforms to increase women's access to decision-making positions and his advocacy of women's rights. They threw their support behind McGovern early in the primary season and mobilized an impressive force of grass-roots activists committed to women's issues. This unprecedented involvement of women in primary campaigns was dubbed "the Nylon Revolution."[6]

Contrary to expectations, once McGovern's nomination was secured, women's issues became peripheral to the campaign. Both Nixon and McGovern paid lip service to feminist aspirations but avoided commitment to specific policies and goals. The electorate, however, expressed strong support for role equality. In fact, men were slightly more supportive of women having equal roles in running business and government (52 percent) than women were (47 percent).

In short, the 1972 campaign was billed as a mandate on Vietnam, busing, an economic performance, with no mention of women's rights. When faced with these issues, the majority of voters leaned toward a negotiated solution to the war, strongly opposed busing while accepting the need for other government action to help minorities, and wanted government intervention to end inflation but no government intervention to ensure economic well-being. While women's rights was not a prominent campaign issue, the majority of voters felt that men and women should have an equal role in running business and industry.

People's vote choices are based on their evaluations of the issues,

the parties, and the candidates. There was little basis in the issues for a women's vote in 1972, because there were few differences in the policy preferences of men and women (Table 9.1). The similarity in the views of each sex went beyond the major campaign issues to include women's rights. The absence of sex differences in support for sex equality suggests that men and women were equally concerned about women's rights.

People's vote choices are also determined by their evaluations of the parties. But in 1972 there was no basis for a women's vote in terms of sex differences in party identification. Men and women were no more likely to support one party over another ($r = .02$).

Party alignments can also be divided along feminist and traditionalist lines rather than along sex differences. But in 1972 traditionalists were no more likely to favor the Republicans than feminists were to support the Democrats. Traditional men and women were somewhat less likely to identify with the Democrats (35 percent) than strong

Table 9.1. Voter preference on campaign issues, 1972.

Issue	Men	Women	Issue	Men	Women
Jobs			*Inflation*		
Government provide	15%	18%	Government end	45%	45%
	9	8		14	12
Middle/no opinion	37	42	Middle/no opinion	33	38
	13	10		4	2
Get ahead on own	26	22	No government action	4	3
Aid minorities			*Busing*		
Government help	15	16	Bus to integrate	7	8
	10	10		3	2
Middle/no opinion	42	44	Middle/no opinion	12	13
	10	8		3	3
Help themselves	23	23	Keep in neighborhood	76	75
Vietnam			*Women's role*		
Immediate withdrawal	24	28	Equal	44	41
	12	11		8	6
Middle/no opinion	34	39	Middle/no opinion	18	22
	11	9		7	6
Military victory	19	13	In the home	23	25

Source: CPS 1972 National American Election Study.

feminists were (41 percent), but this difference stemmed from the fact that feminists were likely to be liberal and liberals were somewhat more attached to the Democrats ($r = .20$). The relationship between feminism and Democratic partisanship ($r = .12$) disappeared once people's liberal political views were taken into account ($r = .04$). The absence of a feminist-based party alliance was true for both men and women.

The third basis of people's voting choices is their evaluation of the candidates. This kind of evaluation, however, cannot be divorced from personal preferences based on partisan attachments. Citizens' perceptions of candidates' stands on issues are linked to their own preferences. Voters may project their position onto a candidate they like for other reasons, often because the candidate is the representative of their own party, or voters may exaggerate the distance between themselves and a candidate they do not like. Favored candidates can also persuade voters to move in a direction more in line with the candidates' views.[7] For a very favorably evaluated candidate, voters projected away up to 25 percent of any difference between the candidate's position and their own position on issues. The voter's proximity to a candidate on a campaign issue captures both the voter's affect toward a candidate and the voter's evaluation of the candidate's positions.

When people's preferences were linked to their perceptions of the candidate's positions, men and women shared similar evaluations of which candidate would best implement their preferences. Nixon emerged the preferred candidate on all the major issues: jobs (47 percent), busing (46 percent), and Vietnam (53 percent). However, McGovern's objective stance was not radically different from public opinion. On most issues (70 percent) McGovern was in agreement with the opinions of the average American. People agreed with McGovern's position on withdrawing from Vietnam (62 percent), letting abortion be a matter between a woman and her doctor (64 percent), favoring national health insurance (69 percent), spending more to control pollution (80 percent), and increasing opportunities for blacks (67 percent) and for women (62 percent). Perceptions of McGovern as a left-wing extremist resulted from misleading attacks by his opponents and from objections to his style among the general public that were not related to issues.[8]

While voters of both sexes felt closer to the Republican candidate, Nixon had a larger or more decisive support base among men (Table 9.2). Men felt closer to Nixon's policy preferences than women did on most issues, including jobs (51 percent versus 43 percent), Vietnam (57 percent versus 49 percent), aid to minorities (44 percent versus 35 percent), and busing (51 percent versus 41 percent). These differences in commitment to Nixon are slightly inflated because more

Table 9.2. Voter proximity to candidates on issues, 1972.

Proximity	Men	Women	Men	Women	Men	Women
	Jobs		*Vietnam*		*Inflation*	
Closer to Nixon	51%	43%	57%	49%	36%	29%
No difference	27	32	16	23	40	44
Closer to McGovern	22	23	27	29	24	27
	Aid minorities		*Busing*		*Women's role*	
Closer to Nixon	44	35	51	41	23	19
No difference	37	43	28	36	58	60
Closer to McGovern	19	22	21	23	19	21

Source: CPS 1972 National American Election Study.

women reported a lack of opinion or ignorance on these issues than did men. When the views of only those people who held opinions are examined, men were still more committed to Nixon than women were on issues such as jobs (55 percent versus 48 percent), Vietnam (59 percent versus 53 percent), aid to minorities (48 percent versus 39 percent), and busing (54 percent versus 44 percent). Women were not as committed to the Nixon camp because they did not view McGovern's policies as being as far to the left as men did. When the public rated the candidates' issue positions on a seven-point scale in which 1 represented the liberal position and 7 the conservative position, men's average rating of McGovern's position on jobs, Vietnam, and aid to minorities was more liberal (2.4) than women's estimation of his position (2.7).

Nixon and McGovern presented the electorate with clear alternatives. When presented with such a choice, the majority of the electorate was able to recognize the difference. Nevertheless, on the one issue where the electorate was decidedly in the liberal camp, equal rights for women, most men (58 percent) and women (60 percent) saw no difference between Nixon and McGovern. Feminist activists supported McGovern as the champion of women's rights, but the majority of voters did not make this same association. People who supported equal rights for women were not more likely to vote for McGovern ($r = .07$). There was a surprisingly weak relationship between people's support for women's rights and a preference for McGovern's views on sex equality ($r = .16$).

This inability on the part of the electorate to identify McGovern as the better candidate on role equality may have been due to his

reticence to campaign on women's issues during the general election. Because McGovern assumed that the peace issue would mobilize the women's vote as well as the youth vote, he abandoned feminist issues and ignored the economic concerns of women traditionally aligned with the Democrats.[9] Both McGovern and Nixon supported the ERA, but neither addressed the issue of how their programs would benefit women. People who felt that either Nixon or McGovern was closer to their own position on women's proper role did support that candidate ($r = .33$). The large constituency (40 percent) that aligned itself with a candidate on women's rights issues was almost evenly divided into Nixon and McGovern supporters. As a consequence, popular support for role equality was not converted into an electoral base by either candidate.

Since policy, party, and candidate preferences are what bring voters to the vote decision, a women's vote or a feminist vote depends on the particular weight that voters give to these views in determining which candidate to support. A women's vote emerges when men and women vote for different candidates or when they vote for the same candidate for different reasons. A feminist vote emerges when the candidates' positions on women's rights issues influence how people vote. While women were somewhat more supportive of McGovern, Nixon captured the majority of both men's (68 percent) and women's (61 percent) votes in 1972. McGovern was largely unsuccessful in winning the votes of both men (32 percent) and women (38 percent). Still, men and women gave somewhat different reasons for deciding to vote for the Democrat or Republican candidate. For example, party attachment had a stronger impact on men's vote calculation ($b = .30$) than on women's ($b = .22$).

The issue preferences influencing men's and women's votes were also somewhat different (Figure 9.1). Vietnam was the dominant issue determining whether people would support McGovern or Nixon. Al-

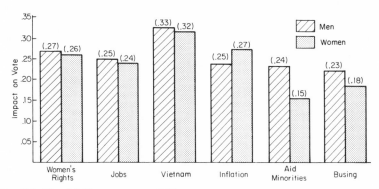

Fig. 9.1 The McGovern vote, 1972

though women are generally assumed to be more concerned about peace, voters' perceptions of the candidate's proximity to their own preferences for ending the war were equally important in the voting choices of both men ($b = .33$) and women ($b = .32$). Concern over the government's role in providing jobs and a decent standard of living, a compassion issue that is usually associated with a women's vote, was also equally important to men's ($b = .25$) and women's ($b = .24$) vote decision. Sex differences emerged on race-related issues. Men were more likely than women to weigh the candidates' positions on government aid to minorities ($b = .24$ for men, .15 for women) and busing to achieve integration ($b = .23$ for men, .18 for women), two issues on which they felt much closer to Nixon than to McGovern.

The efforts of feminist activists to sensitize the public on women's issues led to the emergence of a feminist vote in 1972. Candidate preferences on the basis of women's rights issues played a significant role in determining the vote. Men ($b = .27$) were as likely as women ($b = .26$) to translate their concern for women's rights into support for McGovern or Nixon. In the overall decision, however, sex equality played a relatively more important role in women's vote choice because women did not emphasize race-related issues as much as men did. This difference in emphasis meant feminist views had a larger influence on the average voting patterns of women than men.[10] The average male voter was a Democrat with a weak party attachment who favored Nixon's politics. The average female voter was also a weak Democratic supporter who leaned toward Nixon's policies, but not so strongly as men did.

Men and women who did not agree with McGovern's position on role equality did not vote for him (Table 9.3). His support among

Table 9.3. Predicted support for McGovern based on role equality issue, 1972.[a]

Position on role equality	Men	Women
Closer to Nixon	7%	16%
	12	23
No difference	18	31
	26	41
Closer to McGovern	36	52

Source: CPS 1972 National American Election Study.
a. Based on probit estimates in Table A10.

the average voters came from people who leaned toward Nixon's positions on the major campaign issues but felt closer to McGovern on the question of women's rights. Women were already more pre-disposed to vote for McGovern (31 percent) than men were (18 percent) even when they did not see any difference between the two candidates on the issue of role equality. Proximity to McGovern on feminist issues increased the probability of voting for him on the part of both men and women. Feminist women, however, were more likely to vote for McGovern (52 percent) than feminist men were (36 percent).

These 1972 voting decisions provided the underpinnings for both a women's vote and a feminist vote. Men and women decided upon their preferred candidate for somewhat different reasons. Although these differences were not striking, they showed that women approach political choices with a slightly different emphasis than men. The degree of this difference can vary, depending on the political climate.

In the 1972 election people's votes were influenced by their evaluations of the candidates' stands on role equality. This feminist vote went unnoticed because neither candidate capitalized on the popular support for women's rights. Many people did not see any difference between the candidates on this issue. Those people who did choose a candidate as being closer to their own preference on women's rights (40 percent) were equally divided between McGovern and Nixon. The years following the 1972 election, which were marked by political scandal, economic crisis, and a loss of public confidence in government, helped promote the emergence of a women's vote and a feminist vote in 1976.

The 1976 Election

Party loyalty, honesty, and unity were the themes of the 1976 campaign.[11] Gerald Ford, who ran as a moderate Republican, hoped to capture Nixon's previous support base by opposing busing, affirmative action, and the expansion of social programs. Appealing to values rather than issues, Jimmy Carter, the Democratic candidate, pledged to restore honesty and effectiveness to the Presidency. He courted traditional Democratic supporters by stressing party unity and anti-Republican slogans. Carter favored government efforts to end unemployment but did not embrace full employment. He supported busing but hoped to further integration through other means.

The preferences of the electorate on these issues were mixed. Men and women did not entirely agree on how best to address economic and social problems (Table 9.4). Both men and women felt that the government should reduce its efforts to guarantee people jobs (43

Table 9.4. Voter preference on campaign issues, 1976.

Issue	Men	Women	Issue	Men	Women
Jobs			*Insurance*		
Government pro-vide	12%	14%	Government plan	28%	27%
	10	9		7	7
Middle/no opinion	29	39	Middle/no opinion	27	29
	15	11		9	7
Get ahead on own	34	27	Private plan	29	30
Aid minorities			*Busing*		
Government help	14	17	Bus to integrate	7	6
	15	13		3	2
Middle/no opinion	28	35	Middle/no opinion	14	16
	14	10		4	5
Help themselves	29	25	Keep in neighborhood	72	71
Women's Role					
Equal	43	45			
	11	7			
Middle/no opinion	27	24			
	8	8			
In the home	11	16			

Source: CPS 1976 National American Election Study.

percent) and to help minorities (39 percent). The majority of people continued to oppose busing to achieve integration (76 percent). While both men and women opposed active government involvement in providing jobs or helping minorities, men were more likely to stress self-help. More men favored people getting ahead on their own (49 percent) than women did (38 percent). Men also stressed that minorities should help themselves (43 percent) somewhat more than women did (35 percent). These differences, while not overwhelming, once again suggest that men and women place somewhat different emphasis on their expectations from government policy, with women favoring a more activist government.

Feminist activists worked hard during the campaign to keep women's issues, particularly ERA, before the public. People were basically supportive of women having an equal role in business and government. The majority of both men (54 percent) and women (52 percent) supported role equality. Both men and women thus agreed on the

question of women's rights, and this concern formed the basis of a feminist vote.

The potential for a women's vote in 1976 was not rooted in partisan differences, because there was no difference in the party attachments of men and women ($r = .01$). Both feminist men ($r = .08$) and feminist women ($r = .11$) leaned slightly toward the Democrats. This relationship, however, was a function of their being liberal rather than feminist. People who strongly supported role equality did not feel drawn to either of the two major parties on the basis of this issue once the influence of their political ideology was taken into account ($r = .03$).

Men and women did have different preferences for candidates based on their policy concerns. Both candidates took centrist positions on the polarizing issues of the previous campaign: jobs, busing, and aid to minorities. Consequently, the basis of candidate support was less clearly delineated in 1976 than in 1972 (Table 9.5). Still, many voters saw some difference between Ford and Carter on the issues of jobs (58 percent), aid to minorities (47 percent), busing (68 percent), and health insurance (47 percent). People who distinguished the candidates on these issues divided almost evenly in their support. Men were closer to Ford's reluctance to promote government's role in ensuring jobs (40 percent) than women were (27 percent), agreed more strongly with Ford's views on providing health care (30 percent) than women did (21 percent), and agreed more often with Ford's opposition to busing to achieve integration (31 percent) than women did (24 percent). None of these differences, however, approached the party cleavages found in the previous election.[12]

Table 9.5. Voter proximity to candidates on issues, 1976.

Proximity	Men	Women	Men	Women	Men	Women
	Jobs		*Aid minorities*		*Busing*	
Closer to Ford	40%	27%	28%	22%	31%	24%
No difference	37	47	49	56	39	45
Closer to Carter	23	26	23	22	30	31
	Health insurance		*Women's role*		*Candidate for women*	
Closer to Ford	30	21	13	14	11	13
No difference	47	58	70	68	77	73
Closer to Carter	23	21	17	18	12	14

Source: CPS 1976 National American Election Study.

Evaluations of candidates also included the incumbent's past performance. Most people felt that the government had not done a good job in managing the economy. Few men (11 percent) and few women (10 percent) gave the Ford administration good ratings on economic performance. Half the voters of both sexes saw no difference between the parties on economic performance. Those voters who saw a difference favored the Republicans (34 percent) over the Democrats (16 percent), despite Ford's poor performance ratings.

Concern over women's rights never surfaced as a campaign issue. Both candidates supported the ERA and opposed abortion. Ford, however, favored a constitutional amendment banning abortion, while Carter opposed such an amendment.

There were other important differences between the candidates' stands on women's issues. Carter supported federally funded childcare centers and advocated a comprehensive child development bill to subsidize low income families. Ford felt that the family had primary responsibility for child care and, while President, had vetoed an act passed by Congress to provide federal funds for child care. Carter wanted to increase the enforcement of Title IX, especially in the area of women's athletics. Ford wanted to weaken existing regulations on athletics. Finally, Carter had had a much better record of appointing women while he was governor of Georgia. Ford's appointment record as President was considered unacceptable by women's groups.[13] Carter saw no value in publicizing these differences. As a consequence, most people (69 percent) saw Ford and Carter as leaning similarly toward nontraditional views on role equality. Those voters who did see a difference (31 percent) did not favor either candidate. In addition, most men (77 percent) and women (73 percent) did not think that the policies of either candidate would directly benefit women as a group. Once again, neither candidate was able to translate popular support for women's rights into an electoral base.

Women played a critical role in Carter's victory over Ford, because Carter received 49.7 percent of men's votes and 51.3 percent of women's. Since women are a majority of the voting population, representing 52.8 percent of the registered voters as of 1983, women can clearly provide the margin of difference between success or failure in a close race.

Both the Carter and the Ford campaigns promised a return to normalcy. Carter avoided divisive issues, choosing instead to promote unity, strength, and honesty. Each candidate hoped to capture the heart of middle America. To do so, they stayed close to traditional party differences. Ford emphasized controlling inflation, reducing the federal budget, and relying on the private sector. Carter stressed the problems of unemployment, Ford's mismanagement of the economy, and the need for government help to underprivileged groups. Because

of each candidate's reliance on party cues, partisanship became the main determinant of the vote in 1976.[14] The influence of party attachment was somewhat stronger in shaping men's votes ($b = .40$) than women's ($b = .35$).

Ford and Carter avoided controversial positions on the major campaign issues. They stressed moderation and remained ambiguous about specific policies for addressing economic and social problems. As a consequence, issues played a less prominent role in the voting decisions of 1976 than they had in 1972. However, people's perceptions of where the candidates stood relative to their own positions on important issues still played a significant role in determining voter choice (Figure 9.2). Men and women voted for Carter for different reasons. For example, Carter's position on health insurance and minorities won him support among men but not among women. In contrast, Ford's economic performance cost him support among women ($b = .31$) but not among men ($b = .10$). Once again, men and women had similar issue preferences and tended toward similar evaluations of the candidates. Men expressed a slightly higher preference for the Republican candidate in both 1972 and 1976 than women did, but a women's vote emerged because men and women emphasized different issues in deciding on which candidate to support.

Women's rights played a significant role in determining candidate choice. Although most people did not see feminism as an issue in this campaign, some men (30 percent) and women (32 percent) preferred one candidate over the other on the basis of the issue. These men and women seriously considered the candidates' positions on role equality as well the likelihood that they would promote policies of benefit to women as a group in deciding between Ford and Carter. This pattern, which had also been evident in 1972, held the potential

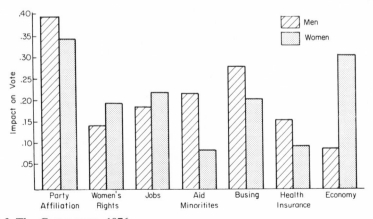

9.2 The Carter vote, 1976

for a feminist vote. In 1972, Nixon's and McGovern's proximity to the voters' positions on women's rights had prompted both men and women to vote for their preferred candidate in equal proportion. By 1976 when the issue was no longer new, men placed less weight ($b = .15$) on the question of sex equality than women did ($b = .20$). The fact that feminist concerns played a more central role in women's evaluations of the political world demonstrates the importance of consciousness in the political mobilization and maintenance of unrepresented groups. It also shows that feminist sympathizers, though not involved in direct action, do evaluate candidates on the basis of women's issues and continue to vote on the basis of those concerns.

Support for sex equality had a significant impact on Carter's expected vote among the typical members of the electorate, weak Democrats who were slightly conservative and saw no major differences between the candidates on the issues but felt that Ford had done only a fair job in managing the economy (Table 9.6). Few men (25 percent) and women (23 percent) who shared these views but also the view that Ford would benefit women were likely to vote for Carter. The race was a virtual toss-up among the average voters who saw no difference between the candidates on women's issues, with 47 percent of the men and 52 percent of the women likely to vote for Carter.

Table 9.6. Predicted support for Carter and Ford based on women's issues, 1976.[a]

Candidate better for women	Candidate closer to women's role	Men	Women
Ford	Ford	25%	23%
Ford	Same	30	29
Ford	Carter	36	37
Same	Ford	41	44
Same	Same	47	52
Same	Carter	53	60
Carter	Ford	59	68
Carter	Same	65	75
Carter	Carter	70	80

Source: CPS 1976 National American Election Study.

a. Probit predictions controlling for partisanship, ideology, position on issues of jobs, aid minorities, busing, and health insurance, and Ford's economic performance. Based on estimates in Table A11.

Carter's support grew markedly among men (70 percent) and women (80 percent) who identified him as championing women's rights. The sex difference in the choice of voters who felt that Ford was closer to their position on women's status was negligible. In contrast, Carter's vote was 10 percent higher among women who favored his position on women's rights than among his male supporters who felt he best represented their position on women's issues. This difference was enough to swing the election.

Feminist issues thus played an important but invisible role in the 1972 and 1976 campaigns.[15] Failing to recognize the potential and significance of a feminist vote, the Presidential candidates made vague references in support of women's rights but ignored substantive women's issues. The actively feminist and antifeminist members of the electorate were able to determine the candidate who best served their concerns, but most people were not encouraged to evaluate the candidates in terms of women's rights. The silence was broken in 1980 when for the first time since World War II, feminism became a partisan issue.

The 1980 Election

The Republican National Convention in 1980 was meant to be a celebration of unity, downplaying potential divisions.[16] And Ronald Reagan succeeded in quashing all debate, except for that on women's rights and abortion. Antifeminist organizations such as the National Pro-Life Impact Committee and Stop-ERA organized a fight against any compromise on these issues, and as a result, the Republicans repudiated their past endorsement of the ERA, supported a constitutional amendment outlawing abortion, and endorsed legislation "protecting and defending the traditional American family."

The Democratic platform presented quite a contrast in its representation of feminist concerns. It included support for the ERA, opposition to reversals of past ratification of the ERA, a pledge to hold no national or regional party meetings in unratified states, endorsement of the 1973 Supreme Court decision allowing abortion, support for increased federal funds for child-care programs, and commitment to the principle of equal pay for comparable work. Carter strongly opposed the addition of two items to the platform: Medicaid funds for abortions and withholding of party funds and campaign assistance from candidates who did not support ERA. But NOW and other feminist women's organizations threatened either to back John Anderson, the Independent candidate, or to sit out the campaign unless the Democratic Party supported these items. Since party rules gave men and women equal representation at the convention, the feminist groups, who had the support of the majority of delegates

prevailed, and these two items were incorporated into the platform.

Once the conventions were over, however, the campaign turned away from women's issues to the economy, foreign policy, and defense. Reagan promised to reduce government, get tough with the Russians, cut taxes, and increase defense spending. Carter, who was also fairly conservative, campaigned on streamlining defense and failed to champion major new civil rights legislation, national health insurance, or full employment. However, he was more committed to federal involvement in the economy and to improving conditions for minorities than Reagan was.

Most voters were ready by 1980 to scale down government involvement in social services and increase military spending (Table 9.7). Men, however, were more inclined to reduce government services (38 percent) than women were (28 percent), while women leaned more to maintaining the status quo (33 percent) than men did (26 percent). The majority of men (73 percent) and women (61 percent)

Table 9.7. Voter preference on campaign issues, 1980.

Issue	Men	Women	Issue	Men	Women
Jobs			*Government spending*		
Government provide	18%	18%	Reduce services	20%	17%
	10	11		18	11
Middle/no opinion	16	24	Middle/no opinion	26	33
	18	17		11	10
Get ahead on own	38	30	Continue services	25	28
Defense spending			*Aid minorities*		
Increase	48	42	Government help	9	11
	25	19		12	11
Middle/no opinion	18	30	Middle/no opinion	25	29
	6	4		24	21
Decrease	3	5	Help themselves	30	28
Women's role			*ERA*		
Equal	51	50	Approve	54	60
	9	13	Disapprove	46	40
Middle/no opinion	15	19			
	10	7			
In the home	15	11			

Source: 1980 National Election Study.

favored increasing the military budget, but women were more likely to suggest moderate increases (30 percent) than men were (18 percent). These differences in support for social services provided the potential basis for a women's vote.

Public support for feminist issues was quite high. The majority of men (60 percent) and of women (63 percent) thought that the sexes should have equal roles in running business and government. The majority of voters also favored the ERA, with women only slightly more supportive (60 percent) than men (54 percent). As in the two previous Presidential elections, men and women were equally supportive of sex equality.

Despite the Republican Party's repudiation of support for the ERA and its emphasis on women's traditional place in the home, women did not abandon the Republican Party. The sexes did not differ in their party attachment ($r = .04$). The Democratic Party, however, was favored among both men ($r = .27$) and women ($r = .25$) who supported the ERA. The preference of ERA advocates for the Democrats was due not simply to the fact that they were liberals ($r = .23$) and liberals leaned toward the Democrats ($r = .25$). The relationship between support for the ERA and party identification remained strong for both men ($r = .23$) and women ($r = .21$) even after the influence of their liberal views was removed. The repudiation of the ERA by the Republican Party prompted a partisan alignment among feminist voters.

Voters had definite preferences on the issues in 1980. Reagan offered voters a Fair Deal as a clear-cut alternative to Democratic politics of the New Deal. Most people felt closer to Reagan on the major campaign issues of jobs, defense spending, government services, and aid to minorities (Table 9.8). The pattern was similar to 1972, when people had seen significant differences between the candidates.[17] Once again in 1980, the views of the Republican candidate were more representative of the electorate. And once again, men were more decisively in the Republican camp than women were, especially on the issues of jobs (43 percent compared to 34 percent), defense spending (53 percent compared to 40 percent), and cut-backs in government services (42 percent compared to 35 percent), although, unlike 1972, the ideologue rather than the centrist candidate dominated.

The only major difference in the evaluation of candidates between 1972 and 1980 involved their attitudes toward role equality. In 1972, few people had seen a difference between Nixon and McGovern on this issue. In 1980 most people saw a difference and favored Carter's position (40 percent). This was the only issue on which Carter received greater support than Reagan. It was also the first election in which there was a group of voters having a preferred candidate on women's

Table 9.8. Voter proximity to candidates on issues, 1980.[a]

Proximity	Men	Women	Men	Women	Men	Women
	Jobs		*Aid minorities*		*Government spending*	
Closer to Reagan	43%	34%	49%	42%	42%	35%
No difference	35	41	29	37	28	38
Closer to Carter	22	25	22	21	30	27
	Defense spending		*Women's role*		*Abortion*	
Closer to Reagan	53	40	24	23	13	13
No difference	26	36	36	37	67	67
Closer to Carter	21	24	40	41	19	19

Source: 1980 National Election Study.
a. Excludes Anderson voters.

rights issues that could be mobilized around a feminist vote. More voters saw a difference between the major party candidates in 1980 (60 percent) than in 1976 (30 percent) or 1972 (40 percent). Moreover, in the two earlier elections these preferences were equally divided among the Republicans and the Democrats. The 1980 election was the first time that the Democrats capitalized on the popular support for sex equality.

Personality and leadership qualities were also issues in the 1980 campaign. Carter painted Reagan as a trigger-happy demagogue who was bound to involve the United States needlessly in war. Reagan played up Carter's incompetence during his term of office. Unfortunately for Carter, Reagan successfully converted the competency question into a decisive issue. On the whole, the electorate was critical of Carter's handling of the economy, the hostages in Iran, and the Soviet involvement in Afghanistan. Carter's low approval ratings made it hard to capitalize on the leadership qualities that usually give an advantage to the incumbent. Although the majority of the electorate felt that Carter had done a poor job over all, men were more critical of the President (63 percent) than women were (51 percent).

People who cared about women's rights faced an unpopular choice between Reagan, who opposed the ERA, and Carter, who gave it only passive support and was otherwise not especially desirable. Carter's critics included many women who felt betrayed by his failure to give the ratification of ERA a fraction of the effort he gave the negotiations for a new Panama Canal Treaty. They also criticized his

cancellation of federal funds for abortions, denying the reproductive rights of poor women. His comment that "Life is unfair" cost him a great deal of support.

Feminist supporters also faced a choice between endorsing the party or endorsing the man. The Republican Party aimed at preserving women's traditional status, while the Democratic Party urged legislation to expand women's roles and opportunities. Carter was no champion of women's rights, but Reagan and the Republican Party were both foes.

Like McGovern, Carter suffered from a lack of popularity, which largely explains why Reagan won the election.[18] But despite Reagan's decisive majority, women were less likely to vote for him (47 percent) than men were (55 percent).

Men and women cast their votes on the basis of different concerns (Figure 9.3). Party cues, for example, were strong determinants of both men's ($b = .53$) and women's ($b = .42$) vote, but women were less likely to support Reagan or Carter on the basis of party loyalty. Men punished Carter for his mishandling of the hostages in Iran ($b = .42$), inflation ($b = .42$), and his job overall ($b = .22$). For women, Carter's handling of the hostage crisis ($b = .24$) or inflation ($b = .18$) did not have as strong an impact on their vote, although they, like men, punished him if they disapproved of his handling of the Presidency ($b = .22$). The critical issues determining the vote for men, besides Carter himself, were aid to minorities ($b = .39$), defense spending ($b = .32$), and government spending ($b = .27$). Policy preferences on aid to minorities ($b = .24$) and defense spending ($b = .24$) played a relatively less important part in women's decision to vote for or against the incumbent than in men's.

There was a significant feminist vote in 1980, but only among women. A decade after the Strike for Equality, women who favored the ERA and saw Carter as a supporter of sex equality solidly cast

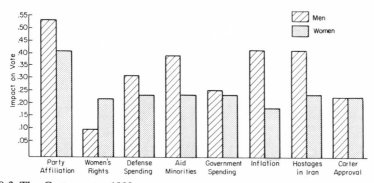

9.3 The Carter vote, 1980

their vote for him ($b = .22$). Many women voted for Carter simply because of his loyalty to women's rights. Men's support for the ERA and preference for Carter's position on sex equality did not have a significant influence on their vote ($b = .10$). They, unlike women, did not punish Reagan for opposing ERA. This difference in the importance of women's rights issues on men's and women's votes, particularly during an election in which sex equality was a central campaign issue, illustrated that once women's consciousness was raised, women's political evaluations were filtered through feminist concerns. In contrast, men's sympathy for women's rights did not impinge on their political decisions because men, who do not confront sexism in their daily lives, felt that other issues were more important.

Carter's vote among the typical members of the electorate, weak Democrats who felt closer to Reagan on most issues including defense spending, aid to minorities, and government services, who felt Carter had done a poor job in managing inflation and the hostage crisis, and who gave Carter only a fair approval rating overall, was greatly aided by his support of women's equality (Table 9.9). Men who felt this way and who opposed the ERA were not likely to support Carter (22 percent). If they favored the ERA and Carter's positions on women's rights, the likelihood of their voting for him increased (35 percent). In contrast, women's vote for Carter was similar to that of men among the opponents of ERA (26 percent) but much higher

Table 9.9. Predicted support for Carter based on women's issues, 1980.[a]

| | Vote for Carter | |
Position on women's issues	Men	Women
Oppose ERA	22%	26%
Favor ERA, close to Reagan on women's role	25	33
Favor ERA, no difference	28	42
Favor ERA, close to Carter on women's role	31	50
Favor ERA, very close to Carter	35	59

Source: 1980 National Election Study.

a. Probit probabilities controlling for partisanship, position on issues of jobs, defense spending, government spending, aid minorities, and abortion, and Carter's handling of inflation, Iranian hostages, and the overall job. Based on estimates in Table A12.

among its supporters (59 percent). These sex differences in the likely choice of the average voter point to the influence of women's issues on women's votes but not on men's. These expected voting patterns were not significantly different from those in 1972, except for the larger feminist support base from which Carter was able to draw votes.

In sum, a women's vote emerged and strengthened over the three Presidential elections following the Women's Strike for Equality. Sex differences in voter preferences on campaign issues began to surface in 1972, with men slightly more in favor of a military victory in Vietnam and of people getting jobs on their own. There was a general shift in preference for a less activist government after 1972, but men became more conservative than women did. On the question of government's role in helping people find jobs, for example, men's support for people getting ahead on their own increased from 1972 (39 percent) in both 1976 (49 percent) and 1980 (56 percent). Women also favored a decrease in government involvement but not as much as men, changing from 1972 (32 percent) in both 1976 (38 percent) and 1980 (47 percent). By 1980 men were also more likely than women by at least 10 percent to favor increases in defense spending and reductions in social services.

There were no dramatic sex differences in party loyalty during this period. Men, however, showed a greater preference by about 8 percent for the policies of the Republican candidates than women did in all three elections. On the question of government involvement in providing jobs, for example, men (51 percent) more than women (43 percent) favored Nixon's position in 1972. By 1980 men's preference for Reagan's position on defense spending was 13 percent higher than women's, and men's support for Reagan's efforts to cut services was also greater by 7 percent.

Partisan divisions on the basis of women's rights also emerged after 1972. In that year feminist men and women were no more likely to be committed as Democrats or Republicans than traditionalists were. In addition, people who paid attention to the candidates' positions on women's rights were evenly divided in preferring Nixon or McGovern. By 1980, however, after the Republican repudiation of forty years of support for the ERA, people who favored the amendment identified with the Democrats for the first time. Women's rights was the only issue on which both men and women clearly favored Carter's position, signaling the emergence of a feminist constituency that has aligned itself with the Democrats.

Sex differences in policy options and candidate preferences on campaign issues form part of the basis for a women's vote. This vote grows out of different priorities and values from those that influence men's decisions. The women's vote is based on issues rather than party allegiance. In all three elections party loyalty had more of an

influence on men's vote than it did on women's. The concerns that defined people's votes also changed over the years. In 1972 ideology, Vietnam, jobs, inflation, and women's rights were the key issues influencing the vote. By 1976 people relied more on party cues than they had in 1972. Still issues played an important role. There was a women's vote in 1976. Men and women voted on the basis of different issues, reflecting a difference in their priorities. Women decided which candidate to support because of his position on women's rights and jobs. Women punished Ford if they felt he had mishandled the economy, while men did not. Men decided on their candidate on the basis of his position on aid to minorities and health insurance, while women did not.

The differences in men and women's priorities grew in 1980. Carter's unpopularity among men stemmed from disapproval of his handling of inflation and the hostage crisis. These issues were considerably less important to women. Men were also more likely to stress defense spending and aid to minorities in reaching their decisions than women were. In contrast, women supported Carter on the basis of his concern for women's rights, while men did not. Thus, the women's vote surfaced in 1980 when Reagan received more of men's votes than women's votes.

A feminist vote also began to emerge in 1972. In that year, when feminism was first being discussed, women's equality was an important priority shaping the votes of both men and women. By 1976 sex equality was no longer a new issue, and the candidates appeared quite similar on women's rights. Feminism still played a significant role in determining how people voted, but men did not give it as high a priority as women did. By 1980, women's rights was a campaign issue. Both men and women favored the ERA and saw Carter as the better candidate on feminist issues, but women voted for Carter because he lent women his support, while men did not. Although men were sympathetic to ERA, other issues were more important to them than women's rights were. Because women confront the problems wrought by sex inequality in their daily lives, women have consistently voted on the basis of promoting their rights ever since these issues were raised in the early 1970s.

In 1972 when men and women voted on the basis of their concern for sex equality, there was a feminist vote but no women's vote. By 1980, the size of the feminist constituency had expanded and become part of a larger women's vote. This women's vote reflects a difference in men's and women's perception of what is best for the country and what is best for women. It provides women with a new political resource that can force politicians to take women and their concerns seriously.

Conclusion

Gender and
the Future

The feminist movement is not likely to disappear in the course of the next two decades. The movement has grown out of women's need to cope with a rapidly changing world that has left them economically and emotionally vulnerable. Women are not responding simply to a theoretical discussion of injustice but to a rising divorce rate that leaves them economically disadvantaged, to increasingly longer periods in the workforce, to a double burden of home and work responsibilities, and to a prolonged life that allows them to be productive long beyond the years of child rearing. These changes have redefined what it means to be female in a postindustrial society and have produced in women a political consciousness and willingness to express their concerns in the political arena.

As the number of women experiencing nontraditional roles and circumstances increased, popular support for feminism grew as well. When the women interviewed in the 1972 national election survey were reinterviewed just four years later, their support for feminism had grown considerably, from a mean of 9.7 to 12.1. Most women leaned toward feminism in 1972, and in 1976 many women (41 percent) continued to maintain that position on women's appropriate roles and perceived discrimination. A sizable number (35 percent) became even more feminist, while a smaller number (24 percent) retreated to a more traditional position.

The heightened support for feminism was not limited to younger women. There was a growth in feminist support for all women born after 1900, increasing from a mean of 6.8–8.9 for the turn-of-the-

century generation to 9.6–12.7 for the Depression generation and to 13.3–15.6 for the postwar generation. As the changes underlying the restructuring of women's experiences continue, the support base for feminist politics will expand.

People recognize that women's lives have changed. Most of the public today (70 percent) acknowledges that women are more independent, working in jobs that in the past were open only to men, and have a great deal more sexual freedom. Women (72 percent) understand that the changing social and economic conditions that prompted the redefinition of their experiences are likely to continue in the years to come. The majority (57 percent) approve of continued change in their status, although some (23 percent) feel that there has already been enough change and still others (15 percent) fear that things have gone too far.

Most people see the move toward nontraditional roles as inevitable, independent of whether they support the change. Looking to the year 2000, many men (74 percent) and women (84 percent) believe that by then all adult women will be working, that the institution of lifetime marriage will have vanished (49 percent), and that the male homemaker will become more accepted (65 percent). Most people (68 percent) believe and hope that things will be easier for young girls growing up today than in the past.[1]

Yet these changes raise fundamental questions about how people are going to live. Recognizing that individual women cannot solve the burdens of both home and work responsibilities, feminists are now working to secure policies that promote women's access to the public world outside the home and which increase the sharing of child-care and housekeeping responsibilities within the home. The public supports feminist efforts to ensure stricter enforcement of laws punishing husbands for wife abuse (84 percent) and banning discrimination against women on the job (73 percent) or in education (72 percent) and to secure the expansion of federal assistance for child care centers (63 percent).[2]

There are no easy answers to women's problems. The integration of women into the workforce to ensure economic independence requires dramatic changes in the structuring of both the economy and the family. In trying to solve the economic and social problems that confront women, one is forced to face fundamental questions about how society should be structured and what the role of government should be in bringing about the changes needed to improve women's life chances.

As we move into the 1980s, the debate over women's work roles is no longer whether women should work but rather women's value as workers. Most women work very hard for relatively little pay. They make barely enough money to support themselves, let alone a

family. In 1980 the women who worked full-time, year-round earned a median weekly wage of $204, while men earned $322, a difference of $6,136 for the year.[3]

Economists concede that a significant part of the wage gap between men and women is due to sex discrimination. Full-time, year-round women workers earn substantially less than men at the same level of education. In fact, the average woman college graduate earns less than the average male high school dropout. College educated women (20 percent) are sometimes forced to work at clerical jobs because they cannot find other work.

This economic discrimination is due not simply to the prejudice of individual, errant employers who prefer to pay men more than they pay women for the same work. It is largely rooted in a sex-segregated labor market that confines women to a limited number of low-paying jobs. Nearly 80 percent of women are employed in clerical, sales, service, and factory or plant jobs. More than a third of all women hold clerical jobs that pay on the average less than $10,000 a year. Few women hold professional jobs (16 percent). For women, professional jobs are most likely to be elementary and secondary school teachers, nurses, health technicians, and librarians. Yet even teaching, which is one of the best-paid jobs open to women, pays on the average only $16,000 a year, which is far below what professional men can expect to make.[4]

Women have made some inroads into traditionally male professional jobs. In the years between 1970 and 1979 the percentage of women lawyers and judges increased from 4.7 percent to 12.4 percent, and the percentage of physicians increased from 8.9 percent to 11 percent. The pay gap does not disappear, however, once women enter male professions. Female college professors currently make 71 percent of the wage of their male colleagues. Female scientists earn 76 percent and women engineers earn 85 percent of what their male counterparts earn.

Women have also made some inroads into a range of blue-collar jobs that until recently have been male enclaves. Between 1962 and 1979 the male-female ratio for people working as garage workers and gas attendants dropped from 70:1 to 20:1; for mail carriers, it declined from 35:1 to 11:1; and for taxicab drivers, it dropped from 27:1 to 11:1. In 1972 not even one woman was employed in the coal mines. By 1980 there were some 3,300 women coal miners.[5]

Yet for every woman who moved into a traditionally male-dominated job, thousands of women remained in low-paying occupations in which more than two-thirds of the workers were women: clericals (80 percent female), non-college teachers (71 percent), librarians (81 percent), nurses (97 percent), and health technicians (70 percent). Although news stories focus on men's entrance into female-domi-

nated work, in reality the pattern of occupation segregation has changed only slightly since 1960. And when men do work at women's jobs, they make more money. The median weekly earnings for male non-college teachers is 16 percent higher than that of women. The wage disparity in favor of men is even greater among health service workers (25 percent), typists, secretaries, and stenographers (29 percent), cleaning persons (38 percent), and waiters (30 percent).[6]

In the past, wage differentials and occupation segregation were accepted because of the presumption that men supported families. This premise no longer holds true for the present and certainly will not do so for the future as women remain single for longer periods and a higher divorce rate leaves more women and children financially vulnerable. The number of women taking primary responsibility for supporting themselves and their families increased dramatically (51 percent) between 1970 and 1979. In 1970, 10 percent of all American children were raised in a female-headed family. By 1980, 17 percent of all children under eighteen years old, or 11 million children, were being raised by women alone.[7]

In the 1960s and 1970s the campaign to end sex discrimination focused primarily on moving women into traditional male occupations and encouraging employers to promote women. The concept of equal pay was initially part of this campaign, but its impact was limited since most women and men still do not do the same kind of work. Equal opportunity or antidiscrimination legislation became the main vehicle for integrating women into the workplace because it asks for changes in basic features of the labor market. Women sought to have firms adopt new personnel procedures for recruiting, selecting, training, assigning, and promoting employees. Antidiscrimination laws attempt to regulate the workplace by breaking patterns of occupational segregation through affirmative action in hiring and promotion and through nondiscrimination in seniority rights and job security. This is no small task.

Government efforts to regulate the workings of the labor force have met with tremendous resistance. The business community is challenging the government's right to interfere in its managerial prerogatives. Labor unions are fighting to maintain seniority rights over affirmative action, arguing that seniority is the workers' only protection against unfair firings. The public has become concerned about reverse discrimination against white males. Even some supporters of affirmative action question its effectiveness if the public perceives all minority and female hirings as inferior. The fundamental question of women's economic survival is becoming blurred or ignored in the midst of all this controversy.

In the 1980s women's efforts to improve their economic situation have expanded beyond integrating women into male occupations to

include reevaluating women's traditional jobs according to their real worth. Women's work is undervalued. Many of women's traditional jobs require a high degree of motor control and rapid movement with low error rates, as in secretarial work, and a high degree of responsibility for human life, as in teaching and nursing. Increasingly working women are asking why a bus driver should be paid more money than a licensed nurse when both jobs require physical labor, life-and-death decisions, and special training. Secretarial work is a skilled job requiring command of the English language, discretion, and decisionmaking responsibilities, in addition to the ability to operate sophisticated business machines, but it does not command a living wage. Equal pay for work of comparable value is quickly becoming a major public policy issue because women are now defining themselves as breadwinners. Men no longer have the sole prerogative to that role.

Comparable worth is not a simple solution to sex discrimination. It is likely to cost employers billions of dollars. The business community maintains that raising salaries to comparable levels would be inflationary and that supply and demand, not the government, should determine the level of wages. The lack of any unbiased method by which to compare the value of dissimilar jobs is used to encourage the maintenance of a status quo known to be discriminatory. Issues of comparable worth and affirmative action are complicated by the fact that they raise fundamental questions about what role the government and the public should play in determining people's wages and occupational opportunities.

An end to wage differences and occupational segregation is only part of the process that will integrate women into the workplace. The economic incorporation of women also requires that others share in women's primary responsibility for home and child care, that women be respected, and that women's values and perspectives be incorporated in the organization of the workplace. The increasing burdens faced by women will not be reduced without a major restructuring in the relationship between work and family. The demands of family work and paid work are currently in competition with one another.

Once women's role in the labor force is accepted, society is forced to address the question of child care. Until the 1970s most child-care arrangements were informal, either in the child's or caretaker's home. As the labor force participation of women with young children increases, fewer relatives and neighbors are available to help care for the young. The need for affordable, reliable, high-quality child care has grown dramatically. The number of licensed child-care centers and nursery schools almost quadrupled during the 1970s. In 1980 about 6 million children aged three to five participated in an out-of-home child-care program. Many women cannot find or afford day care, which has led to a dramatic increase in the number of latchkey

kids who are left alone to care for themselves. For working women in the late 1970s child care was one of the most severe problems that they faced. The working mother cannot maintain sole responsibility for the care of her children. The public policy issue is how otherwise to care for children.

In the 1970s women advocated day care, part-time work, pregnancy and parenting leaves, flextime, and job sharing in order to close the gap between home and work. These innovations are seen not simply as a way of making women's dual roles as mothers and workers easier but also as a step toward a recognition that the sole responsibility for children no longer rests with women. The success of these policies depends on greater cooperation between men and women in sharing family responsibilities. Currently commitments to the workplace come before the family. Job promotions often require relocation that disrupts family life and business meetings and overtime schedules, and business travel leaves men little time to spend with their families. This imbalance between the demands of work and the needs of the home needs to be addressed if parenting roles are to be shared.

The public is in favor of setting up more day-care centers. In 1980 most people (74 percent) felt that it was important for the government to undertake some responsibility for this service. People were concerned about the quality of care provided, and they supported government licensing and regulation of centers. They also supported assistance through social service provisions and tax deductions (63 percent). But few people (22 percent) felt that the government is solely responsible for seeing to it that children have good day-care if the mother works.[8]

The United States does not have a comprehensive, national family policy the way that most European countries do. We are currently experimenting with a mixture of public assistance, private responsibility, and corporate initiatives. Child care is seen as a family responsibility. In reality, the government already provides child care through the public school system. There is some advocacy for the use of schools as a means of extending care provisions. As the number of children attending school declines, the money that is unused could be reallocated both to extending school services to younger children and to providing afterschool programs until the end of the workday so as to reduce the number of latchkey kids. Yet today's schools are not well equipped to care for children under four years old. Moreover, schools in low-income areas, which are already overcrowded and understaffed, are not likely to be able to provide the same quality of child care as schools in more advantaged areas and would thus contribute to the continuation of class differences.

There is some public sentiment in support of having business take

a greater responsibility for providing day-care services (34 percent). A few corporations have set up subsidized day-care centers on their premises. In 1981 about 200 employer-sponsored centers functioned nationwide and some 200 others were under consideration. When child-care centers are provided in the workplace, parents can have lunch with their children, be nearby in case of an emergency, and monitor the quality of care. If women are to be truly incorporated into the work force, however, it is important that the parent is not always the mother and that the child-care workers are not largely women. Businesses are being encouraged to provide day care through tax deductions for expenses spent on establishing and operating programs. There is hope that child care will eventually become an employee benefit in much the same way that health care and disability insurance are currently treated. The provision of corporate day-care will depend on its cost effectiveness. It is unlikely, however, that corporate day-care will service the large bulk of the work force.

There are additional workplace innovations that could reduce the tension between home and work responsibilities. The implementation of these policies will require that business place less emphasis on efficiency and show more concern for the quality of work life and family obligations. Flexible work schedules, available to 12 percent of employees in 1981, allow parents to be home when their children come home from school. The upgrading of part-time work so that the worker is not deprived of fringe benefits, status, and seniority would permit parents to reduce their work commitments for the short time when their children need more constant supervision. Sick leaves for times when children are ill and parental leaves for times when children are being born would allow parents to attend to their children when they are most in need of parental care. Once again it is important for men to avail themselves of these policies as well as women. While most men (77 percent) and women (67 percent) believe that if both husband and wife work full-time, they should share equally in the care of children, only a third of fathers actually share the responsibility with their wives. Even fewer men are scrubbing toilets and ironing clothes as part of their sharing of home responsibilities.[9]

Women do not want to become men. The tension between home and work is not merely spatial; it is also one of values. The workplace currently emphasizes traditionally masculine qualities, such as self-control, logical and objective thought, and an emphasis on efficiency, at the expense of the quality of human relationships. Traditionally female qualities, such as patience, nurturance, and an emphasis on interpersonnel relationships, are seen as impediments to success. If women are to be taken seriously as workers, they cannot be dismissed as emotional and parochial and their work styles cannot be seen as subversive.

Women are used to taking responsibility for the physical, emotional, and financial well-being of their families and friends. But the workplace is not an extension of family and neighborhood. It is hierarchically structured and concerned with profit. Women find such workplaces alienating, with many people under the control of a few. Women in the future are likely to press for a flattening of the hierarchy to promote a wider spread of authority and greater participation. The current failure of the hierarchical, impersonal management of American business, as compared to the less hierarchical, personnel-focused practices of Japanese business, is likely to help legitimize women's criticisms of the workplace and to help promote the feminization of work.

The concept of sex equality need not presume that the development of a public workplace identity is superior to women's private family one. The integration of women into the labor force, however, threatens to suppress the traditional female social world and female identity. Although women have to get paid for their work in order to survive, women's contributions as employed workers are not necessarily more valuable than traditional home and child-care responsibilities. The work performed by a full-time homemaker is estimated to be worth a minimum of $20,000 a year. Receiving wages for housework is one way for women to gain economic independence and maintain their separate sphere. It is important to recognize that some women may not want to integrate into a male economy and male culture.[10]

Who will determine what is good for women and what is good for the family? The restructuring of home and work is inevitable. Women's compassion and concern for human relationships are critically needed in formulating the policies that will bring about this change. The decisions should not and will no longer be made by male legislators, judges, and policy makers alone. Women have found a political voice. They have a new consciousness of their role as women and a new confidence in themselves as citizens. Consequently, gender politics will be a dominant theme in the formulation of public policy as we approach the twenty-first century and consider what kind of brave new world we want.

APPENDIX
NOTES
INDEX

Appendix

Data Analyses

Table A.1. Social characteristics of feminism, 1972.[a]

	Unstandardized coefficient		Standardized coefficient	
Independent variable	Men (n = 647)	Women (n = 848)	Men	Women
Role integration	1.68	2.96	.16	.24
Liberalism	7.66	4.56	.25	.13
Conservativism	−1.41[b]	−2.40	−.05	−.08
Community size	.12[b]	1.33	−.01	.12
Community of origin	1.39	.36[b]	.18	.04
Working mother	1.78	.90[b]	.09	.04
Frequency of worship	.76	.96	.13	.14
Held back	.10[b]	.48	.02	.09
Age	−.05	−.10	−.08	−.16
Constant	−8.33	−2.07		
R	.50	.49		

a. Standardized coefficients here are the source of Figure 7.1.
b. Not significant $p > .01$.

Table A.2. Nontraditional roles, historical context, and feminism, 1972.[a]

Independent variable	Unstandardized coefficient (n = 851)	Standardized coefficient
Nineteenth century role	− .66[b]	− .02[b]
Turn-of-century role	1.45	.12
Depression role	2.77	.25
Post World War II role	3.78	.39
Frequency of worship	.85	.13
Held back	.31[b]	.06[b]
Community size	1.35	.12
Liberalism	4.12	.12
Conservativism	−2.34	− .08
Economic discrimination	5.70	.21
Constant	−9.08	
R	.53	

a. Standardized coefficients here are the source of Figure 7.2.
b. Not significant $p > .01$.

Table A.3. The feminist housewife, 1972.[a]

Independent variable	Unstandardized coefficient (n = 356)	Standardized coefficient
Education	1.70	.15
Liberalism	3.06	.08[b]
Worship	.90	.16
Discrimination	6.06	.24
Housework	1.80	.15
Future work	2.16	.22
Age	− .03	− .05[b]
Constant	−13.67	
R	.50	

a. Standardized coefficients here are the source of Figure 7.3.
b. Not significant $p > .05$.

Table A.4. Support for collective action, 1972.[a]

Independent variable	Men		Women	
	Probit coefficient	Standard OLS coefficient	Probit coefficient	Standard OLS coefficient
Feminism	.029	.18	.048	.33
Liberalism	.34	.20	.167[b]	.08
Discrimination	.047[b]	.05	.073	.07
Responsiveness	−.017[b]	−.05	−.032	−.09
Personal effectiveness	.029	.08	.017[b]	.04
Constant	1.92		1.84	
R	.36		.40	

a. Standarized coefficients here are the source for Figure 8.1.
b. Not significant $p > .05$.

Table A.5. Support for women's liberation, 1972.[a]

Independent variable	Men		Women	
	Unstandardized coefficient	Standardized coefficient	Unstandardized coefficient	Standardized coefficient
Feminism	.73	.27	.99	.36
Liberalism	3.83	1.11	3.54	.08
Aid minorities	1.13[b]	.08	1.16	.08
Personal effectiveness	.43	.08	.40	.07
Race	6.39[b]	.06	6.30	.07
Constant	20.63		16.45	
R	.39		.44	

a. Standardized coefficients here are the source for Figure 8.1.
b. Not significant $p > .01$

Table A.6. Support for protest, 1972.[a]

Independent variable	Men		Women	
	Probit coefficient	Standardized OLS coefficient	Probit coefficient	Standardized OLS coefficient
Feminism	.021	.14	.029	.21
Liberalism	.212	.10	.087[b]	.04
Aid minorities	.167	.21	.063	.08
Vietnam	.04[b]	.05	.068	.04
Responsiveness	−.031	−.10	−.030	−.10
Cynicism	.024	.08	−.000[b]	−.00
Age	−.011	−.12	−.004[b]	−.05
Constant	1.19		.60	
R	.43		.34	

a. Standardized coefficients here are the source for Figure 8.1.
b. Not significant $p > .05$.

Table A.7. Support for collective action, 1976.[a]

Independent variable	Men		Women	
	Probit coefficient	Standardized OLS coefficient	Probit coefficient	Standardized OLS coefficient
Feminism	.027	.19	.044	.29
Liberalism	.208	.12	.337	.18
Aid minorities	.091	.11	.082	.09
Responsiveness	.021[b]	.06	−.025	−.07
Personal effectiveness	.039	.11	.014[b]	.03
Constant	2.31		2.15	
R	.33		.42	

a. Standardized coefficients here are the source of Table 8.2.
b. Not significant $p > .05$.

Table A.8. Support for women's liberation, 1976.[a]

Independent variable	Men		Women	
	Unstandardized coefficient	Standardized coefficient	Unstandardized coefficient	Standardized coefficient
Feminism	.48	.27	.78	.44
Aid minorities	1.91	.19	.76	.07
Personal effectiveness	.37	.09	.25	.07
Constant	38.56		40.95	
R	.38		.46	

a. Standardized coefficients here are the source of Table 8.2.

Table A.9. Support for protest, 1976.[a]

Independent variable	Men		Women	
	Probit coefficient	Standardized coefficient	Probit coefficient	Standardized coefficient
Feminism	.004[b]	.03	.022	.15
Liberalism	.184	.08	.289	.09
Aid minorities	.090	.12	.007[b]	.01
Age	−.014	−.17	−.012	−.16
Constant	−.485		−.526	
R	.250			

a. Standardized coefficients here are the source of Table 8.2.
b. Not significant $p > .05$.

Table A.10. The Democratic vote, 1972.[a]

Independent variable	Probit coefficient		Coefficient/standard error	
	Men (n = 711)	Women (n = 879)	Men	Women
Party affiliation	.30	.22	7.12	7.07
Liberalism	.32	.29	2.71	2.69
Conservativism	−.20[b]	−.13[b]	−1.35	−1.33
Women's role[c]	.27	.26	2.64	3.37
Jobs	.25	.24	3.86	4.22
Vietnam	.33	.32	6.05	6.90
Inflation	.25	.27	3.43	4.35
Aid minorities	.24	.15	3.09	2.29
Busing	.23	.18	3.82	3.66
Constant	6.50	5.62	10.83	12.97
R	.79	.73		

a. Probit estimates here are the source of Figure 9.1.

b. Not significant $p > .05$.

c. Issue positions on women's role, jobs, Vietnam, inflation, aid minorities, and busing proximity measures that take candidate as well as self-placement into account.

Table A.11. The Democratic vote, 1976.[a]

Independent variable	Probit coefficient		Coefficient/standard error	
	Men (n = 769)	Women (n = 926)	Men	Women
Party affiliation	.40	.35	10.83	12.05
Liberalism	.04[b]	− .06[b]	.34	− .58
Conservativism	− .21	− .13[b]	−2.55	−1.53
Women's issues[c]	.15	.20	3.75	5.46
Jobs	.19	.23	2.91	3.85
Aid minorities	.23	.08[b]	2.89	1.14
Busing	.27	.21	4.43	3.76
Health insurance	.17	.11[b]	2.62	1.83
Economy	.10[b]	.31	1.90	5.97
Constant	5.08	5.13	10.83	12.10
R	.74	.70		

a. Probit estimates here are the source of Figure 9.2.

b. Not significant $p > .05$.

c. Issue positions on women's roles, jobs, aid minorities, busing, and health insurance are proximity measures that take candidate as well as self-placement into account. Women's issues is a measure combining role proximity with perceptions of which candidate would benefit women.

Table A.12. The Democratic vote, 1980.[a]

Independent variable	Probit coefficient		Coefficient/standard error	
	Men (n = 354)	Women (n = 425)	Men	Women
Party affiliation	.53	.42	6.66	7.40
Women's rights[b]	.10[c]	.22	1.12	3.17
Defense spending	.32	.24	2.63	2.11
Aid minorities	.39	.24	2.93	2.21
Government spending	.27	.25	2.24	2.28
Carter on inflation	.42	.18[c]	2.46	1.35
Carter on hostages in Iran	.42	.25	3.05	2.26
Carter overall job	− .22	− .22	− 3.10	3.86
Constant	7.02	5.33	7.43	7.77
R	.73	.71		

a. Probit estimates here are the source of Figure 9.3.

b. Women's rights, defense spending, aid minorities, and government spending are issue proximity measures taking candidate and self-placement on issues. The Women's rights measure combination of role proximity and support for the ERA.

c. Not significant $p > .05$.

Notes

Introduction. Consciousness and Politics

1. Paul M. Sniderman and Richard R. Brody, "Coping: The Ethic of Self-Reliance," *American Journal of Political Science* 21 (Aug. 1977): 501–521; Richard A. Brody and Paul M. Sniderman, "From Life Space to Polling Place: The Relevance of Personal Concerns for Voting Behavior," *British Journal of Political Science* 7 (July 1977): 337–360; Donald R. Kinder and Roderick Kiewiet, "Economic Discontent and Political Behavior: The Role of Personal Grievances and Collective Economic Judgements in Congressional Voting," *American Journal of Political Science* 23 (Aug. 1979): 495–527; David O. Sears and Jack Citrin, *The Tax Revolt: Something for Nothing in California* (Cambridge: Harvard University Press, 1982).

2. Karl Marx, "Wage, Labor, and Capital," *Selected Works,* vol. 1 (New York: International Publishers, 1933), ch. 9; Marx, *The Eighteenth Brumaire;* Marx, *The Poverty of Philosophy* (New York: International Publishers, 1939); Max Weber, "Class, Status, and Party," in *From Max Weber: Essays in Sociology,* ed. Hans H. Gerth and C. Wright Mills (New York: Oxford University Press, 1958), pp. 180–195; Charles H. Anderson, *The Political Economy of Social Class* (Englewood Cliffs, N.J.: Prentice-Hall, 1975); George Lukas, *History and Class Consciousness: Studies in Marxist Dialectics* (Cambridge: MIT Press, 1971); Susan A. Ostrander, "Upper-Class Women: Class Consciousness as Conduct and Meaning," in Ralph Dahrendorph, ed., *Power Structure Research* (New York: Russell Sage, 1980), pp. 73–95; Karl Marx, *The Poverty of Philosophy* (New York: International Publishers, 1939).

3. Weber, "Class, Status and Poverty," pp. 180–195; Anthony Oberschal, *Social Conflict and Social Movements* (Englewood Cliffs, N.J.: Prentice-

Hall, 1973); Michael Useem, *Protest Movements in America* (Indianapolis: Bobbs Merrill, 1975); Joseph R. Gusfield, *Symbolic Crusade: Status Politics and the American Temperance Movement* (Urbana: University of Illinois Press, 1966).

4. See Richard Centers, *The Psychology of Social Classes* (Princeton: Princeton University Press, 1949); Robert Merton, *Social Theory and Social Structure* (Glencoe, Ill: Free Press, 1957); George C. Homans, *Social Behavior: Its Elementary Forms* (New York: Harcourt, Brace, and World, 1961); Peter M. Blau, *Exchange and Power in Social Life* (New York: Wiley, 1964); Samuel Stouffer et al., *The American Soldier,* vols. 1-2 (Princeton: Princeton University Press, 1949); W. G. Runciman, *Relative Deprivation and Social Justice* (London: Routledge and Kegan Paul, 1966); E. E. Jones et al., *Attribution: Perceiving the Causes of Behavior* (Morristown, N.J.: General Learning Press, 1971).

5. Carl N. Degler, "Revolution Without Ideology: The Changing Place of Women in America," in Robert J. Lifton, ed., *The Woman in America* (Boston: Beacon Press, 1967), pp. 209–210.

6. Abbott L. Ferriss, *Indicators of Trends in the Status of American Women* (New York: Russell Sage, 1971), p. 1; Jo Freeman, *The Politics of Women's Liberation* (New York, McKay, 1975), pp. 44–45.

7. Albert Bandura, *Psychological Modeling: Conflicting Theories* (Chicago: Aldine-Atherton, 1971); Bandura, *Social Learning Theory* (Englewood Cliffs, N.J.: Prentice-Hall, 1977); Walter Mischel, "A Social Learning View of Sex Differences in Behavior," in Eleanor E. Maccoby, ed., *The Development of Sex Differences* (Stanford: Stanford University Press, 1966); Nancy Reeves, *Womankind: Beyond the Stereotypes* (Chicago: Aldine, 1982); Lenore J. Weitzman, "Sex-Role Socialization," in Jo Freeman, ed., *Women: A Feminist Perspective* (Palo Alto; Mayfield, 1979), pp. 153–216; Sandra Bem and Daryl Bem, "Case Study of a Nonconscious Ideology: Training the Woman To Know Her Place," in *Beliefs, Attitudes, and Human Affairs* (Belmont, Mass.: Brooks/Cole, 1970), pp. 89–99.

8. E. E. Schattschneider, *The Semi-Sovereign People* (New York: Holt, Rinehart, and Winston, 1960); Michael Lipsky, "Protest as a Political Resource," *American Political Science Review* 62 (Dec. 1968): 1144–1158.

1. Political Mobilization of Women

1. See Charles Tilly, *From Mobilization to Revolution* (Reading: Addison-Wesley, 1978); William A. Gamson, *The Strategy of Social Protest* (Homewood, Ill.: Dorsey Press, 1975); Anthony Oberschall, *Social Conflict and Social Movements* (Englewood Cliffs, N.J.: Prentice-Hall, 1973); John Wilson, *Introduction to Social Movements* (New York: Basic Books, 1973); Mayer N. Zald and John D. McCarthy, *The Dynamics of Social Movements* (Cambridge: Winthrop, 1979).

2. See William Gamson, *The Strategy of Social Protest* (Homewood, Ill. Dorsey Press, 1975).

3. Ann N. Costain and W. Douglas Costain, "Movements and Gatekeepers:

Congressional Responses to Women's Movement Issues, 1900–1980," paper presented at workshop on Women's Movements in Comparative Perspective, Cornell University, May 6–8, 1983.

4. Costain and Costain, "Movements and Gatekeepers."

5. Reprinted in June Sochen, *Herstory: A Record of Women's Past* (Palo Alto: Mayfield, 1981), App. 1. See also Ellen Carol Du Bois, *Feminism and Suffrage* (Ithaca: Cornell University Press, 1978).

6. See Eleanor Flexner, *A Century of Struggle: The Women's Rights Movement in the United States* (New York: Atheneum, 1968); Aileen S. Kraditor, *The Ideas of the Woman Suffrage Movement, 1890–1920* (New York: Norton, 1981).

7. Mary P. Ryan, *Womanhood in America: From Colonial Times to the Present* (New York: Franklin Watts, 1983), p. 203.

8. Kraditor, *The Ideas of the Woman Suffrage Movement*, p. 7.

9. Flexner, *Century of Struggle*, p. 284.

10. See William H. Chafe, *The American Woman: Her Social, Economic, and Political Roles* (Oxford: Oxford University Press, 1977), ch. 1; June Sochen, *Movers and Shakers: American Women Thinkers and Activists, 1900–1970* (New York: Quadrangle, 1973), chs. 2-3; Sochen, *Herstory*, chs. 10-11; Mary P. Ryan, *Womanhood in America: From Colonial Times to the Present* (New York: Franklin Watts, 1983), chs. 4-5; Stanley Lemons, *The Woman Citizen: Social Feminism in the 1920s* (Champaign-Urbana: University of Illinois Press, 1973).

11. Quoted in Chafe, *The American Woman*, p. 129.

12. See Susan Ware, *Beyond Suffrage: Women in the New Deal* (Cambridge: Harvard University Press, 1981); Clarke A. Chambers, "The Campaign for Women's Rights in the 1920s," in Jean E. Friedman and William G. Shade, ed., *Our American Sisters: Women in American Life and Thought* (Lexington, Mass.: D.C. Heath, 1982); Sochen, *Herstory*, ch. 12; Chafe, *The American Woman*, chs. 1, 4-5; Ryan, *Womanhood in America*, ch. 5.

13. *New York Times* (Feb. 2, 1930): 8; (Oct. 5, 1930): 5; (Oct. 29, 1930): 26; (Mar. 2, 1931): 2; (Oct. 2, 1931): 43; (Dec. 21, 1931): 15; (Mar. 1, 1932): 21; (Nov. 7, 1932): 19; (Jan. 7, 1933): 17; (Apr. 27, 1933): 14; (July 16, 1933): 19; (Oct. 30, 1933): 14; (Nov. 9, 1933): 6; (June 10, 1934): 10; (Mar. 18, 1939): 8; (Feb. 21, 1937): VI.6; (Feb. 21, 1938): 10; (July 25, 1938): 17; (Jan. 16, 1939): 2. For the BPW, see (July 9, 1930): 26; (July 7, 1931): 28; (Apr. 11, 1932): 17; (July 16, 1933): 9; (Feb. 26, 1939): II.4. For the NWP, see (Sept. 21, 1930): II.1; (May 2, 1932): 2; (July 19, 1933): II,16. For the American Association of Women, see (Dec. 8, 1930): 6; (Nov. 29, 1931): II.1. For the WTUL, see (Oct. 9, 1932): 18; (July 11, 1932): 2; (Apr. 9, 1933): 17. For the League of Women Voters, see (Apr. 25, 1934): 15; (May 24, 1936): II.6.

14. *New York Times* (Feb. 27, 1930): 5; (May 2, 1930): 23; (June 1, 1930): 3; (Oct. 19, 1930): 30; (Nov. 18, 1930): 2; (Mar. 2, 1931): 2; (Mar. 4, 1931): 14; (Apr. 3, 1931): 47; (Dec. 13, 1932): 11; (Jan. 22, 1933): II.2; (Feb. 1, 1933): 38; (Dec. 15, 1934): 2; (Feb. 27, 1935): 17; (June 7,

1937): 8; (May 22, 1938): 4; (June 26, 1939): 15; (July 11, 1939): 21; (Nov. 26, 1939): II.4.

15. *New York Times* (Jan. 12, 1940): 32; (Mar. 13, 1941): 23; (Mar. 27, 1941): 25; (Dec. 29, 1943): 20; (Dec. 30, 1944): 9; (Oct. 30, 1945): 16; (May 30, 1947): 26; Cynthia Harrison, "A 'New Frontier' for Women: The Public Policy of the Kennedy Administration," in Friedmen and Shade, ed., *Our American Sisters,* pp. 543–546.

16. See Edith Mayo and Jerry Frye, "ERA: Postmortem of a Failure in Political Communication," *OAH Newsletter* (Aug. 1983): 21–24; *New York Times* (Jan. 10, 1937): VI.6; (Feb. 7, 1937): VI.6; (Feb. 28, 1937): VI.6; (Mar. 16, 1937): 25; (Apr. 25, 1937): VI.6; (Dec. 19, 1937): VI.5.

17. Harrison, "A 'New Frontier' for Women," p. 543; Ware, *Beyond Suffrage,* p. 121; *New York Times* (Jan. 7, 1943): 12; (Jan. 22, 1943): 23; (Apr. 25, 1945): 20; (Sept. 22, 1945): 14; (Feb. 18, 1947): p. 28.

18. Harrison, "A 'New Frontier' for Women," p. 543.

19. *New York Times* (Jan. 30, 1933): 3; (Aug. 9, 1937): 2; (Apr. 11, 1944): 22. For BPW, see (Jan. 16, 1936): 23; (May 22, 1939): 19; For AAUW, see (Mar. 18, 1937): 22; For League, see (Oct. 18, 1937): 19; For WTUL, see (Oct. 9, 1938) II.p.5; For YWCA, see (Jan. 14, 1940) II.8.

20. See Judith Hole and Ellen Levine, *Rebirth of Feminism* (New York: Quadrangle, 1971); Kirsten Amundsen, *The Silenced Majority* (Englewood Cliffs, N.J.: Prentice-Hall, 1971); Lucy Komisar, *The New Feminism* (New York: Warner, 1972); Caroline Bird, *Born Female* (New York: Pocket Books, 1971); Lois W. Banner, *Women in Modern America: A Brief History* (New York: Harcourt Brace, and Jovanovich, 1974); Chafe, *The American Woman,* ch. 10; Harrison, "The 'New Frontier' for Women," pp. 541–562.

21. Irene Murphy, *Public Policy on the Status of Women* (Lexington, Mass.: Lexington Books, 1973), p. 5.

22. Quoted in Deckard, *The Women's Movement,* p. 347.

23. See Jo Freeman, *The Politics of Women's Liberation* (New York: Longman, 1975); Cellestine Ware, *Woman Power: The Movement for Women's Liberation* (New York: Tower Publications, 1970); Maren Lockwood Carden, *The New Feminist Movement* (New York: Russell Sage Foundation, 1974); Sara Evans, *Personal Politics: The Roots of Women's Liberation in the Civil Rights Movement and the New Left* (New York: Alfred A. Knopf, 1979); Hole and Levine, *Rebirth of Feminism.*

24. Quoted in Hole and Levine, *Rebirth of Feminism,* p. 107.

25. Hole and Levine, *Rebirth of Feminism,* p. 269.

26. Freeman, *Politics of Women's Liberation,* pp. 214–218.

27. Joyce Gelb and Ethel Klein, *Women's Movements: Organizing for Change in the 1980s* (Washington, D.C.: American Political Science Association, 1983), pp. 15–24, 30.

28. Lindsey Van Gelder, "Four Days That Changed the World," *Ms.* (Mar. 1978) 52–56, 86–93; U.S. National Commission on the Observance of International Women's Year, *What Women Want* (New York: Simon and Schuster, 1979).

29. Gelb and Klein, *Women's Movements,* pp. 41–44

30. Abbott L. Ferriss, *Indicators of Trends in the Status of American Women* (New York: Russell Sage, 1971), pp. 404–405.

31. Carol Mueller, "Women's Movement Success and the Success of Social Movement Theory," paper presented at workshop on Women's Movements in Comparative Perspective, Cornell University, May 6–8, 1983. See also Ruth Mandel, *In the Running* (New York: Ticknor and Fields, 1981); Jeanne Kirkpatrick, *Political Woman* (New York: Basic Books, 1974); Alice Rossi, *Feminists in Politics* (New York: Academic Press, 1982).

2. From Housework to the Marketplace

1. Alexis de Tocqueville, *The Old Regime and the French Revolution* (New York: Doubleday Anchor, 1955); Karl Marx and Frederick Engels, *Basic Writings on Politics and Philosophy* (New York: Anchor Books, 1959); Marx, *The Eighteenth Brumaire of Louis Bonaparte* (New York: International Publishers, 1963).

2. See Karl Deutsch, "Social Mobilization and Political Development," *American Political Science Review* 55 (Sept. 1961): 493–515.

3. William Chafe, *The American Woman, 1920–1970* (New York: Oxford University Press, 1972); Carl N. Degler, "Revolution Without Ideology: The Changing Place of Women in America," in Robert J. Lifton, ed., *The Woman in America* (Boston: Beacon Press, 1965), pp. 193–210.

4. See Carl N. Degler, *At Odds: Women and the Family in America from the Revolution to the Present* (Oxford: Oxford University Press, 1980); Alice Kessler-Harris, *Out to Work: A History of Wage-Earning Women in the United States* (Oxford: Oxford University Press, 1982); Julie A. Matthair, *An Economic History of Women in America: Women's Work, the Sexual Division of Labor, and the Development of Capitalism* (New York: Schocken Books, 1982); unless otherwise indicated, the labor force statistics come from U.S. Bureau of the Census, *Historical Statistics of the United States, Colonial Times to 1970* (Washington, D.C.: Government Printing Office, 1975), pp. 131–135; U.S. Bureau of the Census, *Statistical Abstracts of the United States, 1982* (Washington, D.C.: Government Printing Office, 1982.)

5. Theodore Dreiser, *Sister Carrie (1900);* Stephen Crane, *Maggie, a Girl of the Streets* (1894); Mary Wilkins Freeman (1891); Kate O'Flaherty Chopin, *The Awakening* (1899). See also June Sochen, *Herstory: A Record of the American Woman's Past* (Palo Alto: Mayfield, 1981), pp. 194–197.

6. Although enumerators for the 1910 Census were given special instructions not to overlook women workers, such workers may have been undercounted in 1900, 1920, and 1930 because of improvements in techniques, broader definition of labor force status, and a redistribution of the female work force from unpaid farm work to paid employment. Robert W. Smuts, "The Female Labor Force," *Journal of the American Statistical Association* 55 (Mar. 1960): 71–79. See also Valerie Kincade Oppenheimer, *The Female Labor Force in the United States* (Berkeley:

University of California, Institute of International Studies, 1970), pp. 3–5.

7. Chafe, *The American Woman,* pp. 178–179.

8. See also Abbott Ferriss, *Indicators of Trends in the Status of Women* (New York: Russell Sage, 1971), pp. 85–119; Ann R. Miller, "Changing Work Life Patterns: A Twenty-Five Year Review," *The Annals of the American Academy of Political and Social Science* 435 (Jan. 1978): 83–101; Juanita Kreps, *Sex in the Marketplace* (Baltimore: Johns Hopkins University Press, 1971).

9. Oppenheimer, *The Female Labor Force;* Valerie Kincade Oppenheimer, "Demographic Influence on Female Employment and the Status of Women," in Joan Huber, ed., *Changing Women in a Changing Society* (Chicago: University of Chicago Press, 1973), pp. 184–199. See also Georgiana M. Smith, *Help Wanted–Female: A Study of Demand and Supply in a Local Job Market for Women* (Rutgers: Rutgers University, Institute of Management and Labor Relations, 1964); Gertrude Bancropt McNally, "Patterns of Female Labor Force Activity," *Industrial Relations* (May 1968): 204–218; Margery Davies, "Women's Place Is at the Typewriter: The Feminization of the Clerical Labor Force," *Radical America* 8 (1974): 1–28; Belton M. Fleisher and George F. Rhodes, Jr., "Fertility, Women's Wage Rates, and Labor Supply," *American Economic Review* 69 (Mar. 1979): 14–24.

10. See Glen G. Cain, *Married Women in the Labor Force* (Chicago: Chicago University Press, 1966); Malcolm S. Cohen, "Married Women in the Labor Force: An Analysis of Participation Rates," *Monthly Labor Review* 92 (Oct. 1969): 31–35; Howard Hayghe, "Families and the Rise of Working Wives: An Overview," *Monthly Labor Review* 99 (May 1976); Linda J. Waite, "Working Wives, 1940–1960," *American Sociological Review* 41 (Feb. 1976): 65–80.

11. Clarence D. Long, *The Labor Force under Changing Income and Economic Employment* (Princeton: Princeton University Press, 1958).

12. Chafe, *The American Woman,* p. 188.

13. See F. Ivan Nye and Lois W. Hoffman, *The Employed Mother in America* (Chicago: Rand McNally, 1963); Howard Hayghe, "Marital and Family Characteristics of Workers," *Monthly Labor Review* 98 (June 1975); Jean C. Darian, "Factors Influencing the Rising Labor Force Participation Rates of Married Women with Preschool Children," *Social Science Quarterly* 56 (Mar. 1976): 614–630.

14. Oppenheimer, "Demographic Influence of Female Employment," pp. 123–126.

15. Betty Friedan, *The Feminine Mystique* (New York: Dell, 1963).

16. Carl N. Degler, "Revolution Without Ideology," pp. 193–210.

17. Chafe, *The American Woman,* pp. 64, 99.

18. Chafe, *The American Woman,* p. 108.

19. Hazel Erskine, "The Polls: Women's Role," *Public Opinion Quarterly* 35 (Summer 1971): 283–289; Chafe, *The American Woman,* p. 108.

20. Erskine, "The Polls," p. 284.

21. Chafe, *The American Woman*, pp. 178–179.

22. Erskine, "The Polls," p. 284.

23. Erskine, "The Polls," p. 284.

24. Friedan, *The Feminine Mystique*.

25. Oliver Jensen, *The Revolt of American Women* (New York: Harcourt Brace Jovanovich, 1971), p. 216.

26. Kay F. Reinartz, "The Paper Doll: Images of American Women in Popular Song," in Jo Freeman, ed., *Women: A Feminist Perspective* (Palo Alto: Mayfield, 1975), pp. 293–308.

27. Barbara McGowan, "Postwar Attitudes Toward Women and Work," in Dorothy McGuigan, ed. *New Research on Women and Sex Roles* (Ann Arbor: University of Michigan, Center for Continuing Education of Women, 1976), pp. 144–145; June Sochen, *Herstory: A Record of the American Woman's Past* (Palo Alto: Mayfield, 1981), ch. 13; Mary P. Ryan, *Womanhood in America: From Colonial Times to the Present* (New York: Franklin Watts, 1983), ch. 6.

28. Robert Weiss and Nancy Samuelson, "Social Roles of American Women: Their Contribution to a Sense of Usefulness and Importance," *Journal of Marriage and Family Living* 20 (Nov. 1958): 358–366.

29. "American Woman's Dilemma," *Life* 22 (June 16, 1947): 901–912; Margaret Mead, *Male and Female* (New York: William Morrow, 1949); Mirra Komarovsky, *Women in the Modern World* (Boston: Little, Brown, 1953); Sidonie Gurenberg and Hilda S. Krech, *The Many Lives of Modern Woman* (New York: Doubleday, 1952).

30. Erskine, "The Polls," p. 286.

3. The Decline of Motherhood

1. Eric Erikson, *Identity, Youth, and Crisis* (New York: Norton, 1968), p. 266.

2. See Linda Gordon, *Woman's Body, Woman's Right* (New York: Grossman, 1976); James C. Mohr, *Abortion in America: The Origins and Evolution of National Policy, 1800–1900* (New York: Oxford University Press, 1978); Carl N. Degler, *At Odds: Women and the Family in America from the Revolution to the Present* (Oxford: Oxford University Press, 1980), chs. 9–12.

3. Jessie Bernard, "Women, Marriage, and the Future," *The Futurist* 4 (Apr., 1970): 41; Bernard, *The Future of Motherhood* (New York: Dial Press, 1974), pp. 112, 116–117.

4. Paul C. Glick, "Updating the Family Life Cycle," *Journal of Marriage and the Family* 39 (Feb., 1977): 5–13; Paul C. Glick and Robert Parke, Jr., "New Approaches in Studying the Life Cycle of the Family," *Demography* (1965): 187–202; Paul C. Glick, "The Family Cycle," *American Journal of Sociology* 12 (Apr., 1947): 164–174.

5. Bernard, *The Future of Motherhood*, p. 112–137.

6. Edward G. Stockwell, *Population and People* (Chicago: Quadrangle, 1968), pp. 48–49, 94–95; Linda Gordon, *Woman's Body, Woman's Right*,

pp. 48–49; Karl Taeuber and James A. Sweet, "Family and Work: The Social Life Cycle of Women" in Juanita M. Kreps, ed., *Women and the American Economy* (Englewood Cliffs, N.J.: Prentice-Hall, 1976), p. 35.

7. Mary Jo Bane, *Here To Stay: American Families in the Twentieth Century* (New York: Basic Books, 1976), Appendix, Table A-2.

8. Bernard, *The Future of Motherhood,* p. 125.

9. Kathleen Gough, "The Origin of the Family," in Jo Freeman, ed., *Women: A Feminist Perspective* (Palo Alto: Mayfield, 1975), pp. 43–63.

10. Joan Bel Geddes, *Small World: A History of Baby Care from the Stone Age to the Spock Age* (New York: MacMillan, 1964), p. 90.

11. Geddes, *Small World,* p. 109.

12. Joan Huber, "Toward a Socio-Technological Theory of the Women's Movement," *Social Forces* 23 (Apr. 1976): 374; Samuel J. Foman, *Infant Nutrition* (Philadelphia: Sanders, 1974), ch. 2; Herman F. Meyer, *Infant Food and Feeding Practices* (Springfield, Ill.: Charles C Thomas, 1960), ch. 1.

13. Foman, *Infant Nutrition,* pp. 7–11.

14. Geddes, *Small World,* p. 122.

15. *New York Times* (July 28, 1946): III.4; (May 17, 1960): 41.

16. *New York Times* (June 7, 1946): 22; (Aug. 30, 1972): 24; (June 6, 1982): 34.

17. William H. Chafe, *The American Woman: Her Changing Social, Economic, and Political Roles, 1920–1970* (Oxford: Oxford University Press, 1972), p. 129.

18. The growth of television during this century has dramatically altered the nature of child care. The average preschooler spends about 33 hours a week watching television; the average sixth grader watches about 31 hours. This built-in baby sitter, which invaded the American home in the 1950s, has resulted in the reduction of motherwork. *Here To Stay,* p. 15.

19. See Abbott L. Ferriss, *Indicators of Trends in American Education* (New York: Russell Sage, 1969), pp. 17–31; Robert E. Potter, *The Stream of American Education* (New York: American Book, 1967), pp. 368–407.

20. U.S. Bureau of the Census, *Statistical Abstracts of the United States, 1977* (Washington, D.C.: Government Printing Office, 1977), p. 135; U.S. Bureau of the Census, *Statistical Abstract of the United States, 1980* (Washington, D.C.: Government Printing Office, 1980), p. 147; Ferriss, *Indicators of Trends in American Education,* p. 381.

21. Doris B. Gold, "Women and Voluntarism," in Vivian Gornick and Barbara K. Moran, ed., *Women in Sexist Society* (New York: Basic Books, 1971), pp. 533–554.

22. Gordon, *Woman's Body, Woman's Right,* p. 52.

23. U.S. Bureau of the Census, *Statistical Abstract of the United States, 1977* (Washington D.C.: Government Printing Office, 1977), p. 49; Gordon, *Woman's Body, Woman's Right,* pp. 136, 142; Leta S. Hollingsworth,

"Social Devices for Impelling Women To Bear and Rear Children," in Ellen Peck and Judith Senderowitz, ed., *Pronatalism: The Myth of Mom and Apple Pie* (New York: Crowell, 1974), p. 23.

24. Gordon, *Woman's Body, Woman's Right*, p. 236.

25. Chafe, *The American Woman*, p. 95.

26. Gordon, *Woman's Body, Woman's Right*, pp. 291, 270; Hazel Erskine, "The Polls: The Population Explosion, Birth Control, and Sex Education," *Public Opinion Quarterly* 30 (Fall 1966): 49.

27. The percentage of women living in urban areas increased from 47.3 percent in 1910 to 52.3 percent in 1920, 57.4 percent in 1930, and 58 percent in 1940. In 1970, 74.2 percent of American women lived in urban areas. U.S. Bureau of the Census, *A Statistical Portrait of Women in the United States* (Washington, D.C.: Government Printing Office, 1976), p. 12.

28. Gordon, *Woman's Body, Woman's Right*, p. 283.

29. Judith Blake, "Ideal Family Size among White Americans: A Quarter of a Century's Evidence," *Demography* 3 (1966): 154–173; Lois Hoffman and Frederick Wyatt, "Social Change and Motivations for Having Larger Families: Some Theoretical Considerations," in John N. Edwards, ed., *The Family and Change* (New York: Knopf, 1969), pp. 171–182.

30. Stockwell, *Population and People*, p. 171.

31. Gordon, *Woman's Body, Woman's Right*, pp. 397–398; Commission on Population Growth and the American Future, *Population and the American Future* (New York: Signet Classics, 1972), p.xv.

32. Robert E. Gould, "The Wrong Reasons To Have Children," in Peck and Senderowitz, ed., *Pronatalism*, p. 193.

33. Stockwell, *Population and People*, p. 68; *Gallup Report* 69 (Mar. 1971): 18; *The Virginia Slims American Women's Opinion Poll* (New York: The Roper Organization, 1974), III, 66.

34. Ellen Peck, "Obituary: Motherhood," *New York Times* (May 3, 1972): 31.

4. Changing Patterns of Marriage

1. See Arthur J. Norton and Paul C. Glick, "Marital Instability: Past, Present and Future," *Journal of Social Issues* 32 (1976): 5–20; Paul Glick and Arthur Norton, "Perspectives on the Recent Upturn in Divorce and Remarriage," *Demography* 10 (Aug. 1973): 301–314; Murray S. Weitzman, "Finally the Family," *The Annals of the American Academy of Political and Social Science* 435 (Jan. 1978): 61–82; Helena Znaniecki Lopata, *Family Factbook* (Chicago: Marquis Academic Media, 1978); Sar A. Levitan and Richard S. Belous, *What's Happening to the American Family?* (Baltimore: Johns Hopkins University Press, 1981).

2. Gary S. Becker, "A Theory of Marriage," in Theodore W. Schultz, ed., *Economics of the Family: Marriage, Children, and Human Capital* (Chicago: University of Chicago Press, 1973).

3. Paul C. Glick, "Updating the Life Cycle of the Family," *Journal of Marriage and the Family* 1 (Feb. 1977): 9.

4. Kingsley Davis, "Statistical Perspective on Marriage and Divorce," *The Annals of the American Academy of Political and Social Science* 272 (Nov. 1950): 10.

5. Norton and Glick, "Marital Instability," pp. 10–11.

6. Elizabeth Douvan, "Differing Views on Marriage, 1957 to 1976," *Newsletter, Center for Continuing Education of Women* 12 (Spring 1979): 1–2.

7. U.S. Bureau of the Census, *Historical Statistics of the United States, Colonial Times to 1970* (Washington, D.C.: Government Printing Office, 1970); U.S. Bureau of the Census, *Statistical Abstracts of the United States, 1982* (Washington, D.C.: Government Printing Office, 1982).

8. U.S. Bureau of the Census, *Current Population Report*, Series P–20, 297 (Oct. 1976).

9. Davis, "Statistical Perspective on Marriage and Divorce," pp. 18–19; Lopata, *Family Factbook*, pp. 208–212.

10. Larry Bumpass and James Sweet, "Differentials in Marital Instability," *American Sociological Review* 37 (1972): 754–766; Paul C. Glick and Arthur J. Norton, "Frequency, Duration, and Probability of Marriage and Divorce," *Journal of Marriage and the Family* 33 (1971): 307–317; Phillip Cutright, "Income and Family Events: Marital Stability," *Journal of Marriage and the Family* 33 (1971): 291–306; Hugh Carter and Paul C. Glick, *Marriage and Divorce* (Cambridge: Harvard University Press, 1976).

11. Norton and Glick, "Marital Instability," pp. 13–14.

12. Freed and Foster, "Divorce American Style," p. 84; Norton and Glick, "Marital Instability," pp. 15–16.

13. *New York Times* (Dec. 9, 1970): 50; *U.S. News & World Report* (Dec. 10, 1976): 56; Abbott L. Ferriss, *Indicators of Trends in the Status of American Women* (New York: Russell Sage, 1971), pp. 330–331; U.S. Bureau of the Census, *Statistical Abstracts of the United States, 1980* (Washington, D.C.: Government Printing Office, 1980), p. 80.

14. Stanley F. Mazur-Hart and John J. Berman, "Changing from Fault to No-Fault Divorce: An Interrupted Time Series Analysis," *Journal of Applied Social Psychology* 7 (Oct.–Dec. 1977): 300–312; Gerald C. Wright, Jr., and Dorothy M. Stetson, "The Impact of No-Fault Divorce Law Reform on Divorce in American States," *Journal of Marriage and the Family* 40 (Aug. 1978): 575–580; Max Rheinstein, *Marriage Stability, Divorce, and the Law* (Chicago: University of Chicago Press, 1972).

15. George H. Gallup, *The Gallup Poll: Public Opinion, 1935–1971* (New York: Random House, 1977), II, 1222; III, 1990.

16. Gallup, *The Gallup Poll,* II, 1951; Douvan, "Differing Views on Marriage," p. 2.

17. Judy Klemesruel, "Women's Calls for Advice Lead to a Divorce Handbook," *New York Times* (Oct. 8, 1975): 2; Anne-Gerard Flynn, "The New Divorcee," *New York Times* (Jan. 18, 1976): XI. 12-13.

18. *New York Times* (Mar. 13, 1967): 6; (Apr. 17, 1969): 1; (Aug. 8, 1971):

52; Eleanor Blau, "Divorced Catholics Ponder Their Role," *New York Times* (Jan. 19, 1975): 45.

19. Lopata, *Family Factbook,* p. 196.

20. Lopata, *Family Factbook,* p. 196.

21. Lopata, *Family Factbook,* p. 208; Norton and Glick, "Marital Instability," p. 8.

22. Davis, "Statistical Perspective on Marriage and Divorce," p. 19; *New York Times* (Jan. 8, 1976): 62; Glick and Norton, "Perspectives on the Recent Upturn in Divorce and Remarriage," p. 309.

23. Lopata, *Family Factbook,* p. 198; Glick, "A Demographer Looks at American Families," p. 21.

5. The Rise of Feminist Consciousness

1. Aileen S. Kraditor, *The Ideas of the Woman Suffrage Movement, 1890–1920* (New York: Norton, 1981).

2. Kraditor, *The Ideas of the Woman Suffrage Movement,* p. 46.

3. Kraditor, *The Ideas of the Woman Suffrage Movement,* p. 69.

4. Kirsten Amundsen, *The Silenced Majority* (Englewood Cliffs, N.J.: Prentice-Hall, 1971), p. 122.

5. Karen Oppenheim Mason, John L. Czajka, and Sara Arbor, "Change in U.S. Women's Sex-Role Attitudes, 1964–1974, *American Sociological Review* 41 (Aug. 1976): 573–596; L. Ann Geise, "The Female Role in Middle Class Women's Magazines from 1955 to 1976: A Content Analysis of Nonfiction Selections," *Sex Roles* 5 (Feb. 1979): 51–64.

6. Hazel Erskine, "The Polls: Women's Role," *Public Opinion Quarterly* 35 (Summer 1971): 275–282; *The Gallup Opinion Index* 128 (Mar. 1976): 4.

7. Erskine, "The Polls," pp. 286–287.

8. Erskine, "The Polls," pp. 285, 277; *The Gallup Opinion Index,* p. 44; *The Virginia Slims American Women's Opinion Poll* (New York: Roper Organization, 1974), III, 6.

9. Marcia Greenberger, "The Effectiveness of Federal Laws Prohibiting Sex Discrimination in Employment in the United States," in Ronnie Steinberg Ratner, ed., *Equal Employment Policy for Women* (Philadelphia: Temple University Press, 1980), pp. 108–127.

10. *Virginia Slims American Women's Opinion Poll,* p. 3.

11. Catherine Arnott, "Feminists and Anti-Feminists as 'True Believers,' " *Sociology and Social Research* 57 (Apr. 1973): 300–306; Theodore Arrington and Patricia Kyle, "Equal Rights Amendment Activists in North Carolina," *Signs* 3 (Spring 1978): 666–680; Maren Lockwood Carden, *The New Feminist Movement* (New York: Russell Sage, 1974); Carol Mueller and Thomas Dimieri, "Consensus and Oppositional Consciousness: Beliefs of ERA Activists in Three States," paper presented at 1982 annual meetings of American Sociological Association.

12. Deborah Durfee Barron and Daniel Yankelovich, *Today's American Woman: How the Public Sees Her* (New York: Public Agenda Foun-

dation, 1980), pp. 54–61; *The 1980 Virginia Slims American Women's Opinion Poll* (New York: Roper Organization, 1980), pp. 33–43.

13. Barron and Yankelovich, *Today's American Woman,* pp. 79–82.
14. Barron and Yankelovich, *Today's American Woman,* pp. 67–69.
15. Barron and Yankelovich, *Today's American Woman,* pp. 8–11.

6. Sex and Feminism

1. John Stuart Mill, *Utilitarianism, Liberty, and Representative Government* (London: Dent, 1950); Karl Marx, "Wage, Labor, and Capital," *Selected Works,* vol. 1 (New York: International Publishers, 1933), ch. 9; Marx, *The Eighteenth Brumaire of Louis Bonepart* (New York: International Publishers, 1963); Marx, *The Poverty of Philosophy* (New York: International Publishers, 1939); Max Weber, "Class, Status, and Party," in *From Max Weber: Essays in Sociology,* ed. Hans H. Gerth and C. Wright Mills (New York: Oxford University Press, 1958), pp. 180–195; Emile Durkheim, *The Division of Labor in Society* (New York: Macmillan, 1933); Durkheim, *Suicide: A Study in Sociology* (Glencoe, Ill.: Free Press, 1951); Richard Hofstadter, *The Paranoid Style in American Politics* (New York: Knopf, 1965); Samuel P. Huntingon, *American Politics: The Promise of Disharmony* (Cambridge: Harvard University Press, 1981).

2. Mancur Olson, *The Logic of Collective Action* (Cambridge: Harvard University Press, 1965); Morris Fiorina, *Retrospective Voting in American Elections* (New Haven: Yale University Press, 1981); Edward R. Tufte, *Political Control of the Economy* (Princeton: Princeton University Press, 1978).

3. David O. Sears, Carl P. Hensler, and Leslie K. Speer, "Whites' Opposition to 'Busing': Self-Interest or Symbolic Politics," *American Political Science Review* 73 (June 1979): 369–384; Donald R. Kinder and D. Roderick Kiewiet, "Economic Grievances and Political Behavior: The Role of Personal Grievances and Collective Economic Judgements in Congressional Voting," *America Journal of Political Science* 23 (Aug. 1979): 495–527; David O. Sears and Jack Citrin, *Tax Revolt: Something for Nothing in California* (Cambridge: Harvard University Press, 1982); Kay L. Schlozman and Sidney Verba, *Injury to Insult* (Cambridge: Harvard University Press, 1979).

4. Patricia Gurin and Edgar Epps, *Black Consciousness, Identity, and Achievement* (New York: Wiley, 1975); Arthur Miller, Patricia Gurin, Gerald Gurin, and Oksana Malanchuk, "Group Consciousness and Political Participation," *American Journal of Political Science* 25 (Aug. 1981): 494–443; Jeffrey M. Paige, "Political Orientation and Riot Participation," *American Sociological Review* 35 (Oct. 1971): 810–820; Francis Fox Piven and Richard A. Cloward, *Poor People's Movements: Why They Succeed, How They Fail* (New York: Vintage, 1977).

5. Center for Political Studies, *The American National Election Series: 1972, 1974, and 1976* (Ann Arbor: Inter-Consortium for Political and Social Research, 1979).

6. Richard T. Morris and Raymond J. Murphy, "A Paradigm for the Study

of Class Consciousness," *Sociology and Social Research* 50 (Apr. 1966): 297–313; Edward O. Lauman and Richard Senter, "Subjective Social Distance, Occupational Stratification, and Forms of Status and Class Consciousness," *American Journal of Sociology* 81 (Apr. 1976): 1304–1338; Robert Merton, *Social Theory and Social Structure*; Henri Tajfel, "Social Identity and Intergroup Behavior," *Social Sciences Information* 13 (Apr. 1974): 65–93; Avery M. Guest, "Class Consciousness and American Political Attitudes," *Social Forces* 52 (June 1974): 496–510; Andrew M. Greeley, "Political Participation among Ethnic Groups in the United States: A Preliminary Reconnaissance," *American Journal of Sociology* 80 (July, 1974): 170–204.

7. Helen M. Hacker, "Women as a Minority Group," *Social Forces* 30 (Oct. 1951): 60–69.

8. Wade N. Nobles, "Psychological Research and the Black Self-Concept: A Critical Review," *Journal of Social Issues* 39 (1973): 11–31; Thomas F. Pettigrew, "Social Evaluation Theory: Convergences and Applications," in David Levine, ed., *Nebraska Symposium on Motivation* (Lincoln: University of Nebraska Press, 1967), pp. 241–318; Gordon W. Allport, *The Nature of Prejudice* (New York: Doubleday, 1958); Henri Tajfel, *Differentiation Between Social Groups* (London: Academic Press, 1978); Walter Mischel, "A Social-Learning View of Sex Differences in Behavior," in Eleanor E. Maccoby, ed., *The Development of Sex Differences* (Stanford: Stanford University Press, 1966).

9. E. F. Jackson, "Status Inconsistency and Symptoms of Stress," *American Sociological Review* 27 (1962): 469–480; I. W. Goffman, "Status Consistency and Preference for Change in Power Distributions," *American Sociological Review* 22 (1957): 275–281; George E. Lenski, "Status Crystallization: A Non-Vertical Dimension of Social Status," *American Sociological Review* 19 (Aug. 1954): 405–413.

10. Juliet Mitchell, *Woman's Estate* (New York: Vintage, 1971), p. 92; Ellen Peck, *A Funny Thing Happened on the Way to Equality* (Englewood: Prentice-Hall, 1975), p. 1.

7. Paths to Feminism

1. *Gallup Opinion Index* 128 (Mar. 1976): 30.

2. In contrast, a study of currently married, college-educated young women aged twenty-three to twenty-nine found no relationship between marital duration or age at first marriage and nontraditional sex roles. Karen Oppenheim Mason, John L. Czajka, and Sarah Arbor, "Change in Women's Sex-Role Attitudes, 1964–1974," *American Sociological Review* 41 (Aug. 1976): 583.

3. Duncan SEI Scores were used to distinguish between low- and high-status occupations. David L. Featherman and Robert Hauser, "Sexual Inequalities and Socioeconomic Achievement," *American Sociological Review* 41 (June 1976): 462–483. These scores, which are computed on the income and education of male incumbents, are not valid for measuring the occupational status of women, especially since women's wages are depressed. The prestige hierarchy is essentially invariant with regard

to sex, for men and women give similar prestige ratings for males and females in equivalent occupations, such as waiters and waitresses. Donald J. Treiman and Kermit Terrell, "Sex and the Process of Status Attainment: A Comparison of Working Women and Men," *American Sociological Review* 40 (April 1975): 174–200. Standard prestige scores such as Duncan, Treiman, or Census codes do not compute scores for housewives. When social background factors and education on status were used to estimate the probable occupational status for homemakers, the SEI score for housewives was estimated to be 39.9, as compared to an average of 43.9 for working women. Most of the housewives (73 percent) had some prior work experience and averaged a score of 41.8. Makee J. McClendon, "The Occupational Status Attainment Processes of Males and Females," *American Sociological Review* 40 (Feb. 1976): 52–64. A different approach found that men rate the status of housewives equivalent to skilled blue-collar and low status white-collar jobs, while women's rankings were considerably lower. In this study housewives are combined with low status workers for SEI scores of 1–30. Linda B. Nilson, "The Social Standing of a Housewife," *Journal of Marriage and the Family* 40 (Aug. 1978): 541–548.

4. Anne Macke, Paula Hudis, and Don Larrick, "Sex-Role Attitudes and Employment among Women: Dynamic Models of Continuity and Change," in *Women's Changing Roles at Home and on the Job,* U.S. Department of Labor Special Report 26 (Sept. 1978): 129–154; Arland Thorton and Deborah Freedman, "Changes in Sex Role Attitudes of Women, 1962–1977: Evidence from a Panel Study," *American Sociological Review* 44 (Oct. 1979): 381–842.

5. See Linda J. Waite, "Projected Female Labor Force Participation from Sex-Role Attitudes," *Social Science Research* 7 (Dec. 1978): 299–318.

6. U.S. Bureau of the Census, *A Statistical Portrait of Women in the United States,* Current Population Reports: Special Studies, Series P-23, #58 (1976), p. 23, Table 6–1; Shirley Angrist and Elizabeth Almquist, *Careers and Contingencies* (New York: Dunellan, 1975); Ann Parelius, "Emerging Sex-Role Attitudes, Expectations, and Strains among College Women," *Journal of Marriage and the Family* 37 (Feb. 1975): 146–153; Thorton and Freedman, "Changes in Sex Role Attitudes," pp. 11–12.

7. Claude S. Fischer, "The Effect of Urban Life on Traditional Values," *Social Forces* 53 (Mar. 1975): 420–433; Sidney Verba and Norman Nie, *Participation in America* (New York: Harper and Row, 1972), pp. 229–237; *Gallup Opinion Index,* p. 30; *The Virginia Slims American Women's Opinion Poll* (New York: Roper Organization, 1974), III, 3. Community type was measured by the SRC four-category Primary Sampling Unit code.

8. Morris Rosenberg, "Perceptual Obstacles to Class Consciousness," *Social Forces* 32 (Oct. 1953): 22–27; Selig Perlman, *A History of Trade Unionism in the United States* (New York: Macmillan, 1923); Lynn Smith-Lovin and Ann R. Tickamyer, "Nonrecursive Models of Labor Force Participation, Fertility Behavior, and Sex Role Attitudes," *American Sociological Review* 43 (Aug. 1978): 541–557; Catherine Arnott, "Fem-

inists and Anti-Feminists as 'True Believers,' " *Sociology and Social Research* 57 (Apr. 1973): 300–306; David Brady and Kent Tedin, "Ladies in Pink: Religion and Political Ideology in the Anti-ERA Movement," *Social Science Quarterly* 56 (Mar. 1976): 564–575; Theodore S. Arrington and Patricia A. Kyle, "Equal Rights Activists in North Carolina," *Signs* 3 (Spring 1978): 737–748.

9. The correlation between role integration and feeling of having been held back was not significant ($r = -.07$).

10. See M. Kent Jennings and Richard G. Niemi, *The Political Character of Adolescence* (Princeton: Princeton University Press, 1974); Norman B. Ryder, "Notes on the Concept of a Population," *The American Journal of Sociology* 69 (Mar. 1964): 447–463; Ryder, "The Cohort as a Concept in the Study of Social Change," *American Sociological Review* 30 (Dec. 1965): 843–861. See also Peter Uhlenberg, "Cohort Variations in Family Life Cycle Experiences in United States Females," *Journal of Marriage and the Family* 34 (May 1974): 284–292.

11. James D. Wright, "Are Working Women Really More Satisfied? Evidence from Several National Surveys," *Journal of Marriage and the Family* 40 (May 1978): 301–313.

12. August Meier and Elliot Rudwick, *From Plantation to Ghetto* (New York: Hill and Wang, 1970), chs. 6-7.

13. In 1979 the high school and college completion rates for blacks aged twenty-five to twenty-nine were 74.8 percent and 12.4 percent, and for whites were 87 percent and 24 percent. U.S. Bureau of the Census, *Current Population Reports: Educational Attainment in the United States:* Series P-20, #356, 1980.

14. Daniel O. Price, *Changing Characteristics of Negro Population* (Washington, D.C.: Government Printing Office, 1969), p. 129.

15. Jeffrey M. Paige, "Political Orientation and Riot Participation," *American Sociological Review* 36 (Oct. 1971): 810–820; Patricia Gurin and Edgar Epps, *Black Consciousness, Identity, and Achievement* (New York: Wiley, 1975); Gary T. Marx, *Protest and Prejudice* (New York: Harper and Row, 1967); *Report of the National Advisory Commission on Civil Disorders* (New York: Bantam, 1968).

8. *The Women's Movement*

1. See Patricia Gurin and Edgar Epps, *Black Consciousness, Identity, and Achievement* (New York: Wiley, 1975); Richard A. Brody and Paul M. Sniderman, "From Life Space to Polling Place: The Relevance of Personal Concerns for Voting Behavior," *British Journal of Political Science* 7 (July 1977): 337–360.

2. Political conflict consists of two parts: the activist and the audience. The audience is an integral part of the conflict situation because it often determines the outcome. E. E. Schattschneider, *The Semi-Sovereign People* (New York: Holt, Rinehart and Winston, 1960), p. 2; Michael Lipsky, "Protest as a Political Resource," *American Political Science Review* 62 (Dec. 1968): 1144–1158. This constituency does not comprise

a part of a social movement itself, since it fails to undertake any action, but it provides an important base of support for a movement. Roberta Ash, *Social Movements in America* (Chicago: Markham, 1972), p. 2.

3. Jo Freeman, *The Politics of Women's Liberation* (New York: Longman, 1975), ch. 5.

4. Ted Robert Gurr, "Psychological Factors in Civil Violence," *World Politics* 20 (Jan. 1968): 245–278; James C. Davies, "Toward a Theory of Revolution," *American Sociological Review* 27 (Jan. 1962): 5–19; James A. Geschwender, "Explorations in the Theory of Social Movements and Revolutions," *Social Forces* 47 (Dec. 1968): 127–135; Alejandro Portes, "On the Logic of Post-Factum Explanations: The Hypothesis of Lower-Class Frustration as the Cause of Leftist Radicalism," *Social Forces* 50 (Sept. 1971): 26–44.

5. Nathan Caplan and J. M. Paige, "A Study of Ghetto Rioters," *Scientific American* 219 (Aug. 1968): 15–21; John R. Foward and Jay R. Williams, "Internal-External Control and Black Militancy," *Journal of Social Issues* 26 (Winter 1970): 75–91; Gary T. Marx, *Protest and Prejudice: A Study of Belief in the Black Community* (New York: Harper and Row, 1968); Gurin and Epps, *Black Consciousness,* pp. 274–280; Melvin Seeman, "Alienation and Engagement," in Angus Campbell and Philip E. Converse, ed., *The Human Meaning of Social Change* (New York: Russell Sage, 1972); Thomas J. Crawford and Murray Naditch, "Relative Deprivation, Powerlessness, and Militancy: The Psychology of Social Protest," *Psychiatry* 33 (May 1970): 208–223.

6. Alan Marsh, *Protest and Political Consciousness* (Beverly Hills: Sage, 1977); Samuel H. Barnes, Max Kaase, et al., *Political Action: Mass Participation in Five Western Democracies* (Beverly Hills: Sage, 1979); William A. Gamson, *Power and Discontent* (Homewood, Ill.: Dorsey Press, 1968), pp. 39–48; Anthony Orum, "On Participation in Political Protest Movements," *Journal of Applied Behavioral Science* 10 (April-June 1974): 181–207; Edward N. Muller, "A Test of a Partial Theory of Potential for Political Violence," *American Political Science Review* 56 (Sept. 1972): 928–959; Charles Tilly, *From Mobilization to Revolution,* (Reading, Mass.: Addison-Wesley, 1978), pp. 98–138.

7. Karen Oppenheim Mason, John L. Czajka, and Sara Arbor, "Change in U.S. Women's Sex Role Attitudes, 1964–1974," *American Sociological Review* 41 (Aug. 1976): 573–596.

8. Mason et al., "Change in U.S. Women's Sex Role Attitudes," pp. 573–596.

9. These predicted probabilities are converted from Probit estimates on the impact of perceived race discrimination on support for collective action by blacks, controlling for liberalism, cynicism, age, and positions on Vietnam and sex equality.

10. *Gallop Report* 128 (Mar. 1976): 24–25.

9. The Women's Vote

1. Richard F. Hamilton, *Class and Politics in the United States* (New York: Wiley, 1973); Seymour Martin Lipset, *Political Man: The Social Bases*

of Politics (Baltimore: Johns Hopkins University Press, 1981); Angus Campbell, Philip E. Converse, Warren E. Miller, and Donald E. Stokes, *The American Voter* (New York: Wiley, 1960); Morris P. Fiorina, *Retrospective Voting in American National Elections* (New Haven: Yale University Press, 1981); Benjamin I. Page, *Choices and Echoes in Presidential Elections* (Chicago: University of Chicago Press, 1978).

2. Eleanor Flexner, *Century of Struggle* (Cambridge: Harvard University Press, 1976); William Chafe, *The American Woman: Her Changing Social, Economic, and Political Roles, 1920–1970* (New York: Oxford University Press, 1972).

3. Walter D. Burnham, "Theory and Voting Research," *American Political Science Review* 68 (Sept. 1974): 1013; Kristi Andersen, "Generation, Partisan Shift, and Realignment: A Glance Back to the New Deal," in Norman Nie, Sidney Verba, and John Petrocik, *The Changing American Voter* (Cambridge: Harvard University Press, 1979), p. 77; Sophinisba Breckinridge, *Women in the Twentieth Century: A Study of Their Political, Social, and Economic Activities* (New York: McGraw Hill, 1933); John Stucker, "Women as Voters: Their Maturation as Political Persons in American Society," in Marianne Githens and Jewel Prestage, ed., *A Portrait of Marginality* (New York: McKay, 1977).

4. Marjorie Lansing, "The American Woman: Voter and Activist," in Jane Jacquette, ed., *Women in Politics* (New York: Wiley, 1979); Naomi Lynn, "Women in American Politics: An Overview, in Jo Freeman, ed., *Women: A Feminist Perspective* (Palo Alto: Mayfield, 1979); Martin Gruberg, *Women in American Politics* (Oshkosh, Wis.: Academia Press, 1968).

5. Theodore White, *The Making of the President 1972* (New York: Atheneum, 1973); Ernest R. May and Janet Fraser, *Campaign '72* (Cambridge: Harvard University Press, 1973); Benjamin Page, *Choices and Echoes;* Arthur H. Miller, Warren E. Miller, Alden S. Raine, and Thad A. Brown, "A Majority Party in Disarray: Policy Polarization in the 1972 Election," *American Political Science Review* 70 (Sept. 1976): 753–778.

6. White, *The Making of the President 1972*, p. 37.

7. Benjamin I. Page and Calvin C. Jones, "Reciprocal Effects of Policy Preferences, Party Loyalties, and the Vote," *American Political Science Review* 73 (Dec. 1979): 1071–1089; Gregory B. Markus and Philip E. Converse, "A Dynamic Simultaneous Equation Model of Electoral Choice," *American Political Science Review* 73 (Dec. 1979): 1061.

8. Page, *Choices and Echoes*, pp. 55–56.

9. White, *The Making of the President 1972*, p. 337.

10. Men and women were assigned the mean value on each of the independent variables for their group in predicting the vote probabilities, to arrive at the "average" voter.

11. See Jules Witcover, *Marathon* (New York: Signet, 1977); Page, *Choices and Echoes;* Verba et al., *Changing American Voter;* Fiorina, *Retrospective Voting.*

12. See Page, *Choices and Echoes,* pp. 62–102. See also Teresa E. Levitin and Warren E. Miller, "Ideological Interpretations of Presidential Elections," *American Political Science Review* 73 (Sept. 1979): 751–771.

13. Helen Dimos Schwindt, "Tip Sheet for Sizing Up the Candidates," *Ms* 1 (July 1976).

14. Verba et al., *The Changing American Voter,* ch. 20, Fiorina, *Retrospective Voting,* pp. 167–175.

15. See Sandra Baxter and Marjorie Lansing, *Women and Politics: The Invisible Majority* (Ann Arbor: The University of Michigan Press, 1980).

16. See Austin Ranney, ed., *The American Elections of 1980* (Washington, D.C.: American Enterprise Institute, 1981); Jack W. Germond and Jules Witcover, *Blue Smoke and Mirrors* (New York: Viking, 1981); Paul Abramson, John H. Aldrich, and David W. Rhode, *Change and Continuity in the 1980 Elections* (Washington, D.C.: Congressional Quarterly, 1982).

17. See John R. Petrocik and Sidney Verba, "Choosing the Choice and Not the Echo: A Funny Thing Happened to the Changing American Voter on the Way to the 1980 Election," paper presented at 1981 annual meetings of American Political Science Association.

18. Paul R. Abramson, John H. Aldrich, and David W. Rhode, *Change and Continuity in the 1980 Elections* (Washington, D.C.: Congressional Quarterly, 1982); Warren E. Miller and J. Merrill Shanks, "Policy Directions and Presidential Leadership: Alternative Interpretations and the 1980 Presidential Election," *British Journal of Political Science* 12 (1982): 299–356; Arthur H. Miller, "Policy and Performance Voting in the 1980 Election," paper presented at 1981 annual meetings of American Political Science Association; Keith T. Poole and L. Harmon Ziegler, "Gender and Voting in the 1980 Presidential Election," paper resented at 1982 annual meetings of American Political Science Association.

Conclusion. Gender and the Future

1. *The 1980 Virginia Slims American Women's Opinion Poll* (New York: Roper Organization, 1980), pp. 101–106.

2. Deborah Durfee Barron and Daniel Yankelovich, *Today's American Women: How the Public Sees Her* (New York: Public Agenda Foundation, 1980), pp. 64–65.

3. Marc Leepson, "Affirmative Action Reconsidered," in *The Women's Movement: Agenda for the '80s,* Editoral Research Reports (Washington: Congressional Quarterly, 1981), p. 37.

4. Sandra Stencel, "Equal Pay Fight," in *The Women's Movement,* p. 3.

5. Stencel, "Equal Pay Fight," pp. 4–6; Leepson, "Affirmative Action Reconsidered," p. 27; Sandra Stencel, "Women in the Work Force," in *Changing American Family,* Editorial Research Reports (Washington: Congressional Quarterly, 1979), pp. 89–90.

6. Sar A. Levitan and Richard S. Belous, *What's Happening to the American Family?* (Baltimore: Johns Hopkins University Press, 1981), p. 97.

7. Levitan and Belous, *What's Happening to the American Family?* p. 110;

Sandra Stencel, "Single Parent Families," in *Changing American Family,* pp. 63–64.

8. Barron and Yankelovich, *Today's American Woman,* pp. 64–65.
9. *New York Times Women's Survey,* Nov. 1983.
10. Barbara Deckard, *The Women's Movement: Political, Socioeconomic, and Psychological Issues* (New York: Harper and Row, 1983), p. 417.

Index